PHOTOGRAPHY Made Simple

The Made Simple series
has been created
primarily for self-education
but can equally well
be used as
an aid to group study.
However complex the subject,
the reader is taken
step by step,
clearly and methodically,
through the course. Each volume
has been prepared by experts,
using throughout the
Made Simple technique of teaching.
Consequently the gaining
of knowledge now becomes
an experience to be enjoyed.

In the same series

Accounting
Acting and Stagecraft
Additional Mathematics
Administration in Business
Advertising
Anthropology
Applied Economics
Applied Mathematics
Applied Mechanics
Art Appreciation
Art of Speaking
Art of Writing
Biology
Book-keeping
British Constitution
Business and Administrative
 Organisation
Business Economics
Business Statistics and Accounting
Calculus
Chemistry
Childcare
Commerce
Company Law
Computer Programming
Computers and Microprocessors
Cookery
Cost and Management Accounting
Data Processing
Economic History
Economic and Social Geography
Economics
Effective Communication
Electricity
Electronic Computers
Electronics
English
English Literature
Export
Financial Management
French
Geology
German

Housing, Tenancy and Planning Law
Human Anatomy
Human Biology
Italian
Journalism
Latin
Law
Management
Marketing
Mathematics
Modern Biology
Modern Electronics
Modern European History
Modern Mathematics
Money and Banking
Music
New Mathematics
Office Practice
Organic Chemistry
Personnel Management
Philosophy
Photography
Physical Geography
Physics
Practical Typewriting
Psychiatry
Psychology
Public Relations
Rapid Reading
Retailing
Russian
Salesmanship
Secretarial Practice
Social Services
Sociology
Spanish
Statistics
Systems Analysis
Transport and Distribution
Twentieth-Century British History
Typing
Woodwork

PHOTOGRAPHY Made Simple

Derek Bowskill

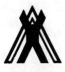

Made Simple Books
HEINEMANN : London

Made and printed in Great Britain
by Butler & Tanner Ltd, Frome and London
for the publishers William Heinemann Ltd,
10 Upper Grosvenor Street, London W1X 9PA

First edition, March 1975
Reprinted, September 1978
Reprinted, January 1980
Reprinted, March 1982

SBN 434 98529 5 Cased
 434 98530 9 Paperback

Acknowledgments

The author and publisher acknowledge the help and cooperation of Photax Limited in the preparation of this book and for supplying information on Paragon and Yashica products, and thank Japanese Cameras Limited for supplying the illustrations on pages 49–50 and information on Minolta and Rokkor products.

Acknowledgement is also made for reproduction of material supplied by the following: Agfa-Gevaert Ltd, Bowens Sales and Service Ltd, CZ Scientific Instruments Ltd (for Praktica), Kodak Ltd, Charles Knight & Co. Ltd, Rank Audio Visual (for Nikon Tokyo), Rollei (UK) Ltd, K. L. Biggs Precision Equipment Ltd, Johnsons of Hendon Ltd (for Durst), and E. Leitz (Instruments) Ltd (for Leica).

This book is for
Sara-Jane
who helped open eyes

Preface

'It is far more difficult to be simple than to be complicated, far more difficult to sacrifice skill and cease exertion in the proper place, than to expend both indiscriminately.
To see clearly is poetry, prophecy and religion, all in one.'

John Ruskin: *Modern Painters*

In a society which regurgitates commercial films, television programmes and colour supplements with so much apparent relish and ease, the man with a camera is most able to make an effective stand against the potential, comparative and real debasement of visual imagery that surrounds most of us for most of our lives. The man with a camera can help us to see—and most of us say every day '*See* what I mean?'

The photographer has had from the outset a special role and a certain image, but since the socio-cultural explosion of the fifties, both role and image have become singularly fascinating, glamorous and very often prestigious. There is no doubt that the photographer is a man of today, with an eye on tomorrow.

This book is designed primarily for the non-commercial photographer —the photographer who has time, money, effort and opinion on his side, and who can, therefore, innovate without restraint, experiment without fear and take whatever time he needs. The non-commercial photographer can set his own standards and his own priorities; his disciplines and conventions are his own and those of the photographic art he creates. The discovery and creation of those disciplines and conventions within the continuously expanding boundaries of self-expression is what this book is all about.

While the book is mainly intended as a personal guide for the non-commercial photographer, it can also be used as a basis for, or in conjunction with, group training and practice in schools, colleges and further education classes. The importance and value of such classes and courses organised by Local Education Authorities cannot be over-stressed. Not only can they offer a high level of instruction, but they can also be of real help in easing the burden of the cost of equipment, materials and the hire of premises. Any small group—a society or just a few friends—can request such assistance and it is your right to do so. It is undoubtedly in your interests to exercise that right.

Photography is essentially practical with an endless variety of forms, and the best way to learn about it and the only way to understand it

so that it has real meaning for you, is to do it. In photography, as in life, anybody can do anything, but too many of us are put off too many things by jargon and mystique; by apparent complexities and difficulties.

This book sets out less to make photography simple than it does to make it clear that photography is simple.

Table of Contents

SOME BASIC PRINCIPLES

'Thy eyes have one language everywhere'

Outlandish Proverbs—1640

'There is no light
Unless there is something for it to shine upon.'

Ronald Duncan—1964

Photography and its Many Facets

The arts and crafts, techniques and end-products of photography surround us wherever we go. More and more, we are becoming accustomed to photographs doing duty for words; on the television, on posters and in magazines.

Photography has an important role in the world at large. Science and commerce, medicine and industry, sport and journalism are only a few of the areas of work and play that use the services, skills and techniques of an already vast but still expanding industry.

Photography is a leisure-time activity for millions. It is also an art form.

Any activity which embraces social and commercial functions, an industrial and financial empire, a leisure time pursuit and an art-form at one and the same time, is bound to be difficult to summarise, especially since the activity can be pursued at any level of appreciation, expertise, intensity and financial investment.

Photography uses up-to-date techniques but is totally reliant upon the timeless phenomenon of one form of radiant energy: light rays (see Fig. 1.2). Photography is sometimes called the art of painting with light. Its main merit lies in its ability to record what the eye sees, or rather, what we think it sees. It is a way of making permanent those passing images that gain our interest or catch our eye. This was fully exploited in Antonioni's film *Blow-Up*; not only, of course, in its making, but also in its subject matter: the analysis of an apparently insignificant event through the eyes of a professional photographer and his enlarger.

We live in a world of light. Light comes naturally from the sun, moon and stars and artificially from devices like matches, torches, gas and electricity; light rays surround us everywhere, but we cannot see

1

them, although we see by them and can often see their source. We are so accustomed to living with these light rays, that we frequently take them for granted.

However, you are able to read the words on this page only because the light rays travelling from it have free access to the lens of your eye. This lens arranges the light rays to focus and so create an image you can recognise.

Place your hand between the page and your eye. You will block the light rays and will no longer see the page. Your hand is not sensitive to light and therefore you cannot see with it, neither is it transparent and therefore the light rays cannot pass through it. Instead, you 'see' your hand and not the page.

The Human Eye and the Camera Compared

The human eye and the camera have a number of things in common: they both need light rays in order to function; a lens to organise the rays to make sense and an image-forming surface so that the rays can be read. Before exploring the aspects of light, lens and surface further, it is important to note the major difference between the camera and the human eye. This difference exists, and significantly so, in the matter of the image-forming surface. In a camera, this is the **emulsion-treated side of the film**, and in the eye it is the **retina**. The retina registers the image and immediately passes it on to the brain to be interpreted, perceived and understood. The emulsion registers the image and **records** it. (Later it will be developed and a photograph printed. These processes are dealt with in Chapters Eight to Ten.) The film has no mechanism with which to understand and in this context, the retina has no memory with which to record.

Briefly, for the camera, the phrase might be:

'Message received and *recorded*'

and for the human eye:

'Message received and *understood*'

Above and beyond everything else concerned with the making of a good photograph is the relationship between the eye of the photographer and the eye of his camera. Fig. 1.1 illustrates in simple terms the ways in which the two systems work.

The following table offers some comparisons between the human eye and the eye of a camera:

Function	Human Eye	Camera
Mobile	Yes	More so
Detachable from photographer	No	Yes
Registers visible rays	Yes	Yes
Records visible rays	No	Yes
Registers 'invisible' rays	No	Yes
Records 'invisible' rays	No	Yes
Senses light, shade, colour	Yes	Yes
Records light, shade, colour	No	Yes
Interprets light, shade, colour	Yes	No
Adjusts for level of light	Yes⎫ automatic ⎫ Yes	manipulated
Adjusts for focus	Yes⎭ and very ⎭ Yes	over greater
	flexible	range
Adjusts for angle of view	Only a little	Greatly
Sees small objects	Yes	Better
Sees into the distance	Yes	Better
Catches fast motion	Yes	Better

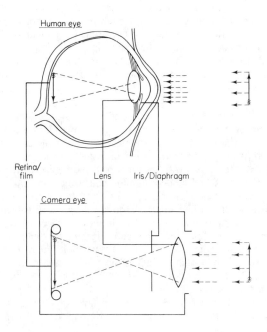

Fig. 1.1. The human eye and the camera eye.

Light and Colour

Light is the first of the common needs of camera and human eye. Visible light is radiated from a source and travels in virtually straight lines at a tremendous speed. It can pass, apparently imperceptibly, through air, water and a vacuum. It can also pass through glass.

Since what happens to light when it does pass through glass is a vital part of photography, it is worthwhile considering the subject for a moment. In his excellent and fascinating book *The Vision of Glory: The Extraordinary Nature of the Ordinary** John Stewart Collis has this to say:

'Glass is not a natural compound. Great heat turns sand into a liquid. When that liquid cools it becomes glass. Pure glass is an invisible stone, as it were. We cannot see it. It is not apparent, it is transparent we say. We see through it because the waves of light pass through it. It does not absorb all of them and give us a black stone. It does not reject all of them and give us a white stone. It does not select some of them and give us a coloured stone. The waves pass right through—quite easy, since everything is chiefly made of holes.

One of the most interesting ways of making the mystery of light and colour real to ourselves is by simply putting a prism to our eyes. Then we come upon it with a flash of surprise. Yet it is noteworthy that not a few of those who know all about the prism and the spectrum (in the famous school way of knowing things) do not know what happens if they simply put a prism to their eyes—and probably they think that they do not possess one. But any piece of smooth glass with three sides will do. Personally I use one of the glass fingers which used to hang from a lampshade.

We look through it and see a very different world. So fantastic is the change that at first we may suspect some trickery in the glass. I looked at a line of washing, chiefly white. Through the glass the things appeared rainbowed. The white towel hanging there had a band of orange at the top with parallel bands below of red, green, yellow, blue and violet. I turned my attention to an area of earth on which I had made a bonfire, consisting now of odd bits and pieces of sticks, silver paper, burnt heads of tins and so forth, on the edge of which was a flowerpot in a white saucer. Through the glass all was transfigured. The flowerpot stood in a bright rainbow. The tawdry piece of tin became a pearl of great price. The sticks and flints and ridges of clay and ash were coloured walls surrounding something like the Tower of London done up as a fairy palace. A seagull, happening to alight there just then became nearly a peacock in colour-scheme. A well-to-do thrush whose frontage faced the sunlight achieved a fancy-waistcoat.

I took away the prism from my eyes and saw again the bleak area of rubbish. Yet there was nothing in the glass by way of colour to make this transformation.

* *The Vision of Glory: The Extraordinary Nature of the Ordinary*, by John Stewart Collis, Charles Knight, London, 1972.

Before this was discovered in the seventeenth century little was known as to the nature of light and no one had thought of attempting to split it up. It was left for the great Newton to appear with his prism in the dark room. Even today the little experiment still fascinates us. We go into a dark room; we make a neat hole in the blind; a ray of sunshine passes across the room to a screen. Then we place a prism (roughly a piece of glass with at least three sides) in the path of the ray. Instead of the beam passing on—though bent by the glass—we see separate bands of light each of a different colour, the most obvious being red, orange, yellow, green, blue, and violet. A beam of ordinary white light, any thread of it however thin, is a bundle of rays which can be fanned out by a prism because the particular wave-length or scale of each makes it subject to a particular degree of bending. Thus spread out each ray is discerned as a different colour. We close the fan and it is white again. We call this the Spectrum, the word simply meaning spectacle or appearance.'

Fig. 1.2 illustrates the visible spectrum with its marginal regions.

Optical radiation range according to DIN 5031: 100 nm–1mm

ultra-violet rays — visible light rays — infra-red rays

280 UV, short waves | 315 UV, medium waves | UV, long waves | 420 blue | 495 green | 566 yellow | 589 orange | 627 red | 780 | 1400 IR, short waves | 1400–3000 IR, medium waves | 3000–>10000 IR, long waves

Fig. 1.2. The visible spectrum and its marginal regions.

The ability of the prism to create the spectacle or appearance that John Collis so beautifully describes is known as dispersion (Fig. 1.3).

Dispersion

Dispersion is the unequal bending of rays of different wavelengths, causing white light to be broken into its constituent colour rays. It is only one of the things that can occur when light rays fall upon the surface of an object.

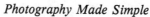

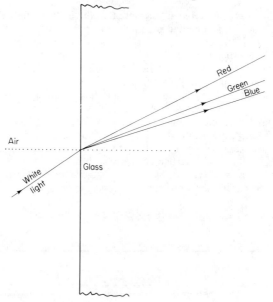

Fig. 1.3. Dispersion of light.

Fig. 1.4. Diffuse and specular reflection.

Reflection

Reflection may be from a **gloss** or **matt** surface. If it is gloss (such as a mirror, polished metal, mercury, water or gloss paper) there will be a close relationship between each light ray striking and being reflected. If the surface is matt, the close relationship will be broken and the rays will be reflected equally in all directions.

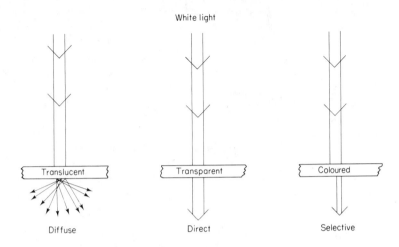

Fig. 1.5. Transmission of light.

Transmission

Transmission may be **direct** or **diffuse** and the basic principle is similar to that of reflection. If the light rays pass through the material on a one-to-one basis and their direction remains unchanged, the transmission is direct—similar to specular reflection. If the rays pass through the material and are equally scattered the transmission is diffuse—similar to matt reflection. Direct transmission can occur through air, clear glass and clear water. Diffuse transmission can occur through translucent materials such as plastics, ground glass and frost filters. Colour filters are a special case. They transmit only selected wavelengths, the rest being absorbed.

Some filters and materials neither transmit nor reflect any light at all. They absorb it completely.

Absorption

Some light rays are never transmitted, never passed on to be seen. They are absorbed by opaque materials such as matt, black plaster or matt, black paper and the light rays are converted into heat. Classroom physics lessons show this clearly by demonstrations of how a piece of black card will heat up more quickly in sunlight than a similar piece of white card. Owners of black cars are also aware of this factor.

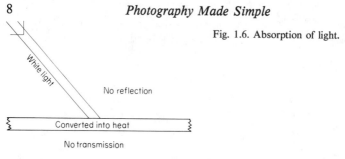

Fig. 1.6. Absorption of light.

Fig. 1.7. Wavelength.

Refraction

Refraction is a special case of transmission and occurs when light rays pass from one transparent material to another, but meet the surface of the new material at an angle other than ninety degrees. Visible light (like radar and radio, a member of the family of electro-magnetic radiation) appears to travel in wave formation, perhaps best imagined as a cross-section of the ripples formed when a stone is dropped in a pool. The **wavelength** of these rays is defined as the distance from crest to crest and can vary from many metres to a millionth of a metre.

Because light rays travel at different speeds through different materials (slower through glass than through air, for example) and because the wave-front is approaching the new surface at an angle and not 'head-on', one side of the wave-front is slowed down before the other and the light ray is therefore 'bent'. This bending is influenced by three factors: the angle of entry of the light rays to the new surface (the **angle of incidence**); the density of the new material (the **refractive index**); and the wavelength of the light.

Refraction and dispersion are essential factors in photography. Without them, photography as we know it today would not exist. They are the principles on which all lenses depend for their effect and application.

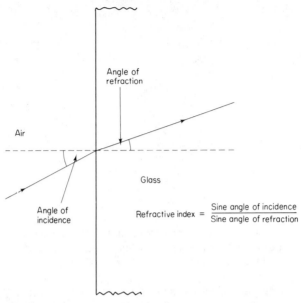

Fig. 1.8. Refraction of light.

To summarise so far: we need light in order to see things at all; we need light to be able to photograph them; and we need light to see the end-product—the finished print.

Light is undoubtedly the most important common need of the human eye and the camera, but it is only one. Some form of control over the light rays is needed if they are to be formed into meaningful images or pictures.

Controlling Light

If light-sensitive paper, film or the retina of the human eye were placed directly in front of an object, they would register an even scatter of light rays that would appear as a grey fog. Many photographers have been made unhappily aware of this fact when their film or paper has been accidentally exposed to uncontrolled light rays. The consequent **'fogging'** is well named.

Light rays are reflected ('bounced') from almost every object in almost every direction. Unless a control factor is introduced to select and arrange the rays, they will not form an image. The result is not a picture, but a complete blur. The diagram of a woman with an umbrella

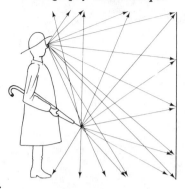

Fig. 1.9. Light scatter.

(Fig. 1.9) shows how light rays from only two points—her nose and the tip of the umbrella—cover the whole area in front of her with an even but meaningless distribution of light rays.

Since every part of the woman—shoes, hat, hands, umbrella, etc.—is sending out rays, it can readily be understood that no image will be formed unless we can put the rays from the nose and the rays from the umbrella where they belong. They must be collected and rearranged so that the nose looks like the nose and the umbrella looks like the umbrella. This must be done for the light rays from every particular, to create the right total impression.

Pinholes

One simple method of control is used in the pinhole camera. It exploits a phenomenon that has been known for centuries: the capability of a pinpoint hole to make a picture with light. The principle has been used for years in the *camera obscura*, a room-sized camera, dark inside, with a single light source of a very small hole in one wall. A large and effective image is thrown on to the facing wall. The camera obscura can be a source of interest and amusement and there are still some working for their living in seaside resorts.

On a smaller scale, a light-tight shoe-box, with a pinhole at one end and a piece of photographic paper at the other, is a basic camera and it is simple but effective, within limits. Fig. 1.10 shows how the light rays from the woman with an umbrella are organised.

The major drawback to the general use of the pinhole as a control factor is its inflexibility. The small amount of light the pinhole admits means long exposures. This is not only inconvenient but it also renders

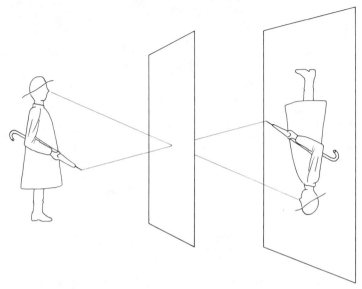

Fig. 1.10. Principle of the pinhole camera.

the camera incapable of being hand-held or of photographing moving objects. Fortunately, the lens provides a control factor which overcomes these difficulties.

Lenses

The lens can work with much more light than the pinhole and requires much shorter exposure periods. Its increased flexibility and efficiency enables moving objects to be caught in action; the camera to be hand-held; and scenes with low-level light to be photographed. As a result, the whole process becomes more convenient and attractive.

It is refraction that enables lenses to do this. Earlier in this chapter it was said that refraction (the bending of light rays) occurs when those rays strike the surface of a transparent material at an angle other than 90 degrees. This can be brought about in two ways:

(a) By angling the rays themselves on to the flat surface of the material (see Fig. 1.8).
(b) By angling or curving the surface of the material.

The simple, converging lens is thicker in the middle than it is at the edges. It collects some of the many light rays from an object and brings them together at a single point of focus as shown in Fig. 1.11.

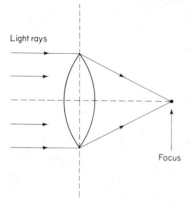

Fig. 1.11. Convex (or converging) lens.

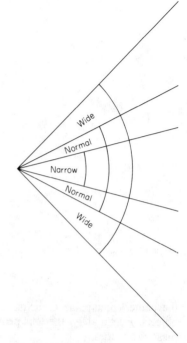

Fig. 1.12. Angles of view.

Some lenses bend light rays more sharply than others and this rate of bend is defined as the **focal length** of the lens. A lens with a short focal length will bend rays very sharply and bring them into focus close behind the lens. A lens with a greater focal length will bring the rays into focus further from the lens. The distance from the point of focus (**focal point**) to the centre of the lens is generally known as its focal length and is usually measured in millimetres.

The lens in the human eye works on exactly the same principle but is made of gristle and controlled by muscles which change its focal length automatically and imperceptibly.

The most noticeable contrast between lenses of different focal lengths comes with the angles of view they will accept. The relationship between focal length and angle of view is directly influenced by the size of film being used. More will be said of this later. At this time the film

size is presumed to be constant, and in any case the general principle remains the same. The human eye has an average angle of view of 50 degrees and camera lenses with angles of view between 45 and 55 degrees are called **standard** or 'normal' lenses, because they create images approximating to those usually seen by the human eye. Lenses offering wider or narrower angles of view are called **wide-angle** or **narrow-angle** respectively. In Fig. 1.12 this difference is shown clearly.

Images

Having examined how to control light rays to make them present images we can understand, we now turn to the third common need of the camera and the human eye: a surface on which the image can register. This common need is no longer met in similar ways. Although both retina and film are sensitive to light, they register and use it in different ways.

The retina registers what it senses and immediately passes it on to the brain as a revealed and significant image and we 'see'.

The film registers what it senses and stores it as a secret image for later revelation through chemical processing.

Just as the human eye needs an agent to reveal its message—the brain, so does the film—chemicals. The film retains its message in chemical compounds held in emulsion in a gelatin base. When treated by chemicals the 'negative' is revealed. Additional but different treatment will provide a 'positive'.

There is also a parallel in the way the retina and film emulsion 'sense' light rays:

The retina contains rods and cones;
The film contains chemicals.

Both these sensors are responsive to light; both can be specially sensitive to little light (twilight and night time); to a lot of light (full sunlight or powerful spots and floods); and to coloured light (the primary colours of red, blue and green—separately or in combination).

The major difference between retina and film is that the latter deals with one image only, storing it away as a latent image, and only later revealing it, after chemical treatment.

The retina registers many images in quick succession so they mean something both *functionally*—as when reaching for a cup or cigarette, looking where to step, or avoiding a bus—and *aesthetically*—as when appreciating a sunrise, a painting, a film or an attractive person.

Although the eye registers all these things, it can retain them only for a second or indeed a split second. Eye-memory or persistence of vision is a vital part of cine-photography. The camera enables us to

record and retain images permanently, no matter the colour, form or texture of the object or collection of objects. However, only the photographer can ensure the record will be eye-catching and worthwhile.

Ways of Looking

The camera helps us illuminate, in more ways than one, the world we live in. Many things affect the quality of the permanent record, but nothing affects it in a more central and essential way than the sensitivity and perception of the photographer's seeing eye.

The photographer's equipment, if it is carefully looked after, will stay constant in the rules it obeys and will faithfully record what he tells it to record. His perception of the world about him may well undergo many changes after training his eyes to look with special insight.

Shifting Perception

Human perception through sight can change dramatically, and it is the way the man with the camera sees the possibilities of change that helps him make good pictures. Neither the magic, the significance nor the importance of this aspect can be over-stressed in the appreciation of the art of photography. The following examples demonstrate the leaps in perception that our eyes can help us take.

Look at Fig. 1.13: it is known as the **Kohler Cross**. Look at it and see if you first recognise a white cross or a black cross.

In fact both crosses are present in the one figure. If you continue to look at it you will find that your perception will enable you to switch from a white cross on a black background to a black cross on a white background. The figure remains the same, it is only what you make of it that changes. If you look for longer, you will come to recognise how often you make, and can *control* making, the changes from one 'view' to another. You will also note that although both crosses co-exist in the same figure, and you know it, it is almost impossible to see the two together.

Now look at Fig. 1.14. There are two equally contrasting 'images' available in each. Continue to look at the figures until you achieve the same mastery over them that you had with the Kohler Cross.

In these black and white figures the subject to background relationship is deceptive. At first glance it may appear to be clear and positive, but a few seconds only will show that it is by no means as concrete or definitive as was first thought. In such circumstances the change in our understanding of the relationships within the whole image is brought about by our shifting perceptions. The main principle behind this is

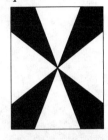

Fig. 1.13. The Kohler Cross.

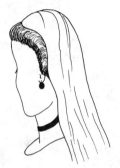

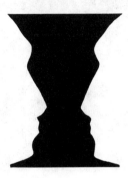

Fig. 1.14

known as the **figure-ground relationship.** Figures and their back-grounds play a large part in photography, and an understanding of the importance of their inter-relationships is vital for any work with a camera.

Plates 1.1 and 1.2 illustrate the principle in action in a more subtle way than the two previous figures. Study the photographs at length and make a note of your conclusions before discussing them with a friend.

Training the Eye—Exercises

Consciously exercising the faculty of shifting perception is one way of training the eye. Here are some more:

(a) Look around any room to discover objects and collections of objects with specific lines or shapes: straight lines and curved lines of all kinds, including circular lines; squares, ovals, triangles and circles, etc. See how many lines and shapes appear to echo one another or to contrast sharply. With this exercise, and with those that follow, try these variations in the order you most prefer:

(i) Look with the intention of remembering and later, bring back the images to the mind's eye.

Plate 1.1

Plate 1.2. How many images? How many meanings?

Fig. 1.15

(ii) Make quick sketches of what you see and later, of what you remember.

(iii) Sketch what you see with your hands in the air.

(iv) Make a camera viewer with a piece of card, or your hands, as shown in Fig. 1.15, and select chosen shots.

(v) Take a photograph to show clearly the special point of view you have in mind.

(b) Make shapes of your own, as in (a) above, from pipe-cleaners, matches and match-boxes, egg-shells, egg-cartons and marbles, etc.

(c) Look around any room and choose an object such as a cushion, a vase, a chair or a kettle. See how many shapes it contains and what other objects in the room echo or contrast with those shapes.

(d) Look around any room and note the relationships between the objects in it. For example: a clock and an ornament on a mantlepiece, adjacent chairs, crockery and cutlery, a table leg and the pattern on the carpet. Analyse the apparent relationships by paying particular attention to the lines and shapes as in (a) above. Change the positions of the objects to create new ideas and relationships.

(e) Go into any room with windows and carefully note the changes in atmosphere brought about by the changing light from morning to night. Note also the apparent changes in colour, form and texture. Pay particular attention to the changing shapes of shades and shadows.

(f) Go into the same room at night, with the curtains fully closed, and inspect it with a torch with a narrow beam. An ordinary torch or flashlight with the lens covered by a mask with a pinhole in it is satisfactory. Concentrate on small areas at length.

(g) Choose a small area in the garden—no more than four inches square—and see how many different shapes and colours of things and creatures (alive or dead) you can discover. Try the exercise with flowerheads, the bark of a tree, the soil and the grass. Try it also in the street, on pavements, seats, gutters, wastebins, etc.

(h) Look at a room, a car, the inside of a bus or a group of buildings and divide what you see into colour blocks. Note whether they echo or contrast with one another.

Plate 1.3

Plate 1.4. Close-ups: who, what, where, how?

(i) Watch television with the sound off. Watch for the things mentioned in the previous exercises and also for facial expressions, body positions and unusual gestures. Take particular note of the way people use their hands and feet.

(j) Watch people at work to discover if they have any repetitive movements or gesture patterns. For example: bus conductors, traffic-wardens, lorry drivers, street cleaners, people going through doors or riding bicycles, etc. Decide which 'frozen' position would most describe and explain them.

(k) Look at as many things as possible through binoculars, telescopes, magnifying glasses and microscopes.

(l) Look at paintings and photographs. Study the work of individual artists and get to know their styles and subjects, then study them comparatively.

(m) Study close-ups like the ones illustrated in Plates 1.3 and 1.4. Make your own.

Above all: *Look at people and look at things*, with the camera eye, the human eye and the mind's eye.

We have now begun the journey of exploration into what makes photography work. It has been established that light rays, a lens and a sensitive register (retina or film) must be properly combined if we are to:

make sense of what there is to be seen,
register and record it,
enjoy the record.

To create enjoyable records that offer interesting and worthwhile images, rather than merely mundane pictures, the eye of the camera must be put to work, 'pointed' as it were, by the perception and insight—the third eye—of that unique product of today's world: the creative / artist / artisan / technician / mechanic / optician—the photographer, be he enthusiastic amateur, overworked professional, novice or sophisticate. It is the purpose of this book to help you master the handling and pointing of your camera and to deepen the perception and insight of your seeing eye.

CAMERA BODIES

In the handling and pointing of the camera referred to in the last chapter, the size, shape and weight of the camera body itself are of real importance. This chapter is devoted to a brief survey of the main types of camera bodies in use today and their major characteristics.

But before moving on to that area, a word of caution. For some enthusiasts, the camera body can become an end in itself, and there must be thousands of very expensive cameras, perhaps now gathering dust in cupboards, that are used to shoot no more than the occasional roll of film each year. Their owners became carried away by the thought of possessing a beautiful camera but not by the ideal of wanting to create beautiful pictures.

True, the machinery of the process is important, but only in its support role of enabling the provision of good negatives to allow the creation of even better positives. In the world of photography there is little point in the worker blaming his tools. Almost everyone knows that it is seldom likely to be a case of the photographer being limited by his camera; much more will the camera be limited by its manipulator. Your camera, in real terms, is only as efficient and sensitive as you are.

Basic Requirements

Basically all cameras are alike: **they are light-tight boxes with a hole at one end and a piece of film,** or light sensitive paper, **at the other.** A shoe-box with a pinhole provides the means for getting an image on to paper, but it does not do so easily or very well. The four types of camera body described in this chapter improve on the shoe-box in different ways. In their extreme variations they may be almost un-recognisable as the same functioning object to an untutored eye but they all have certain features in common.

Every camera body must:

(a) Be light-tight.
(b) Provide a mechanism to hold and move the film as needed—**transport**.
(c) Have a hole to admit the light—**aperture**.
(d) Have a device to collect the light rays and project them as a sensible image—**lens**.

(e) Have a device to keep the light rays from the film until they are actually wanted, and to control the time they fall upon the film—**shutter**.

(f) Provide a viewing system to enable the operator to point his camera with an accurate aim.

Additional Features

Nowadays most cameras offer more sophistication than the basic requirements outlined above:

(a) Some models are built to receive light-tight cartridges of film which can be changed at any time during shooting with the loss of only the one frame actually exposed to the light at the time of changing.

(b) Most models have a smooth wind-on film transport mechanism with automatic devices to prevent accidental double exposures.

(c) Many models are equipped with an adjustable diaphragm to control the size of the aperture, and therefore the amount of light falling on to the film.

(d) Many models have a focusing mechanism to enable the lens to form clear images of both close and distant objects.

(e) Many models have a mechanism to control the speed at which the shutter opens and closes.

(f) Many models have optional viewing methods providing facilities for waist or eye-level use. The methods themselves are: (i) through the lens system used for taking the picture; (ii) through a separate lens system used for viewing and composing the picture but not taking it; (iii) through 'open' viewers to provide good sight for fast-moving action as in sport.

There are also many kinds of viewing screens.

There are four main types of camera body: viewfinder; single lens reflex; twin lens reflex; and 'view-through' technical.

Viewfinder

These are essentially **eye-level cameras** designed to be **held in the hand** and more than readily portable. Generally they are used as an extension of the photographer's normal vision and are basically the modern counterpart of the old-fashioned, classic box camera. There are many models available and they vary from the simple and inexpensive, taking 126 film cartridges and costing as little as under £9 to complex and highly priced models taking 35 mm film cassettes and complete with electronic controls, parallax correction, coupled rangefinders and facilities to accept interchangeable lenses. These models have prices ranging to hundreds of pounds.

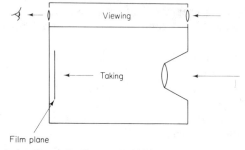

Fig. 2.1. Viewfinder camera in diagrammatic form.

Plate 2.1

Plate 2.2. Yashica 35ME.

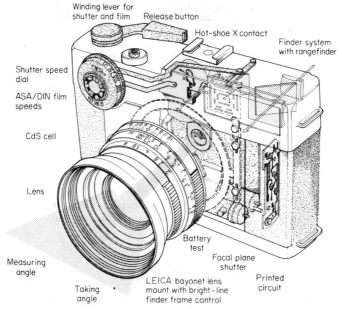

Winding lever for
shutter and film Release button

Hot-shoe X contact

Finder system
with rangefinder

Shutter speed
dial

ASA/DIN film
speeds

CdS cell

Lens

Measuring
angle

Battery
test

Focal plane
shutter

Printed
circuit

Taking
angle

LEICA bayonet lens
mount with bright-line
finder frame control

Fig. 2.2. Leica CL.

Fig. 2.1 illustrates in simple terms the main feature of the viewfinder camera.

A simple and inexpensive 126 cartridge loading version of the viewfinder camera, the Agfamatic 200, is shown on Plate 2.1 and a compact automatic 35 mm cassette version, the Yashica 35ME, is shown on Plate 2.2. One of the most sophisticated models, the Leica CL, is illustrated in Fig. 2.2. The Agfamatic costs under £16, the Yashica under £70 and the Leica over £100.

The **main advantages** of the viewfinder camera are:

(a) There is a model available in almost every price bracket.
(b) They are simple to use.
(c) They require little maintenance.
(d) They are small, light and easily portable—as such they are excellent units for catching quick, informal shots, and have a strong appeal for family and domestic use.

The **main disadvantages** are (many of these are overcome in sophisticated models but with a corresponding increase in cost):

(a) Parallax error due to the different positions of the user's eye and the camera's eye—Fig. 2.3 illustrates the problem.

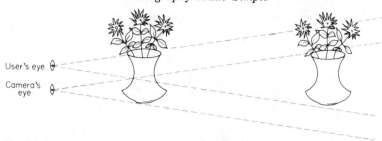

User's eye

Camera's
eye

Fig. 2.3. Parallax.

(b) Minimal control over focusing, aperture size and shutter speed (except in more expensive models) which means there must be plenty of light about (preferably good daylight or clear sunshine—seldom, if ever, is there sufficient light indoors) and little or no movement in any of the subjects to be taken.
(c) Lack of capability for close-ups, 5–6 ft being the closest distance that most inexpensive models can deal with.

Plates 2.3 and 2.4 were both taken on an Ilfomatic Universal 50C using a Kodak Verichrome Pan 126 cartridge and show something of the capabilities of a viewfinder-type camera from the least expensive price range.

The more complex the viewfinder camera becomes and the more accessories that are added to it, the more does it approach the essence of the next type of camera—the single lens reflex.

Single Lens Reflex

This is probably the most popular type of camera in use today. As its name suggests, a **single lens is used for both viewing and taking the picture**, thus eliminating the parallax error problem associated with the viewfinder type. With a single lens reflex camera, **what the photographer actually sees, the camera will shoot,** and this has obvious advantages in picture composition—particularly so for depth-of-field and close-up assessment. Most single lens reflex cameras (SLR is the usual abbreviation) take 35 mm film cassettes, and for £90–150 you should be able to purchase an efficient camera with a wide range of control over aperture settings and shutter speeds. (There are some SLR's that take $2\frac{1}{4} \times 2\frac{1}{4}$ in. (6 × 6 cm) film but their price range, which starts at £200 and rises rapidly to over £600, places them in a category that is outside the scope of this book.)

Fig. 2.4 illustrates in simple terms the main feature of the single lens reflex camera.

Plate 2.3

Plate 2.4. Prints from an inexpensive camera.

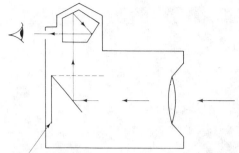

Film plane

Fig. 2.4. Single lens reflex in diagrammatic form.

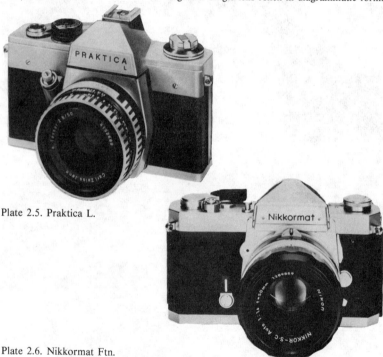

Plate 2.5. Praktica L.

Plate 2.6. Nikkormat Ftn.

An inexpensive version of the SLR, the Praktica L, from the middle of their price range at about £70, is shown on Plate 2.5, and at around twice the price the Nikkormat Ftn is shown on Plate 2.6. Fig. 2.5 shows the Yashica TL Electro X ITS in diagrammatic form.

The **main advantages** of the single lens reflex camera are:

(a) Complete elimination of parallax error—the user can view, easily and quickly (except at the actual moment of exposure) the whole image that will fall on to the film.

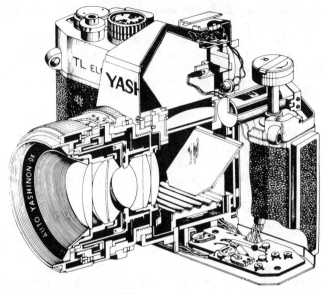

Fig. 2.5. Yashica TL Electro X ITS.

(b) Focusing is simple and direct—usually at eye-level, but some models incorporate waist-level viewing adaptors.
(c) Depth of field can be checked visually at any time (except at the moment of exposure).
(d) An extremely wide range of interchangeable lenses is available and because of the through-the-lens viewfinding system mentioned in (a) above, the user can immediately see the image each lens will throw on to the film.

The **main disadvantages** are:

(a) Larger and heavier than the viewfinder type.
(b) Mechanically complex and therefore more likely to break down and/or need special care and attention (although with currently accelerating improvements in technology the situation will undoubtedly get much better very soon).
(c) Can be very noisy in operation, mainly due to the moving mirror.
(d) Can be expensive to buy initially.

The 35 mm film size has the *advantage of being economical* but the *disadvantage of a small frame size* (24 × 36 mm) and the latter can cause problems when enlarging—either in the dark-room or for a slide projection. The slightest flaw, perhaps not even noticeable to the naked

eye on the film frame itself, can assume very nasty proportions on the screen or enlarging easel.

In brief, the single lens reflex camera is an intricate and delicate instrument, requiring sensitive handling if it is not to break down frequently, but offering speed and facility of operation over a wide area of photography that are difficult to match in any other camera.

Twin Lens Reflex

As its name implies, this camera type uses two lens systems within the one instrument. It is, in fact, **two 'cameras' mounted one on top of the other—one exclusively for viewing the image and the other exclusively for recording that image on film.** Traditionally it has two main features:

It is used at waist-level, not eye-level (though some models offer both facilities).

It takes $2\frac{1}{4} \times 2\frac{1}{4}$ in. (6 × 6 cm) film size (though some models also accept 35 mm cassettes).

The main appeal of the twin lens reflex camera (TLR is the usual abbreviation) is to the user *who places a premium on quality rather than speedy facility and is prepared to take time in composing his pictures.* The viewing lens usually passes more light than the taking lens and has a smaller depth of field, thus enabling *focusing to be assessed critically.* The bright image on the large viewing screen also contributes to this. The user has the benefit of large negatives and the resultant potential improvement in enlargements that accompanies them.

For the same price range as an SLR (£90–150) you should be able to purchase an efficient camera with a wide range of control over aperture settings and shutter speeds, although, as with an SLR, it is possible to spend much more.

Fig. 2.6 illustrates in simple terms the main feature of the twin lens reflex camera.

An inexpensive version of the TLR, the Yashica Mat, at about £110 is shown on Plate 2.7, and at around the same price, the Rolleicord Vb is shown on Plate 2.8. In diagrammatic form in Fig. 2.7, is the Rolleiflex at almost twice the price again.

The **main advantages** of the twin lens reflex camera are:

(a) Focusing is convenient and critically accurate with the viewing screen—for all but very close shots.

(b) A bright image the size of the negative is seen at all times—even during exposure.

(c) Quietness of operation—there is no mirror movement.

(d) The simple and often rugged construction make it less likely to mechanical breakdown than the SLR.

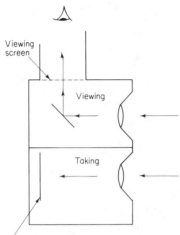

Fig. 2.6. Twin lens reflex in diagrammatic form.

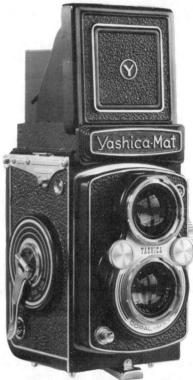

Plate 2.7. Yashica-Mat.

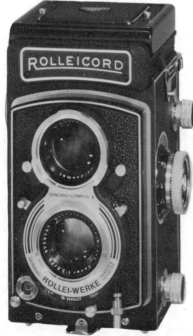

Plate 2.8. Rolleicord Vb.

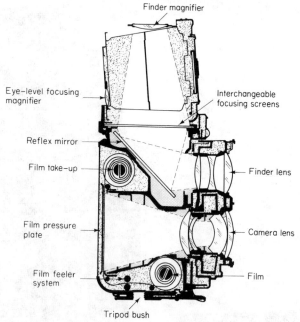

Finder magnifier

Eye-level focusing magnifier

Interchangeable focusing screens

Reflex mirror

Film take-up

Finder lens

Film pressure plate

Camera lens

Film feeler system

Film

Tripod bush

Fig. 2.7. Rolleiflex.

(e) The viewfinder arrangement allows tremendous latitude in placing the camera to take shots—from ground to waist to eye-level and even high above the user's head.

The **main disadvantages** are:

(a) Parallax error is still a problem, although many TLR's go some way towards overcoming it by providing connected correcting devices between the two lenses and/or markers on the viewing screen to delineate any diversion between the two images. (It is also possible to overcome the problem by using a tripod and, when image composition and focus are completed, *moving the whole camera upwards the distance between the two lenses*: the taking lens then occupies the position previously taken by the viewing lens.)

(b) Interchangeable lenses are not always available and tend to be expensive even when they are, since two are needed on each occasion. Some manufacturers supply additional accessories to adapt the lenses to different focal lengths but, of course, they are not capable of rendering the same quality image as a prime lens set.

(c) Tends to be on the bulky and heavy side.

(d) The image on the viewing screen, although large and bright, is reversed side-to-side, and this can take some time to get accustomed to—in particular it makes for difficulties with moving subjects.

The twin lens reflex is a *sensitive but not over-intricate or delicate camera* that is at its best when the user can *take time over composing his pictures* and is in a position to *benefit fully from the larger negative size*. In brief, it is a half-way house between the SLR and the 'view-through' technical camera described next.

'View-through' Technical

The journey that started with simple, light and compact viewfinder cameras (the modern counterpart of the old-fashioned box) finds one logical destination in the classic type of large-format camera: the technical monorail. The viewing system is direct and harks back to the beginnings of photography. Even today, because the image that falls on the viewing screen is comparatively dim, the photographer must cover his head and the back of the camera with a cloth, thus assuming the classic position of the archetype operator. The cameras are heavy with many moving parts and are therefore slow to use. They can be 'built' to suit each specific task, but the building up and stripping down is time consuming. The use of a stand is, not unexpectedly, essential.

The main appeal of the view-through camera lies in its ability to offer superlative control over focus, shape, size and depth of field of the image as it falls on the viewing screen.

Its unique feature is the wide range of camera 'movements' that are possible. These are movements of the lens and/or film planes that permit the achievement of special effects. They are dealt with separately below.

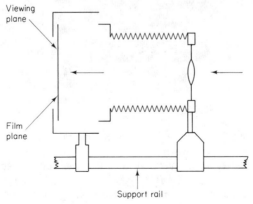

Fig. 2.8. Monorail camera in diagrammatic form.

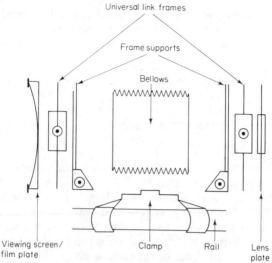

Fig. 2.9. Monorail components.

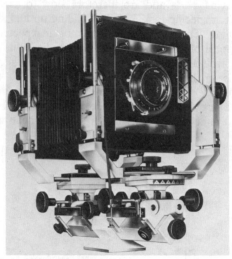

Plate 2.9. KLB Series '77' monorail camera.

Figs. 2.8 and 2.9 illustrate in simple terms the main features of the view-through monorail camera.

An inexpensive, basic version of the monorail (at approximately £100 without lens), the **KLB SERIES '77'** camera system, is shown on Plate 2.9. The same camera, demonstrating extreme 'movements', is shown on Plate 2.10.

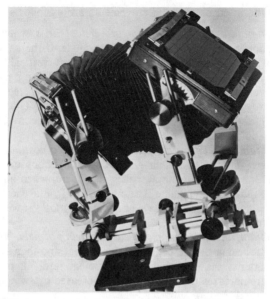

Plate 2.10. Extreme movements of camera shown in Plate 2.9.

Since these 'movements' are unique and central to this type of camera design, they are briefly described below.

Camera Movements
(a) Moving the lens parallel to the film plane, up or down. This is the **rising front** or **drop front** movement.
(b) Moving the lens parallel to the film plane, left or right. This is the **cross front** movement.
(c) Moving the lens around its vertical or horizontal axis. This is the **swing front** movement (swing on the vertical axis is referred to as swivel and on the horizontal axis as tilt).

The three sets of movements of the *lens relative to the film plane* are also applicable to the *film plane relative to the lens*. The following extract from the specification of the **KLB Series 77 Camera System** shows something of the range of movements possible:

Body units have 'on axis' swing in both directions, and can be completely reversed for extra compression (wide angle) or extra extension when needed. Back reverses for upright or horizontal format. Lateral Shift to both body units 25 mm each way, 30 degrees vertical swing to back unit, unlimited to front unit, marked with easily read scales up to 40 degrees. Horizontal swing marked up to 30 degrees. Rise and Fall to both front and back body units, 30 mm down 50 mm up (use of both movements doubles the range).

Some of the main uses of the movements are as follows:

(a) *To eliminate the convergence of vertical lines* when a subject has to be photographed from a low or high angle. If the camera has to be tilted so that the film plane is not vertical, any vertical lines on the subject will appear on the film to be non-vertical and non-parallel; rising or drop movements with lens and/or film plane can correct this.

(b) *To exaggerate perspective for dramatic effect.* The movements used in (a) above, to correct or compensate for convergence, are reversed to exploit the effect.

(c) *To obtain a full frontal view from a camera position to the side of the subject.* This is useful in eliminating reflections of the camera itself in mirrors and shop windows; it is also useful when an object like a tree, telegraph pole or pillar obstructs the full frontal view.

(d) *To present front and side views in combination* yet without distortion to the front view.

(e) *To obtain an increase or decrease in depth-of-field.* The effect is achieved by focusing on the centre of the subject and then swinging the film plane against the direction of the subject until all points are in focus; in extreme cases the effects can be increased by swinging the lens in the opposite direction.

These movements create an extended depth of field without the need to 'stop down' the aperture (see Chapter Five) and therefore use slower shutter speeds. 'Stopping down' used in addition to the movements will give even greater extension of depth of field.

The **main advantages** of the 'view-through' monorail camera are:

(a) It can be custom built by the user for each job.
(b) It affords maximum movements to overcome distortion and/or focus problems; these movements also allow full expression to the user's creativity and wish to experiment.
(c) It will accept almost any lens capable of covering its film size.
(d) It is of simple unit construction with individual parts being easily interchanged or replaced if damaged.
(e) The viewing screen is large and what appears on it will be what falls on to the film: there is no possibility of parallax error.

The **main disadvantages** are:

(a) The camera is bulky and heavy and cannot be used without a stand (although there are variations which enable it to be hand-held, and baseboard cameras offer some of the facilities).
(b) Although the viewing screen is large, it is not very bright and, in addition, the image is reversed vertically and horizontally; it may take some time for the user to accustom himself to this.

(c) Time is needed to assemble and use the camera.

(d) There are many moving parts that need to be locked in position—it is comparatively easy to overlook one of them and thereby unknowingly spoil perhaps an hour's otherwise careful preparation.

(e) It is not inexpensive.

The techniques of the 'view-through' camera are manifold and the foregoing is intended merely as an appetite whetter to introduce you to an aspect of photography that is frequently overlooked. Once you know something of what this kind of camera can do, your eye, even when looking through the most humble viewfinder type, will begin to 'see' more varied pictures more clearly and with greater insight. (The reader whose interest has been caught should now turn for further information to specialist literature.)

In brief, the 'view-through' monorail type camera is *unhappy on location or working at speed*. In the studio it is *superlative* and its excellence shows whenever the user's *prime considerations are large pictures of top quality taken under exact (perhaps even exacting) and critical conditions*.

Polaroid

The polaroid 'instant' type is not only a camera—it is a **camera plus miniature, portable photographic laboratory**. Its main appeal, of course, lies in the immediate availability of the print. Users of the **Polaroid Land camera** process extend from students in primary schools engaged on project assignments in their neighbourhood, through the whole range of domestic and family enthusiasts, to non-professional photographers (architects, designers, scientists) needing a permanent record of some growth aspects of their work, to professional photographers on location or in the studio wanting a quick check on lighting, texture and colour balance.

Polaroid Land cameras offer a wide range of prices, starting at just over £10. Black and white, colour and recoverable negative models are available. The latest model, the SX-70, gets very close to its designer's ideal of instant pictures, with the *user's involvement being restricted to pressing the button*, having aimed at the selected subject. After that he is no way required in the process of getting the print—and the process itself appears to be almost non-existent since the print comes out of the camera less than two seconds after exposure. In just over five minutes, still without action or intervention by the user, the print is finished in permanent full colour.

In addition to the sophistication of mechanics and chemistry that permit this single-action picture making, the SX-70 combines the facilities of a fully automatic SLR within the shape and size of a

cigarette case. Readers are recommended to turn to specialist literature if this particular type of 'photography with an eye on the future' is of special interest.

Electronic

Here, too, is an area of interest for those with an eye to the future. There-are many users who are anxious to have a camera which solves for them the sometimes complicated calculations required to determine the correct (or optimum) combination of aperture size and shutter speed. The Yashica Electro AX does precisely this. It is a fully automatic TTL Single Lens Reflex with facilities for manual override, about which the manufacturers' say:

Providing a check of the fully automatic Thru-the-lens 'Electronic-Eye' exposure control of the ELECTRO AX is its exclusive 'Green Lamp' which lights at the moment of exposure to signal that everything is GO! The ELECTRO AX's automatic Thru-the-Lens 'Electronic-Eye' exposure system functions on the basis of aperture preselection. You choose the lens opening that will give you the best depth-of-field effect; you just focus and press the shutter release button.

The camera will read the light, store it in memory and calculate the shutter speed, all automatically, at the speed of light.

Miniature

Polaroid Land chemistry has *speeded up* the process of getting finished prints. Electronics have brought *automation* into camera operation. The third major move, in keeping with current socio-technological trends, is towards **miniaturisation**. The SX-70, already referred to, is itself in this category. Using more orthodox film processes are the Kodak Pocket Instamatic and the Minolta subminiature 16 mm Quarter frame cameras. The film produced for this size camera (be it negative or slide transparency) is only 12 × 17 mm—*roughly a quarter as large as the 35 mm format, which itself is still condemned as too small for any proper use by some purists*. The quarter frame film may well produce remarkable results when handled by a large commercial laboratory and no doubt heralds the size and shape of things to come, but, as things are, the small size represents real problems for the individual handler. There is no doubt, however, that the up-to-date, automatic features of cameras like the Minolta 16 MG-S (Plate 2.11) and its small size (approximately 4 × 1 × 2 in. (100 × 25 × 45 mm)—the size of a cigarette packet) will make it increasingly popular.

Care of Cameras

Whatever the type of your camera body, it is worth studying the manufacturer's instructions about care, upkeep and servicing, and doing

Plate 2.11. Minolta 16 MG-S.

what they suggest. *Over-enthusiasm for dusting and cleaning can do as much harm as thoughtless handling or sheer inattention over the years.*

Obviously it is desirable to keep dirt and grit away from the camera body altogether. It is equally desirable to keep dusters and oil away from it. Do not be tempted to undertake jobs that are best left to the specialists; and anything that involves the moving parts of the camera body should be put into the care of the appropriate technician. Since the non-specialist (or non-technician) never quite knows what lies beyond the deceptively simple hinge or screw, it is wisest not to dabble at all nor even seriously to investigate the apparently obvious without skilled supervision. In any case, it will serve you well and cost you little to *have your camera body checked and serviced every other year.* Given this attention, you will be unlucky to suffer from a breakdown in the intervening periods.

Keep your camera in a *dry place,* as *dust-free* as possible, and *protected from extremes or violent changes in temperature.* Ensure it is always protected by some kind of case. This also guards against unnecessary exposure to sunlight. Remember that moving your camera from a cold to a warm place is likely to cause condensation. This is even more relevant with regard to lenses, but many users overlook the misting up that can occur within the camera body itself.

If you should be unlucky enough to drop your camera, or to allow it to come into contact with grit, sand or water, especially sea-water, try to get it into the technician's hands without delay. There is something to be said for delicately rinsing with tepid water to remove harmful deposits, but I would urge you to turn to the specialists for help as soon as possible.

It will cost little to *insure your camera* against loss or damage—by

yourself or others—and if you have spent upwards of £50 on your camera body it seems unwise not to give it full cover and protection.

On Getting Started

It was suggested at the beginning of this chapter that the camera body is not an end in itself, and before you spend a lot of money in setting yourself up, it is only sensible to ensure that you know exactly what kind of camera you want—and why.

If you are just starting there is a lot to be said for *buying an inexpensive camera*, new or second-hand, and *concentrating much of your effort upon manipulating your negatives in the darkroom*. This means you will need to give careful thought to the enlarger you will buy, and it is probably best to consider a model that will take negatives up to $2\frac{1}{4}$ in. (6 cm) square so that you can work with all film sizes up to that maximum and, should you want to settle with a $2\frac{1}{4}$ in. TLR, you will be saved further expense, not only in money terms but also in time in becoming accustomed to a new piece of equipment. (This aspect of the work is considered in Chapter Ten and you should consult it accordingly.)

Alternatively, you may decide to join a camera or photographic club or further education class that will offer you access to different camera bodies as well as darkroom and enlarging facilities. Since a straightforward camera that will produce acceptable negatives can be purchased for under £15 you may wish to combine the approaches. In any case, the point of the exercise is to *gain experience in handling negatives and carefully and creatively controlling light, shade, shape and size*. After some experience of this process you will be in an informed position to know exactly *why* you want a camera; what you *want, require and need it to do for you*; and therefore what *kind of camera body* you should choose.

Before you come to a final decision, you will need to have given some thought to the lens that will accompany your camera body. It may be fixed to it or interchangeable, inexpensive or costly, but a lens is a crucial and central part of the process of photography, and is the subject of the next chapter.

Summary

All cameras must be light-tight boxes with a film-securing and transporting system. They must also have an aperture (to admit light rays), a lens (to project sensible images), and a shutter (to obscure the light rays when they are not wanted). They must also provide the user with a means of accurately aiming the camera.

Models vary from the basic and simple to the most complex of instruments, and also from very cheap to ultra-expensive. There are four main types:

Viewfinder: these are mainly 35 mm format; they are simple to use, easily portable and very suitable for spontaneous shooting; they may suffer from parallax error and offer little control over focusing, aperture size and shutter speeds, and may have no capability for close-up work.

Single lens reflex: these are mainly 35 mm format with some models designed for 6 × 6 cm or 6 × 7 cm; a large variety of models exists, some simple and some complicated; they suffer from no parallax error and offer easy framing and focusing with useful visual checks on depth-of-field; a vast range of interchangeable lenses exists; they are excellent for spontaneous creative shots and close-up work although they can be heavy, noisy and expensive.

Twin lens reflex: these are mainly 6 × 6 cm format with some having quick facilities for a change to 35 mm; the main obstacles are parallax error and large bodies with some difficulties regarding availability and cost of interchangeable lenses; they are at their best when used for carefully composed shots requiring the larger negative size; an important factor is the versatility of camera/user operating positions.

'View-through' technical: these are mainly 4 × 5 in. with some models 6 × 6 cm and some 8 × 10 in.; whether hand or stand version, they offer superlative performance for all immaculately composed— especially studio—work; their drawbacks of size, weight, complexity of operation, and even expense are usually irrelevant to their users who place a premium on their quality performance and their unique feature of *camera movements*—by which lens and film plane relationships can be varied to provide control over perspective, depth of field, 'frontal' views from non-frontal positions and 'undistorted' front-and-side views.

Technical developments will almost certainly expand dramatically the use and popularity of single-action picture making, as with Polaroid cameras; streamlined shooting as with automated, electronic cameras; and the world shortage of raw materials will accelerate the move towards miniaturisation.

For the immediate future, however, it seems likely that the TTL metered 35 mm SLR will continue rapidly to consolidate its position as the most versatile camera to be easily available and readily usable by novice and sophisticate alike.

Protect your camera from extremes of temperature, moisture, dirt, damage, loss or theft; remove surface foreign matter with a delicate touch and leave the rest to experts.

LENSES

It is easy for the potential purchaser of a lens to be confronted, probably confused and possibly confounded by the sophisticated marketing campaigns of manufacturers and dealers. It is worthwhile pausing to remember that a lens is basically a *simple transparent device to arrange light rays in such a manner that they can be sensed and perceived*—namely, seen. The lens in the eyeball does this for the retina and the lens in the camera does it for the film. In each case a sensible image is formed.

The Basic Principles

The basic principle behind the image-forming capability of lenses is **refraction—the 'bending' of light rays.** Some lenses bend rays very sharply and others less so. **Positive** lenses bend light rays so that they **converge. Negative** lenses make them **diverge.** Positive lenses are shaped like barrels—they bulge out from the centre. Negative lenses come in to the centre. But the lenses you will use in your camera will not fit into those oversimplified pigeonholes, for most modern lenses are complex combinations of different lenses and are called **compound lenses.** Fig. 3.1 shows some of the positive and negative components that go into the construction of today's compound lenses.

The bending power of any lens depends upon the **thickness of the glass**; its **refractive index**; and its degree of **surface curvature.** Lenses with greater thickness and curvature bend the light rays more and produce their image closer to the lens. They are said to be of shorter focal length. Fig. 3.2 illustrates the main difference between short and long focal length lenses.

It will be seen that for the same distance of subject, the shorter focal length lens gives a smaller, nearer image than the longer one. The **focal length** of a simple lens is defined as the *distance between the centre of the lens itself and the point at which it gathers the light rays together into focus.* Focal length is usually measured in millimetres.

As was mentioned earlier, modern lenses are not simple but compound (consisting of many separate components), and in their case we

40

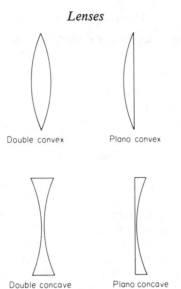

Double convex Plano convex

Double concave Plano concave

Fig. 3.1. Types of lenses.

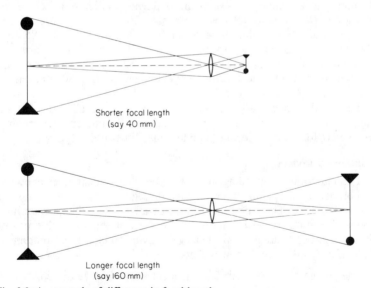

Shorter focal length
(say 40 mm)

Longer focal length
(say 160 mm)

Fig. 3.2. An example of difference in focal length.

should really refer to the **equivalent** focal length, treating the final result as if it were achieved by a single, simple lens. In practice, however, the word 'equivalent' is usually omitted.

Lenses are grouped together according to their focal lengths in three main categories:

Short: for wide angle lenses
Normal: for medium angle lenses
Long: for narrow angle lenses

The yardstick for these categories is the *working angle of view of the human eye*. Since this is usually between 45 and 55 degrees, a lens that accepts an angle of view between those two limits is said to be a *normal, medium or standard lens*.

It is important to digress here for a moment and explain that *what is a normal focal length for one camera size will not be for another*. The reason for this is fairly straightforward: *a 'normal' image is produced by a lens with a focal length equal to the diagonal measurement of the film size in use in any specific camera body.* (In this context, the normality of the 'normal' image is judged by its effect upon the ordinary viewer, and the one-to-one relationship between focal length of lens and diagonal measurement of film size is the one that gives the general eye a sense of reproducing what it thinks it sees in 'real' life.) Thus, in the 16 mm quarter frame film size the normal lens would have a focal length of 21 mm (the Minolta referred to on page 36 has a 23 mm lens); and in $2\frac{1}{4} \times 2\frac{1}{4}$ in. (6×6 cm) the normal focal length would be 85 mm. By the same token, the normal focal length for 35 mm format is 43 mm. In fact, lenses between 40 mm and 55 mm are sold as normal for this format and most camera bodies come with a 50 mm lens as standard.

To avoid unnecessary confusion, from now on all focal lengths mentioned will relate to the 35 mm format, but the mathematics required to convert for another format should cause little difficulty.

Compound Lenses

The illustrations and diagrams of lenses that appear later show the complexity of the many components that go to make up a modern compound lens. Their presence does not affect the principles outlined above regarding image formation but it does affect the quality of that formed image. A single simple lens will provide an image, but that image will suffer from a number of defects:

The image may be sharp at the centre but not at the edges or it
 may be fuzzy all over.
Straight lines may be bowed.
Objects may have coloured linings where none should exist.

By taking a number of single lens elements that have opposing and equalising effects in their individual defects or aberrations, the manufac-

turers attempt to find a balance that gives, if not the best of all possible worlds, at least a compromise of near-excellence by the neat expedient of ensuring that the lenses' faults work against one another. Thus, if one lens unit gives a slight shift to the left, another, which gives an equal and opposite shift to the right can be used to compensate or correct. (This is to oversimplify and, of course, the process cannot be continued ad infinitum if for no other reason than lens size and the cost of manufacture. The correction of lens aberrations is in itself a whole course of study and the interested reader should refer to a specialist manual.)

Standard Lenses

When you purchase a camera with the lens permanently fixed to the body (a non-interchangeable lens) it will be a 'normal' angle version. The interchangeable lens that manufacturers usually advertise with any specific camera body will also be 'normal'. *These 'normal' lenses provide images of the world 'as it is' to the average seeing eye of the average person.* This is the norm, and although each individual photographer will see and achieve markedly different images with any given standard lens, the essential quality of this lens is that it will produce an image that matches what the average eye sees in terms of angle, clarity and relationships of shapes, sizes and textures.

Plates 3.1–3.3 illustrate the typical appearance and lay-out of the standard lens. They also indicate the kind of information that you will find on any modern interchangeable lens, be it standard, narrow or wide angle.

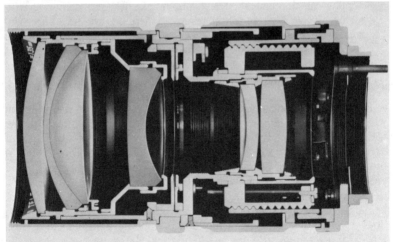

Plate 3.1. A standard lens.

Plate 3.2. A standard lens. Plate 3.3. A standard lens.

Wide-angle Lenses

A lens comes into the category of **wide-angle** when the image that it forms *takes in more of any given subject than does the average eye of the average person.* This is, of course, a subjective matter and there is no hard and fast rule that sets a specific angle-of-vision as being the line of demarcation between normal and wide. There are two major reasons for this:

(a) Every person sees, and makes sense of what he sees, differently; we all have *unique vision.*

(b) In the past decade the wide-angle lens has become increasingly popular in the cinema, television, magazines and colour supplements, as well as in photography generally; we have been increasingly exposed to its effects, and have through acquaintance and habit become accustomed to them, so that what twenty years ago might have been a dramatically noticeable wide-angle effect can now be easily accommodated as normal.

Bearing these two points in mind, there is, however, one criterion which by common consent establishes that a lens has definitely become wide-angle, and that is when its *focal length is the same measurement as the short side of the film format.* In the case of 35 mm (24 × 36) this means a lens of 24 mm—wide-angle by everyone's judgment, and still considered an extreme wide-angle by many.

One of the major advantages of a wide-angle lens is that, for a given camera-to-subject distance, the lens includes more of the subject than does a standard lens. This means that the photographer can *stay close to his subject and still image all of it,* a factor which is especially valuable when working in confined spaces.

Another major advantage is the *tremendous depth-of-field* of wide-angle lenses. Except with critical close-up work, you will find that most subjects, from very near to infinity, will be in focus most of the time. This is particularly useful for catching fast moving subjects, groups and action.

Wide-angle lenses are well known for their apparent ability to exaggerate the comparative sizes of near and distant subjects and to produce dramatically converging horizontal and vertical lines. (The reason for this is that, because of the wide angle-of-view of the lens, the rays of light that travel from the extremes of the angle fall noticeably obliquely on to the film. The shape is resultantly pulled out or elongated. If the subject is symmetrical, the effect becomes immediately apparent. If you shine a torch or slide projector beam at a flat screen or wall you will see how the steepness of the angle controls the elongation of the pool of light. This is a simple example of the principle in action.)

This apparent ability to change the relationships of sizes and shapes is an advantage or a drawback depending upon your individual needs and wishes. It has been thought by many people to be such a disadvantage that the effect is generally known as 'wide-angle distortion'. (Narrow-angle lenses apparently 'change' images to an equally marked degree, condensing rather than exploding the shapes, but hardly anyone refers to 'narrow-angle distortion', so don't be overawed by the phrase.) Lens and perspective 'distortion' are often confused: the first can be real (in a poor lens and as mentioned above) but the second is only apparent. If you enlarge sections of negatives (taken from the same camera position but with wide, normal and narrow-angle lenses) to the same image proportion, you will find they are identical. It is only in the matter of *angle of view and image-proportion in the same full picture* that perspective appears to have been changed. It is an optical illusion —try it and see.

There is a great variety of interchangeable, wide-angle lenses available. The following list shows something of the range:

Manufacturer	*Sizes available (in millimetres)*
Photax	28, 35
Tamron	21, 24, 28, 35
Yashica	20, 28, 35
Nikkor	15, 20, 24, 28, 35

There is a tremendous price range for wide-angle lenses. It stretches from under £50 to well over £350 and you may be able to exceed those two extremes by shopping around or buying second-hand on the one hand and by having ultra special tastes on the other.

The way you approach the use of a wide-angle lens will depend more

on your temperament than it will on your pocket. You may wish to move slowly into the area by starting with a 35 mm lens and thoroughly exploring its possibilities before going on to a 28 mm model . . . and so on. Alternatively, you may prefer to jump in at the deep end and commit yourself to a 24 mm or 20 mm lens. There are merits to both approaches. When you know something of the specific effects you want to create, you will be in an informed position to make your choice. *So spend plenty of time looking at pictures taken with wide-angle lenses* and compare the effects achieved with those taken with other lenses and also with the effects that you have in your mind. Let these two sets of comparisons guide you as you concentrate on the appropriate illustrations in this book and begin to gather your thoughts about wide-angle lens applications.

Plate 3.4

Plates 3.4, 3.5 and 3.6 give an indication of some of the possibilities with a 24 mm lens. Plates 3.7 and 3.8 show the typical appearance and lay-out of the wide-angle lens.

Plates 3.9–3.16 show the capabilities of the wide-angle lens in the context of a full complement of lenses.

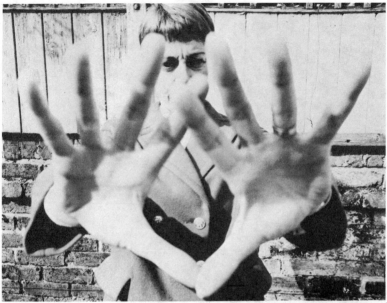

Plate 3.5

Wide-angle lens effects.

Plate 3.6

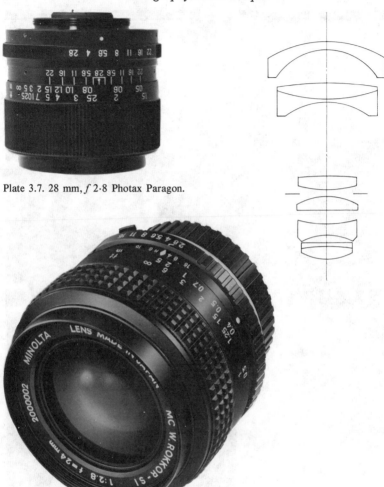

Plate 3.7. 28 mm, *f* 2·8 Photax Paragon.

Plate 3.8. 24 mm, *f* 2·8 Minolta Rokkor.

Fisheye Lenses

These are special (ultra) versions of the wide-angle lens. They offer an angle of vision of 180 degrees or more, thus enabling the lens to see behind itself, as it were. They are capable of producing eye-catching, dramatic and fantastic images. Unfortunately, their prices are equally dramatic. Plate 3.17 shows the typical appearance and layout of the fisheye lens.

16mm

Plate 3.9

21mm

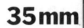

Plate 3.10

35mm

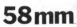

Plate 3.11

58mm

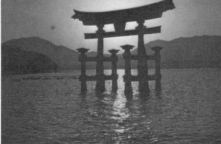

Plate 3.12

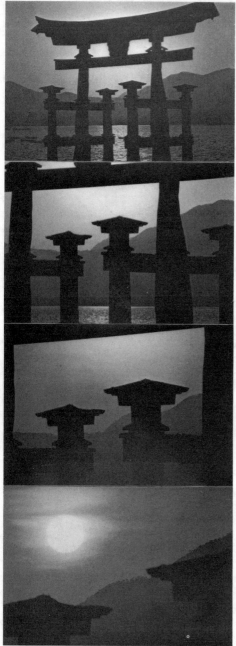

100mm

Plate 3.13

200mm

Plate 3.14

300mm

Plate 3.15

600mm

Plate 3.16

Plate 3.17. 6 mm, *f* 2·8 Fisheye-Nikkor Auto.

Narrow-angle Lenses

A lens comes into the category of **narrow-angle** when the image that it forms *takes in less of any given subject than does the average eye of the average person.* As with a wide-angle lens the line of demarcation between normal and narrow is a subjective matter. The two major reasons are the same:

(a) The uniqueness of vision of each individual.
(b) Usage and habit (bonnets of cars piling up endlessly on one another in packed lines astern were at one time classic, obligatory and typical—now they are near-cliché).

In this category, again just like the wide-angle, there is a point at which, by common consent, a lens becomes narrow-angle, and that is when its *focal length is the same measurement as three times that of the long side of the film format.* In the case of 35 mm (24 × 36 mm) this means a lens of 108 mm—narrow-angle by everyone's judgment, but by no means extremely so.

One major advantage of the narrow-angle lens is that it *enables the photographer to 'reach out' to his subject* and 'touch' it with the aid of his camera, when it may be physically impossible for him to do so in person. This applies particularly to wild-life and sporting subjects.

Another major advantage is the *extremely limited depth of field* of the narrow-angle lens. This enables the user to compose his image with maximum clarity given to the main feature of his subject and gratuitous or even undesirable, surrounding elements, focused, quite literally, out of the picture.

Just as the wide-angle lens 'distorted' the relationships of size and shape in image composition by expanding them when they were relatively near to the camera or at an oblique angle to the lens, so does the narrow-angle lens 'distort' by gathering its image and condensing it so that natural perspective appears 'flattened' and 'head-on' distances seem compressed. This effect was discussed earlier on p. 45.

A combination of the ability to fill the format with a subject's head and shoulders from an alienating, and, therefore, to many oversensitive human and other animals, relaxing distance; delicate control over depth of field to facilitate the blurring, camouflage or complete disappearance of unwanted elements; together with what is generally accepted as being the flattering flattening of perspective when applied to the human face, make the narrow-angle lens a popular choice for portraiture.

Narrow-angle lenses have two factors which require special consideration:

(a) They can be heavy and bulky.
(b) The 'magnification' they produce in the image also relates to any movement of the lens or camera body, so the *slightest tremor or wobble* resulting from the camera being hand-held, *will produce a very unsatisfactory negative*—what was perhaps quite unnoticeable in itself will cause an effect that will look as if the camera was shaken by brute force.

These two factors combine to make the use of *a good stand/tripod almost essential* for much of the work. Certainly the narrow-angle lens user should have one always available.

Plates 3.18 and 3.19 show the 200 mm lens at work and Plates 3.9–3.16 show the capabilities of the narrow-angle in the context of a full complement of lenses. Plate 3.20 shows the typical appearance and layout of the narrow-angle lens.

There is a tremendous variety of interchangeable, narrow-angle lenses available. The following list shows something of the range:

Manufacturer	*Sizes available (in millimetres)*
Photax	135, 200, 300
Tamron	105, 135, 200, 300
Yashica	135, 200, 300
Nikkor	85, 105, 135, 180, 200, 300

The price bracket for narrow-angle lenses is not quite so formidably ranging as for the wide-angles, but it stretches from £50 to £300 and, of course, you can spend much more.

Plate 3.18

Narrow-angle lens effects.

Plate 3.19

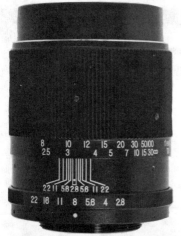

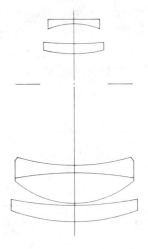

Plate 3.20. 135 mm, *f* 2·8 Photax Paragon.

Telephoto Lenses

These are special (ultra) versions of the narrow-angle lens, and *here are collected together when their focal lengths exceed 300 mm.* The actual length is subjective and almost arbitrary and the title is something of a misnomer since the purists would like it attached only to those lenses that are so arranged as to have their back-focus—the distance between the lens and the film-plane—less than their focal length. In general parlance the title has become accepted as having the meaning given in the first sentence of this paragraph, although many manufacturers give the prefix 'tele' to all their lenses with a focal length greater than standard. (Specialised usage of the title is consolidated by the name many manufacturers attach to their 'elongating' converters or adaptors. They are frequently known as 'tele-converters'—see below—and since the word *tele* in its original Greek means 'from afar', this seems reasonable enough.)

Telephoto lenses offer an angle of vision that is less than about 8 degrees (that of the 300 mm lens). One extreme model, the Nikkor 2,000 mm that costs well over that figure in £'s, has an angle of vision of only 1 degree 10 minutes.

Narrow-angle lenses are capable of producing breathtakingly impressive shots by their combination of 'reaching out' to bring an image from the distance well beyond the range of the ordinary gaze of the average eye, and also condensing head-on distance (flattening perspective) so that the usual proportion of depth no longer apparently obtains. As might be expected, as the angle of vision of the lens gets smaller, the price becomes more breathtakingly impressive. The two

Plate 3.21. 300 mm, *f* 4·5 Nikkor-H Auto.

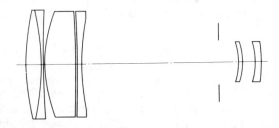

special factors mentioned with regard to narrow-angle lenses generally (their tendency to heaviness and bulk and the need to prevent the smallest vibration) apply even more so here, and continue to do so as the focal length of the lens gets longer. Plate 3.21 shows the typical appearance and lay-out of the telephoto (or ultra narrow-angle) lens, and the place of the lens in the full range of focal lengths can be seen in Plates 3.9 to 3.16.

Zoom Lenses

If any category of lenses is typical of photography at its most current, zoom lenses must be so. (For example, the 1968 edition of *Chambers's Twentieth Century Dictionary* carries no reference to photographic, or even cinematic, use in the main entry of *zoom*; it was still only in the supplement.) There can hardly be a reader who is not familiar with the ability of cine zoom lenses to move from long-shot to close-up and out again while uninterruptedly following the action. This *variability of focal length within a single lens* has a number of attractions:

(a) It is economical of time, saving the user from having to change from lens to lens.
(b) Within its own limits it offers an infinitely variable number of focal lengths.
(c) It is economical, saving the user from needing a collection of separate lenses.

(d) It is economical of space, for similar reasons.
(e) It enables the user to create unique effects in picture composition.

As things are, there are some disadvantages:

(a) Lenses are only available, almost without exception, for 35 mm cameras.
(b) They can be heavy and bulky.
(c) They can be expensive.
(d) Focal length by focal length and image for image, there is (not unexpectedly) a quality loss compared with the individual lens at a similar price. This may or may not be significant, dependent upon your skill, your pocket and the quality of the particular lens you are using.

Overall, the zoom lens must come out in principle with a judgment in its favour. Of course, you never get more than you pay for, and the performance differences between models are noticeable and remarkable, as are the prices. But the improvements that have been made in recent years and will continue to be made through advances in technology, engineering and optics, make the zoom lens a must for the photographer with an eye to the future.

Plates 3.22–3.25 show a few of the simple effects of an 80–200 mm lens at work and Plates 3.26 and 3.27 show the typical appearance and lay-out of the zoom lens.

The following list gives an indication of the range of zoom lenses available:

Manufacturer	Sizes available (in millimetres)
Photax	70–220
Tamron	38–100, 70–220, 80–250, 50–300, 200–600
Yashica	45–135, 75–230
Nikkor	43–86, 80–200, 85–250, 50–300, 200–600

As might be expected, there is a large price bracket for zoom lenses. You will have to shop around a lot or buy second-hand if you do not wish to pay more than £100. Remember that the upper ceiling figure is around £500.

Lens Sets

The collection of a set of lenses only applies if you have, or are intending to have, a camera body that will take interchangeable lenses. The obvious place to start, if you are in such a position, is within the standard or normal angle range. The one that the makers will usually

Plate 3.22

Plate 3.23. Minimum and maximum effects with an 80–200 mm zoom lens.

Plate 3.24

Plate 3.25. Effects with a zoom lens 'on the move'.

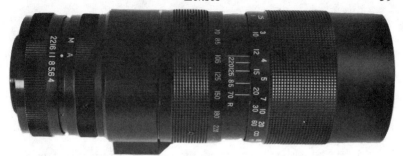

Plate 3.26. 70–220 mm, *f* 4 Photax Paragon.

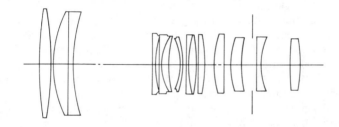

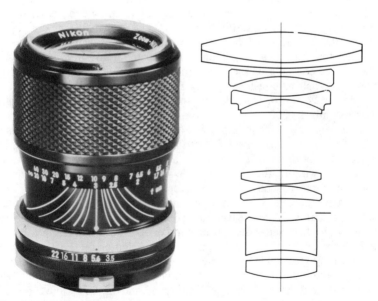

Plate 3.27. 43–86 mm, *f* 3.5 Zoom-Nikkor Auto.

put with your camera body will be 50 mm. Such a lens may appeal to you, and many authorities strongly urge that it is the best starting place. You may wish to vary this norm and the following choices are all reasonable if they suit your special vision:

(a) 50 mm 'normal'—orthodox, straight-down-the-line, impressionist images.
(b) 50 mm, + or − 10 degrees, into the micro/macro range—orthodox, impressionist images, with special design features to make it excel in close-up performance.
(c) 35 mm borderline wide-angle—the expansionist viewpoint, providing images to satisfy the roving eye that needs instant impact all the time and hates to miss a thing.
(d) 85 mm borderline narrow-angle—the selective viewpoint, providing images to please and content the discerning eye that requires always to probe beyond and beneath the superficial appearance, and looks into the nature of things with a seeking vision.
(e) 85–200 mm zoom, + or − 15 degrees—the variable viewpoint, providing images that will shift to accommodate changing views and visions and will enable its user to discover and express his mercurial persona without substantial loss of image quality.

Dependent upon your self-assessment with regard to these different categories, so will you discover the lens that is 'normal' for you. Don't be put off by the advertisers' blurbs. Take your time and decide which viewpoint is attractive, natural and, therefore, 'normal' for you. If you start with the standard 50 mm, your next move will no doubt be to bracket this first lens by getting a 28 mm and a 135 mm. If you have started on one side of the standard (35 mm wide or 85 mm narrow) you may wish to consider moving further in the same direction (from 35 mm to 24 mm or from 85 mm to 135 mm) or jumping dramatically from 35 mm to 200 mm.

It is your eye that is important (not the makers' sales figures) and *your lens is the most crucial item in the whole range of photographic equipment.* Without a lens of any kind you would be photographically blind, and without the right lens you would be constantly frustrated in your attempts to convert your perceptive and mobile imaginings into permanent images. So do not be afraid to reject the manufacturers' standard lenses. If necessary, buy your camera body from one dealer and get the lens separately from another. Do not be taken in by sales talk. Insist on a proper probationary, trial period or get your protection from a fully returnable, guaranteed contract. (It takes a lifetime to learn to look and see. No reputable dealer will want to do anything but help you settle on the best first lens for you, and he will know you will need time.)

Economy

High ideals in choosing your lenses are essential—so is a financially realistic approach to buying them. Do not allow last-minute enthusiasms and calculations about deferred payments to influence your choice.

If you value after-sales service and the hope of a relationship with a dealer who will give continuing interest and respect to your personal needs, *choose a reputable business with a staff you can talk to easily*. Then stay with them. Their advice and help could be invaluable to you over the years. Remember that a dealer will not be able to offer after-sales service and help at the rock-bottom, cut-price bargain prices offered by discount houses. You must decide between making a continuing professional relationship on close, sympathetic and convenient terms, and finding a 'scoop' saving.

Do not be afraid to buy *second-hand*, but do so only through a reputable dealer and *give the proposed lens a detailed examination*. The smooth rubbing away of surface paint may indicate a lot of sensible use. Scratches and dents on an otherwise glittering piece suggest careless handling. Such lenses should be avoided, as should those with scratched lenses or rattling noises. Smoothly-working, efficient second-hand lenses can be purchased without difficulty, and will save you a lot of money.

Another choice that can affect the cost of a lens for an SLR lies between lenses that have **fully automatic diaphragms and those that are pre-set**—FAD and PS are the usual abbreviations. With an automatic lens you always view through the fully open aperture, inspecting the effect of your chosen aperture by using a 'pre-view' button. The aperture automatically closes to the chosen setting when you shoot. With a pre-set lens you have to undertake the closing of the diaphragm by hand. The operations are few and simple, but they do take time—slowing down the handling of the camera fractionally—and they can be overlooked. Since you can save up to half the price of a lens by choosing a pre-set model, there is clearly some merit if finance is a real problem. Many photographers stay with fully automatic diaphragm models for their standard and wide-angle lenses and choose pre-set models for their narrow-angles, where the saving really is noteworthy.

Another way of inexpensively entering the field of **narrow-angle and telephoto work** is to use what are known as 2 and 3 times **adaptors or converters or extenders**. As their name suggests, their function is to multiply the focal length of the lens with which they are used by a factor of 2 or 3. Thus, the 50 mm lens can provide images as if from 100 mm or 150 mm models; the 35 mm as if from 70 mm or 105 mm; and the 85 mm as if from 170 mm or 255 mm. The marked f numbers on the main lens are also doubled or tripled accordingly. (For further details of f stops see Chapter Five.) Of course, the results from these

tele-extenders can *never be better than those from the main lens and are frequently worse*. If you are considering saving money by buying a converter to get an inexpensive narrow-angle effect, get a good one. Do not try to save money on the converter as well—it is well worth the extra money (£25–50 in all) to get an instrument that will serve you, within its own disciplines, well and properly. If you can tolerate the necessary accompanying fall-off in image quality, you will have a financially painless entry into narrow-angle photography. Like the lenses they will be used with, tele-converters are available with or without automatic couplings.

An equally inexpensive entry into the world of **big close-ups** can be obtained by the use of **tubes and/or bellows** with interchangeable lenses (placed between the lens and the camera body) or **supplementary ('close-up') lenses** (placed in front of the lens itself like a filter). The latter method is not so satisfactory as the former since a new combination of lens aberrations has been created. There are also problems of focusing and exposure. (If you are particularly interested in this process, you are recommended to consult specialist literature.) Either method will, however, enable you to experiment with close-up work without having to turn to a micro/macro main lens, and you should be able to set yourself up for less than £25. (Supplementary lenses may be obtained in pairs for TLR's and there are similar devices for viewfinder cameras.)

You may be tempted to spend much more than you actually need by falling for a lens that has a dramatically *fast* capability. (In this context, 'fast' means the ability to form an effective image under very low lighting conditions.) Unless you are going to do much low-level light shooting (in or out of doors) it is unlikely that you will be able to exploit the 'speed' of a lens that opens to more than $f2 \cdot 8$. The difference in cost between that model and an $f2$ can be anything from £15–50. To go to the next stop, $f1 \cdot 4$, can cost you another £100. *So make sure you need the speed.*

Make sure also you need the fantastic sharpness and resolving power that many makers offer to justify the high prices of their lenses. A lens that gives better results than you can use—on film, in the enlarger, or on paper—will merely represent waste to you in realistic terms. This does not mean that you should be satisfied with an inferior model, nor does it mean that you should not get the best lens that you need, or that you can afford. It is a timely reminder that your lens will only be as good as you are; and, in any case, before you get to your finished print, you have still to process and enlarge. The final product can only be as good as the weakest link in the chain.

Care of Lenses

No matter how much you paid for your lens initially nor how good it was, it will stay good and perform well *only if you look after it properly*. As with camera bodies, you can easily do too much *to* the lens without doing anything *for* it, except make it worse. Careful handling of the lens will pay enormous dividends in the quality of your negatives and the life of your lens.

It is good practice to test your lens not only when you first get it, but also from time to time over the years. There are plenty of lens testing charts on the market and they are not expensive. You can easily provide one of your own by using the pages of a newspaper, magazine or book and photographing them at right angles when they are on a wall or a table. Both positions are good for exercising your ability to provide controlled, balanced lighting as well as to take precision shots for critical assessment, in addition to testing your lens.

Camera lenses are made of substantially softer glass than normal domestic glass and, in addition, they are coated delicately to improve their performance. *Dust, grit, sand and finger-nails all represent hazards to the surface of the lens* and you must take every precaution to keep the lens away from them; otherwise, its performance, and its value, will dramatically depreciate. Whether your lens is permanently attached to your camera body or not, it should be well protected by a proper case and kept away from extremes of heat, cold, damp, smoke and fumes. Remember the lens will quickly be covered with condensation if taken from a cold place into a warm one.

Try not to touch the surface of the lens, front or rear, at any time, and keep fingertips away from it at all costs. Fingertips make their presence abundantly clear when it comes to the enlarging stage, even if you could not detect them on the lens itself at the time of shooting. From time to time you should clean the lens with a soft lens-brush, one properly designed for the job and used with a light touch. Avoid the use of lens cleansing tissues and liquids. Your lens should not get into the condition where it needs them. If it should, take it to a reliable specialist. There is no harm in letting such *a qualified specialist check your lens once a year*, but do not be tempted to do it yourself. Take all the precautions you can to keep your lens clean and so avoid the dangers inherent in cleaning it.

As a photographer, the lens is your only eye; it is the key that unlocks the door to your unique inner vision. Use it and care for it with that in mind at all times.

Summary

Lenses bend light: positive lenses converge light rays and negative ones diverge them. Combinations of simple positive and negative lens elements produce compound lenses in which excellence is approached by the neutralising effects of the individual elements.

The focal length of a lens (i.e. its light-bending power) is one factor that controls image size, the other two being the actual size of the subject and the subject-to-lens distance. The ratio of the focal length of the lens to the diagonal of the negative format controls angle-of-view. Camera position controls perspective.

Standard lenses provide a 'natural' angle-of-view—similar to that of the human eye; wide-angle lenses are 'all-embracing'; and narrow-angle lenses selective—telephoto versions being highly so. A zoom lens with its variability of focal length within one unit is economical of time, space and money. They are still evolving and their performance is improving all the time. A working lens set will almost certainly contain a standard, wide and narrow angle lens but the exact denominations of any or all of them are exclusively a matter of taste. Many photographers use one or more zoom lenses to achieve the versatility needed in a working set.

In the interests of financial economy do not buy what you cannot exploit; buy where you will get responsible, informed, sympathetic interest; shop around and do not be afraid to buy second-hand; consider hiring to help you make up your mind about special (or even ordinary) lens features; and, most importantly, think ahead.

Protect your lens from extreme temperatures, moisture, dirt, damage, loss or theft. Use a lens-brush with a delicate touch and leave the rest to experts.

Exercises

1. Choose a panorama, a near scene, a house, a person or an object the size of a mug, and view any or all of them through pieces of black card 12 in. square in which you have cut different shapes—squares, circles, triangles, rectangles—about 1 in. across. View the subjects through the hole(s) by:

(a) Moving the card from immediately in front of your eye to arm's length, while keeping in the same place.
(b) Moving bodily closer to and further away from the subject while keeping the card in the same position.
(c) Changing both card and body position at the same time.

The images you see will give you a good idea of the kind of composed shape and size you can achieve in a finished picture. If you restrict the proportions of the hole to those of your film format, you will get a similar idea of composition in the negative.

2. Study colour supplements and magazines like *Vogue* or *Penthouse*. Look at advertisements and features, and decide how the elements in Exercise 1 combine. Notice how these elements also play a major part in cinema and television. Pay special attention to whether they invite you to be involved or alienated by their presentation.

3. Study paintings and photographs. Use two L-shaped pieces of strong card and experiment by re-framing the images in ways that appeal to you. Analyse the cause and effect of what occurs. (Do not fail to synthesise the artist's original composition by looking at it finally as he wished you to.)

FILMS AND FILM SPEEDS

For all general purposes, and also for all photographic purposes, there is effectively no light unless there is something for it to fall or 'shine' upon. In a similar way, images are not effectively of any use to us unless there is something for them to form or 'settle' upon.

As was mentioned in Chapter One, the human eye and the camera both need a light-sensitive surface on which an image can register—to a sensible purpose. In the human eye this surface is the retina, and the purpose is to pass on the message to the brain. In the camera it is the emulsion-treated side of the film, and the purpose is to record the image until the photographer wishes it to be made manifest. It was suggested in Chapter Three that the lens was only a link in an intriguing chain between your first notion of a shot and image in its final printed form. We now come to consider another important link in that chain: the film itself, its nature and its role.

Black and White or Colour?

It was not long ago that any photographer who wished to undertake his own processing and printing was forced by considerations of time, money and techniques to work only in black and white. Those times have gone and the photographer can now make his choice between black and white and colour without being influenced by having to hand over his work to someone else at any stage in the process between shooting and showing his prints. This places any decisions about using black and white or colour firmly in the area of personal taste and aesthetics and that is where they really belong.

Many traditionalists have defended black-and-white photography as a 'purer' art-form than colour. Its essential quality is to abstract and reduce all colours to shades or tones within the black—white range, and its supporters claim that it offers a special (and they would also say 'classic') view of the world we live in. The claim is by no means un-reasonable, but similar ones can be put quite validly for working in the range of red—white or blue—white or, indeed, any monochrome or tint. It is difficult not to find the traditionalists guilty of some rationalisation, or even making artistic virtuous capital out of technical/financial neces-sity. The future will test the soundness of their claims and their philo-

66

sophy, since all previous barriers, if not finally down, are rapidly falling and will be almost forgotten by the 1980s.

The choice between black and white, monochrome, full-colour and infra-red can now be made exclusively on their artistic merits for any particular assignment. They all enable you to say what you want about the human condition and its environment. Do not be put off by those masters who would urge you to concentrate on what they call natural or faithful reproductions of objects, people or scenes. True, it is worth noting what the average person usually accepts as a true rendering. It is also worth noting that what the average person accepts is lacking in a major aspect of truth in so far as most prints are only two dimensional and the original subjects were usually in three. From three- to two-dimensional is no bigger leap than from full colour to black and white or tints of purple.

All pictures derive their impact from a combination of lines, textures, shapes and sizes; and from light, shade and colour. The priorities given to any of these ingredients can be varied endlessly and what appears suitable for bold projection to fill a large cinema screen may appear quite unsuitable for careful and considered scrutiny when held in the hand. The decisions must be yours. You are the only proper authority.

The Chemical Process

The average photographer is much more concerned with the product of his work—the permanent image—than he is with the processes of chemistry that enable him to obtain it. However, an understanding of the basics will help and encourage him to use the intermediate materials sensitively and well.

The kingpin in the whole of the photographic process as it exists today is the **effect of light on silver salts:** *it causes them to change by decomposition into metallic silver.* These particles are then treated chemically so that they create a permanent record of the amount of light received by each separate area. The negative image in the film is initially formed when countless numbers of these particles are converted into black, where the most light has fallen, and remain unconverted where there has been none. The areas between these extremes (with 'half' or 'quarter' light falling on them) will turn into greys since they will have fewer particles of converted silver (giving 'half' or 'quarter' black accordingly). The lightness or darkness of these shades will depend upon the type of film and the way it responds to coloured light.

It is relevant to note here that colour film consists basically of three layers of this type of emulsion, each more or less the same as in black and white film, but each coupled to one of the three primary colours (see below and also Chapters Six and Nine).

The silver salts (made into silver halides by a previous chemical

process because these are swifter in their response to light) are **suspended in gelatin.** *This in turn speeds up the response of the silver halides to light.* It has other advantages: it is a suitable vehicle for the necessary chemical processes that follow; it is transparent, flexible and strong; and it is easily coated, thinly and evenly, on to a base to make the typical modern film.

Before moving on to contrast, resolving power and speed in films, it is appropriate to note the main stages in the process of creating a negative on film:

(a) The emulsion, containing light-sensitive silver halides suspended in gelatin, is *exposed*, through the camera lens, to light rays from the subject.

(b) Whatever light rays reach the emulsion cause *changes in the silver salts* in direct proportion to their strength, and create what is known as a latent image—at this stage it is neither visible nor permanent.

(c) The exposed silver salt particles are *amplified into black metallic silver* by the chemical action of the *developing agent*, which has no effect on the unexposed particles. In simplified terms, individual particles turn completely black or do not turn at all: intermediate tones are created by the density of the changed particles, i.e. the number in any given area.

(d) The *unexposed particles are removed* by the fixing agent (for further details of developing and fixing see Chapter Nine).

Fig. 4.1 shows the principle of the process.

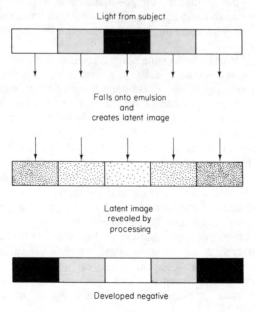

Fig. 4.1

Contrast

The contrast of any film emulsion refers to its ability to reproduce a **range of grey tones** from the one extreme of **full transparency** to the other of **complete opaqueness** or total blackness.

Medium-contrast films are the most generally available and the most generally used. They give a *continuous reproduction of tones* ranging from the *fullest highlight* to the *darkest shadow*, yet without any loss of middle tones. These are the films you are likely to come across most of the time as they occupy the bulk of the commercial market. Low and high contrast films you will not be able to purchase so readily.

Low-contrast films give a *smooth and gentle rendering of the middle tones of grey* from very dark to very light and are useful in smoothing out the stark contrast in a subject that has an unusual and marked differential from very dark to very bright in its (perhaps harsh) lighting. Low-contrast films also have an appeal for the photographer who wishes to create a serene and quiet atmosphere with a subject lit within the normal brightness range.

High-contrast films are capable of rendering their images in terms of *more or less straight black and white*. This obviously makes them useful for copying documents and all kinds of graphics that require a steep 'cut-off' between black and white. They are often referred to as 'line' films. Their aesthetic appeal to the general photographer comes with their ability to reject the middle tones from a subject and render it as strong blocks or lines of near black and white—an effect just as suitable for portraiture as for architecture, if you want to see people or things that way.

Resolving Power

The more accurate a film emulsion is in reproducing **fine** detail from its original subject, the greater its resolving power is said to be. This capability is affected by the *thickness of the emulsion* and the *size of the silver-salt particles*—the 'grain'.

If a film emulsion is thick (or is subjected to severe overexposure), some of the light rays may be *internally reflected* by the particles within the emulsion. This effect, known as *irradiation*, causes a scatter of the light rays and a resultant loss of detail in the lightest parts. As will be seen below, 'fast' films have larger particles—grain—in their emulsion than slow ones. It is obvious that if you paint a picture with 'coarse' materials you will not get a 'fine' result. The same principles obtain with film grain, although the actual measurements are unimaginably small, and fast films will not give as fine a resolution as slow ones. With modern films, however, the difference is seldom noticeable if they are handled properly at all stages, but their characteristics can be exaggerated by extreme treatments.

Unless a film has an *anti-halation backing*, there will be a tendency for the light rays to reflect back from the film base and cause *haloes* to form around the highlights. This also represents a decline in resolving power.

Speed

The speed of a film relates to the **swiftness with which the silver salts in the emulsion respond to light.** The faster a film is, the less exposure it needs to form an image, and therefore the more suitable it is for low-level light subjects or fast action shots with high shutter speeds. The slower the film the more detail there will be from the fine quality provided by the small grain size.

The best way to find out about what any film speed means for you is to expose three reels of the same film type on subjects that you photograph a lot, repeating the shots and lens settings in the same order for each film. With each individual subject take five shots: one with the lens and shutter speed set in accordance with the maker's rating, and then four more, one at each of 1 and 2 stops above and below that. Develop one reel of film in the standard recommended manner, then amend that development procedure by + and − 10 per cent for the other two films. From your negatives you will soon discover the 'rating' that is best for you. Bearing all this in mind, the following is a broad guide:

Slow

When you want, and can exploit, very fine detail, full tonal values and no sign of grain, a film with rating of up to 50 ASA will meet your needs. There is nothing magical about ASA numbers. In themselves they are meaningless—they are no more than a working scale to indicate the speed of the response of the film to light; the higher the number, the faster the film. In this range come:

Kodak Pan X: 32 ASA Ilford Pan F: 50 ASA

Medium

Perhaps the greatest merits of medium-speed film (about 100 ASA) are its high tolerance of exposure limits and its use in brightly lit scenes where the use of a fast film would result in overexposure even at the smallest aperture and the highest shutter speed. Any serious defects in negatives are much more likely to come from failure at the developing stage rather than in exposing, since one or two stops above or below the 'correct' setting will not preclude you from making more than adequate enlargements from this film. The film is recommended for general-purpose use since it can reproduce images in all but the poorest light conditions and at the same time freeze fairly fast-moving objects, with-

out showing noticeable deterioration in resolution from grain trouble. In this range come:

Ilford FP4: 125 ASA Kodak Plus X: 125 ASA

Fast

This range of film is improving year by year and, while it can still be forced or mishandled into showing marked grain, it is likely to gain more adherents as the years go by. It is typically at its best in low-level light conditions and with very fast-moving subjects. It can be forced well beyond its normal limits to provide dramatic images. The results you get from trying this will be so much a matter of personal taste that there is no effective rule of thumb except your own experience. The same also applies to its application to still-life and portraiture. Try using it for careful, studied pictures where you otherwise might have used a medium or slow film, and see if you like what you get. In this range come:

Ilford HP5: 400 ASA Kodak Tri X: 400 ASA

The films mentioned so far have all been black and white. The principles behind the functioning remain the same for colour films, whether they are for negative-types for making prints or reversal-types for slides. Before looking specifically at the range of colour films available it is only sensible to consider the basic qualities and inter-relationships of colour and light.

Colour and Light—The Basic Principles

If you take an ordinary torch or flashlight and switch it on, it will produce something near to 'white light'. (If the battery is low, the filament will not heat up sufficiently to produce more than a reddish glow and the relationship between the heat of an object and the kind of light rays it emits is the basis of the scale of measurement of colour temperature. More is said about this later. For the moment we will take the torch to be efficient and its light to be white.) If you put a colour filter in front of the beam the light will become 'coloured'. *What has happened is that the colour medium has blocked some light rays and allowed others through.* The blocked rays have been absorbed by the medium and their energy converted into heat. The others have been transmitted and their colour will be the colour code of the medium. The process of blocking and transmitting is known as *filtration*; hence the colour media are known as *filters*. Thus, a red filter passes through only red light—just one of the three primary colours (red, blue and green) that go to make up white light.

If you now take a second torch (or any other source of white light), place in front of its beam another primary coloured filter, and shine both light sources on to the same white surface, the following will occur:

(a) First filter, RED: red light only
(b) Second filter, BLUE: magenta light
(c) Second filter, GREEN: yellow light

If you take a third light source and shine the three beams (each filtered by one of the primary colours) on to the same spot the light will now be near white.

These phenomena come about because our eyes have a mechanism which interprets colour sensations by means of receptors which respond to the primary colours in light, and every colour is sensed by this simple function. In the experiment above, the white surface reflects red wavelengths and green wavelenths together and the red and green receptors in our eyes indicate a yellow sensation. When the third source with a blue medium is added to the two above, the reflection will be seen as near white because white light energises all three parts of our colour mechanism. In other words, *white is a complete reflection of all the primaries* and we see the additive effect. (From a painter's point of view the reverse occurs. When pigments are mixed all three primaries together will give black.)

Colours that are lighter than the primaries are called tints. They are produced by mixing the primary colours on an additive basis. Take, for example, red and green—producing yellow—and add a little blue by means of a dimmer; the yellow will immediately appear to be paler, because it is approaching whiteness. The principle is represented diagrammatically in Fig. 4.2 and every television viewer knows of it from advertisements for soap powders with 'added whiteners'.

In the diagram the three primary colours of light are the points of a triangle, and the perpendiculars from the apexes represent the individual colours with 100 per cent light output at the apex and 0 per cent where the perpendicular meets the opposite side. The point of interception of all three perpendiculars represents white, which is an equal mixture of all three colours at approximately one third intensity. Along each side, a range of colours can be produced by mixtures of any two of the primaries. At the centre of each side (approximately half the intensity of each colour) further colours occur: magenta, yellow and cyan, which represent secondaries. All colours can be shown as parts of the triangle and it is interesting to note that the introduction of a third (C) along with any mixture of (A) and (B) will draw the line closer to white, i.e. (D)–(E), and produce a paler tint of the original mixture.

If the surface chosen for any of the experiments described above had not been white, the results would have been different. *Surfaces themselves appear coloured to our eyes because they reflect light* but they do not transmit any of their own account. Like filters, they have the quality of absorbing certain light rays and reflecting—not transmitting—others.

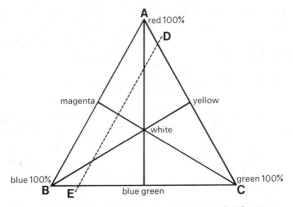

Point of intersection = white formed by an equal mix of all 3 colours at approx. ⅓ intensity.
Addition of colour C on any colour formed along line AB produces a paler tint (line DE).

Fig. 4.2. Colour triangle.

A red surface appears to be that colour because it reflects whatever red light rays fall upon it. If the light is white, the surface will absorb the blue and green rays (converting the energy into heat) and send back only the red. It will also appear to be red in red light, but in blue or green it would appear black—since it would receive no light which it had the power to reflect. (This adds an interesting variation to the earlier mentioned thought: there is no light unless there is something for it to fall upon. We should now add 'effectively'.) Colours of surfaces can be enhanced, modified or even obliterated on the basis that like amplifies and unlike destroys.

The reverse of the additive effect of coloured rays occurs when the filters are placed in front of one source of light only, and not three as in the previous case. If primary colours are used (as mentioned in the last paragraph) any two filters will completely absorb all the light and produce black. If, however, the three secondary or complementary colours are used one can move from 100 per cent white light to 0 per cent (blackness) in infinitely variable steps—just as one did the opposite using the additive technique. This process with the secondary colours is called subtractive.

Both additive and subtractive processes are used in colour photography, and in spite of its more complex chemical techniques, the subtractive method is on its way to taking over completely.

Colour Sensitivity

Black and white, as well as colour, films are sensitive to the different

colour wavelengths that go to make up white light. It is still possible to obtain 'blue-sensitive' film (one of the earliest emulsions) and 'ortho-chromatic' film, which are sensitive to the blue-only and blue-to-yellow wavelengths. Infra-red films are easily obtainable and they respond to light rays in a selective manner, but are impressive to us because they 'see' wavelengths to which the human eye does not respond as if they are 'light'.

You may find it well worth your time to consult the manufacturers' catalogues and data sheets to find out exactly what is available. Some of the possibilities may appeal to you. (Some of the films may only be available in sizes that are too large to fit your camera and you will have to cut them to the right size. The end-product could more than justify the small bother. You may also have some difficulty in obtaining information that carries the forbidding label 'professional'. Do not be put off by this unnecessary jargon. The words 'amateur' and 'professional' are meaningless. Attitudes, standards and results are all that matter. Persist until you are satisfied.)

Colour Temperature

The actual whiteness of light varies considerably within the general category of illumination known as 'white light'. It varies from sunrise to sunset as the rays from the sun are increasingly and decreasingly filtered by the layers of the atmosphere. It varies, according to the source, from lamp to lamp: *tungsten, fluorescent, photoflood* or one or another kind of flash.

The differences in the make-up of white light are designated by the **Kelvin scale** which takes as its basis the *colour of light emitted by a black body at rising temperatures*. You need only to think of the performance of a black poker in a fire to understand the principle: at first it glows dull red; it becomes brighter red and then glows orange until there is sufficient blue light being emitted to take the change in colour from orange to yellow to white. The unit that measures this colour change is known as 'Kelvin' (K = degrees C + 273) and it is the generally accepted method of accurately defining the colour make-up of so-called 'white-light'. The broad divisions for the Kelvin scale are as shown on the opposite page.

Colour films are designed to work at optimum performance in wavelengths of light of a particular colour temperature and their emulsions are sensitised to produce a 'natural' colour grading under those conditions. They are rated accordingly and the information this affords is just as important to the colour photographer as is the ASA speed, whether the film is for negatives for prints or for transparent positives for projection.

Light source	Kelvin
100 watt electric light bulb	2,900
Nitraphot B photoflood	3,300
Argaphot photoflood	3,300
Quartz-iodine lamp	3,400
Blue-coloured over-run lamp (daylight lamp)	5,000
Clear flashbulb	3,800
Average daylight	5,500
Blue flashbulbs or high-intensity arc lamp	6,000
Electronic flash	6,000–6,500
Very blue daylight, e.g. in shadows, at the seaside, in the mountains	6,800–8,200

Colour Reversal Film

All that was said about grain, resolving power and speed with regard to black-and-white films applies to colour films as well, with the additional complexity of the greater range for perceptible change. What previously applied to one tone range only now applies to the whole gamut. Since there are six basics with the primaries and secondaries only, and every step in between can be infinitesimally graded, the combinations and permutations that can lead to unexpected, abnormal or just plain unwanted results are manifold.

Colour reversal film produces transparent positives that are meant to be viewed through slide-holders or by means of projectors. They are, it is generally accepted, more 'faithful' in their colour-rendering yet more dramatic in their effect because of the high level brightness in which they are usually seen. The films are colour-balanced for daylight or artificial light. These are the most common:

Agfa CT18: 50 ASA

Agfa CT21: 100 ASA

Ektachrome ER: 64 ASA, ED: 200 ASA

Kodachrome KM: 25 ASA, KR: 64 ASA

While colour prints can be made from reversal film, and slides from negative film, the process always tends to involve shifts in colour and balance, and prints are best left to negative film.

Colour Negative Film

This film type produces negatives for prints, basically in the same fashion as black-and-white film. It offers greater flexibility in handling since adjustments can be made, to aesthetic taste, for each print. Most negative films come in daylight-balanced type only and need a filter for use in ordinary artificial light or flash that is not blue-tinted. These are the most common:

Agfa CNS2: 80 ASA
Kodacolor II (C): 100 ASA, 400 (CG): 400 ASA

Whether you work in black and white or colour it is worthwhile checking on the availability of *bulk lengths of the film you want to use.* It is simple enough to load (make sure your darkroom is light-tight!) and can save more than half the cost of the small packs.

However, a note of warning: do not let the wish for economy drive you into the bargain basements of outdated stock or any other strange, 'special' offers. The risks of the film not being able to do what it should are too great.

EXPOSING AND FOCUSING

It was suggested in Chapter Four that the best way for you to discover the effective ASA speed rating of any specific film was to give it a series of bracketed test exposures on known and constant subjects. From these tests you will be able to determine how light-sensitive the film is in your hands.

Controlling Doses of Light

Knowing the light sensitivity will only be of use to you if you can get the light to the film surface in the controlled doses that you want. To gain full control over the final dosage of light falling on to the film there are two major elements you can manipulate:

(a) *The size of the aperture* letting in the light; this controls the actual amount of light that is made available.
(b) *The speed at which the shutter opens and closes*, permitting the aperture to be effective; this controls the time.

There are many simple parallels: think of a warm room with a single door giving on to cold air from outside. The final dosage of cold air that enters the room is governed by the size of the door; how widely it is opened; and for how long it is opened. A classic example from schoolbook physics is of taps pouring water into baths (probably with holes in them!). The final dosage of water in the bath is governed by the bore of the tap-pipe (its aperture) and the length of time for which it is running.

The school formula for arriving at the distance an object will travel when the speed and time are known is $D = S \times T$. The simple equivalent in film terms relating to the final *Dosage of light*, the *Strength of the Source* of the light through the *Size of the aperture*, and the *Time allowed by the shutter speed*, can also be represented by the same equation $D = S \times T$. Thus, the greater the size of the aperture the shorter the time it needs to be open, and, conversely, the longer it is open the smaller it needs to be.

The Aperture

Since the basic aperture settings for lenses are graded to let in twice

as much or twice as little as the ones on each side of them and the basic
speeds for shutter movements are graded similarly (to make them twice
as fast or twice as slow), the calculations required to keep them in
balance for the proper final dosage of light to be delivered (the exposure)
are simple and basic.

f number scales

f numbers are the gradations given to *indicate how much light an
aperture will allow through the lens*. Any *f* number is the ratio of the
effective or working aperture to the focal length of the lens. Another
equation:

$$f \text{ number} = \frac{\text{focal length}}{\text{working diameter}}$$

Thus, an aperture setting of *f*8 means the size of the opening is one
eighth of the focal length of the lens, and the larger the *f* number the less
light it will let through.

Lenses are identified and described by their largest aperture size and
the larger that is, the smaller the *f* number will be and the 'faster' the
lens.

The mathematical scale that reflects the gradations referred to above
(where each setting lets in twice or half the light of the next one) is:

f 1, 1·4, 2, 2·8, 4, 5·6, 8, 11, 16, 22, 32, 45, 64

Fig. 5.1 shows something of what this means.

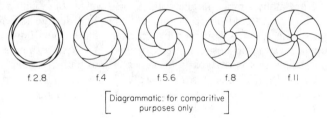

f.2.8 f.4 f.5.6 f.8 f.11

[Diagrammatic: for comparitive
purposes only]

Fig. 5.1.

The ratio of the amount of light that an *f* 1 will pass compared with
and *f* 64 is (4,000+ to 1). An average lens works within the range of
f 2·8 to *f* 22 and this gives a ratio of 64 to 1. At first glance this may
not seem an impressive figure, but when used in conjunction with the
second controller of the final dosage of light to be administered to the
film (mentioned at (b) above) it is soon found to be more than
adequate.

Controlling the size of the aperture does more than merely regulate
the amount of light that passes through the lens. It also controls the

depth of field. This is dealt with later. Now we turn to consider the use of the shutter.

The Shutter

This is the means by which the photographer exposes his film to whatever amount of light the aperture will let through. There are **two main types of shutter control**: *the leaf or iris-diaphragm shutter and the focal plane shutter.* The first operates within the lens, the second from behind it. Figs. 5.2 and 5.3 show the main features.

Fig. 5.2. Leaf or iris-diaphragm type of shutter.

Fig. 5.3. Focal plane type of shutter.

The leaf shutter is generally a series of *overlapping metal blades* constructed in the form of an *iris diaphragm.* It is spring-loaded so that when the action button is pressed the blades flash open (always to their full extent) and close again in a pre-set time. The effective exposure is gained through the fully open iris—the opening and closing of the blades being almost instantaneous, and their effect minimal and marginal. Generally the shortest exposure time available with such shutters is 1/500th of a second.

The focal-plane shutter differs from the leaf type in two main ways: *its placement in the whole camera set-up* and *its manner of providing the effective exposure*—this being gained through the actual travel of the opening. *A curtain or blind with an adjustable slit in it moves in front of the face of the film*, generally at a set speed, and the variations in exposure come from the control exercised over the size of the slit. Thus, there is only one movement of the mechanism in securing the image, not two (opening and closing) as in the leaf type.

If the blind takes, say, 1/50th of a second to pass in front of the whole of the film to be exposed, then all parts of the film will receive 1/50th of a second's exposure when the slit is fully open. When it is half open the effective exposure will be 1/100th of a second; 1/200th when it is quarter open; and 1/500th when it is one tenth open, and so on. If the speed of travel of the blind is also adjustable, combinations of the two variables will offer a very flexible and accurate control over shutter speeds.

A special advantage of the focal-plane shutter is that it shields the film from exposure when interchangeable lenses are in use.

Some modern shutters are *electronically controlled* and this method has two major advantages:

(a) It gives exact shutter speeds as marked on the camera and has a wider range of speeds than usual, especially in the slower section.
(b) It provides a more effective, accurate and direct link with metering systems.

Some traditionalists are opposed to the introduction of electronics into camera operations. However, it can be argued that electronics take away from the user only gratuitous tasks; do not interfere with his overall (or even specific) control; and allow greater freedom so that the user can give full expression to his creativity. They are yet another enabling process for the photographer with an eye to the future.

The basic range of shutter speeds is (in seconds):

1, 1/2, 1/4, 1/8, 1/15, 1/30, 1/60, 1/125, 1/250, 1/500, 1/1,000

There is, in addition, the 'B' setting which allows the user to hold open the shutter for as long as he wishes.

Combining Aperture Sizes and Shutter Speeds

Together, the shutter speed (T) and the aperture (S) control effective exposure (D): $D = S \times T$. Together, they give a wide range of control: for a camera with the shutter speeds given in the previous paragraph and a lens with a range of $f\,2{\cdot}8$ to $f\,22$, there are 77 settings and the ratio of the longest to the shortest (excluding the 'B' setting) is 64,000 to 1.

Of the 77 settings, many will balance out and give the same effective exposure (final dosage of light) because of the mathematical relationships between *f* numbers and shutter speeds—each doubling up on the next setting. Thus, with the camera and lens just quoted (and, indeed, with any camera) *f* 5·6 at 1/60th gives the same effective exposure as: *f* 4 at 1/125, *f* 2·8 at 1/250, *f* 8 at 1/30 and *f* 11 at 1/15. However, although they will yield the *same effective exposure*, and will provide an image that can be sensibly read, they will *not provide the same image*. The changes in aperture size will bring changes in depth of field and the speed of the shutter action will affect the freezing or blurring of movements in the subject. (Depth of field is discussed below.)

There are many guide books that will offer you basic combinations of aperture size and shutter speeds for different situations: sunshine on snow, rain at night, birds in flight, hand-held shots, etc., and film manufacturers also offer similar information in some of their data sheets. But the only way to find out what is best for you is to go out and shoot for yourself. However, the chances are that you will have great difficulty in doing this (no matter how much you wish to train your eye to see what the camera sees) without the persistent advice of the moving finger of the omnipresent TTL meter.

Exposure Meters—Measuring the Brightness of Light

With some experience you will be able to look at a scene or subject and make a fairly accurate assessment of the combinations of film speed, aperture size and shutter speed needed to get an optimum negative or the special effect you need. You will still benefit, more than probably, from the aid of one instrument or another, however, because the human eye can quickly adjust to any changes in the intensity or colour of light. Not only can it do so, it does so constantly without any prompting from you and there is nothing you can do to stop it. There is little you can do to compensate for it except to keep aware of the fact that it occurs. Like the other human senses, the function of sight is to enable us to detect change, note it and adjust and respond to it but not to remember the change nor to make a scientifically accurate recording of the phenomenon.

The camera eye does not adjust and it is therefore sensible to have an instrument that will tell you what the camera is registering and not leave it to you, in the final resort, to have to decide on your settings with insufficient or indeed inaccurate information. *Used separately, your eye and the meter will mislead*, because they both have specific jobs to do that are in many ways mutually exclusive. *Used together, they can ensure you get the images you want* (almost!) every time.

Light meters that are built into the camera are becoming deservedly

more popular because they are so convenient. They are also flexible and accurate within their own disciplines. Their main weakness is that they cannot easily (and on occasions not at all) give the close 'spot' readings you may wish to take to ensure you get the exact, final rendering you wish either in part or overall.

If your camera does not feature a built-in light meter you will almost certainly need one, and even if it has you may still decide you need one anyway. Cost is by no means prohibitive, since you can purchase quite reliable models from about £5.

Meters are powered either by selenium cells (which are self-energising) or by batteries which operate cadmium sulphide cells. Readings are indicated by a needle or pointer on a graduated scale.

Meters register either the light that is *falling on to the subject* (incident-light type) or that which is *being bounced back from it* (reflected-light type). All built-in and TTL (through-the-lens) meters measure reflected light—for fairly obvious reasons. Some separate meters have an adapter so that the same instrument can give reflected and incident light readings.

Because meters have no lens to focus the light rays, they *receive an overall scatter from all the light rays* that come within their angle of acceptance (generally about 40 degrees). Their signal is a response to this diffused stimulus and it will be a true rendering of the average of the light. Averages, by their very nature, are prone to mislead. For example, the average of 49 and 51 is 50; but so is the average of 25 and 75, and also 1 and 99. The light meter is not capable of telling you about the extremes that make up the average, at least, not at just one reading. To discover the full range you use the meter for separate readings at all the individual points your eye tells you are note (or meter) worthy. Obviously, built-in and TTL meters cannot compete with this flexibility, but even they, whether or not specially sensitised at their centre-point (centre-weighted), can be aimed at the more contrasting areas to give you the information you need. The most obvious case is a landscape with a substantial area of sky. Here you can take readings of (i) all sky, (ii) part sky, (iii) no sky, and come to your own exposure figure.

As was suggested earlier, optimum benefit comes when human eye and scientific instrument work together.

Focusing

So far we have considered techniques that ensure the appropriate amount of light reaches the film. It is now time to consider techniques dealing with the fine and detailed arrangement of that light to provide a sensible image. (Final Dosage of light has now become Fine Detail of light rays.)

Chapter Three looked at the ability of lenses to focus. We must now look at *ways of determining how sharply in focus we have created the image of our subject.* (In the final negative we may wish to achieve all kinds of variations on out-of-focus themes, but our starting place must be the point of focus. If there is no in-focus, there can be no out-of-focus.) There are three basic methods of reaching best focus: *scale, rangefinder* and *screen.*

All focusing lenses have a focusing scale marked on the barrel either in metres or feet and inches. The major problem with this method lies not with inaccuracies in the scale, nor with any complexity in handling the barrel or scale. The difficulty is in accurately determining the lens-to-subject distance, in order to set up the scale to any purpose. You must either be an infallible judge of distance (and no one is) or go to the tedious lengths of measuring the distance by hand. Any other approach will merely bring the considerable risk of out-of-focus images. (You may rely on a large depth of field to ensure that everything is more or less in focus from 7 in. to infinity, but this is 'grabbing' and not imaging or focusing, and cannot really be condoned as a modus operandi.)

Many simpler viewfinder cameras have the *rangefinder* built into the viewfinder screen. There are three main types:

(a) Two images are seen when the lens is inaccurately focused and sometimes they are of different colours; *when the lens is correctly focused the two images fuse into one* and this coinciding gives rise to their name, **coincident rangefinders.**

(b) One half of the image is laterally displaced when the lens is inaccurately focused; *when the two halves line up exactly* (most accurately determined on vertical lines of course) *the lens is in focus*; this type is called the **split-image rangefinder.**

(c) **The 'microprism' rangefinder** takes the principle of splitting up the image when the lens is out of focus even further: an apparently crystallised or disintegrated image is seen when the lens is out of focus, and, according to the manufacturers, it 'jumps' into clarity at best focus and *the apparent fractures to the image disappear.*

The remaining method of ensuring focus is by the use of a viewing screen made of glass, either ground or with fresnel rings. The latter are fine concentric circle-lines to ensure the even spread of the light rays over the entire surface of the viewing screen. This viewing screen has a simple function: *to arrest the image and lay it out like a blanket so that it becomes effective and sensible to our eyes.* The image was always there, of course (as an aerial image), but the viewing screen enables it to be made more easily manifest. (There is no image unless there is something for it to form upon.)

Straightforward viewing screens are usually found in TLR's and large format cameras. Rangefinders are most frequent in the viewfinder type of camera and a combination of the two (with the rangefinder device in the central position in the viewing screen) in 35 mm SLR's.

Many cameras offer a choice of viewing screens or rangefinders, and it should not be too difficult to find one that suits your temperament and your eyesight. It is probably a good idea to have at least one viewing screen that gives you an ample area of clear screen for image formation so that you can constantly check the rangefinder device against your own assessment on the unbroken screen.

This is particularly valuable when using a lens with a fully automatic diaphragm, to enable you to achieve viewing and exposure arrangements at full aperture and to check the over-all effect at the shooting aperture with the 'pre-view' device. This is eminently useful in getting an accurate picture of the actual depth of field.

Depth of Field

Any consideration of this subject must be prefaced by some reference to a definition of focus. Earlier in this chapter this was referred to as 'the fine and detailed arrangement of ... light to provide a sensible image'. By its use of such words as 'fine', 'detailed' and 'sensible', that reference was placed categorically in an area of subjective assessment. To shift the reference to objective terms (mathematics, science, optics) means using special criteria: a point becomes that which has 'position but no magnitude' (for example, the point of intersection of two lines) and a line has 'length but no breadth'. These references are, if anything, of less use to the photographer than the previous subjective phrasing.

The compromise norm in general use is known as the **circle of confusion**. This helps us to agree when (theoretical) *point sources of light* on any subject have been rendered by the lens into *circular patches of light too large for the eye to accept as sharp*—that is, as suitable visual symbols for the original point sources. This phenomenon has been much exploited in cine and television films and there can hardly be a reader who has not seen the slow (and sometimes indulgent) diminution of large discs or even 'pools' of light into the recognisable and acceptably sharp images of headlamps, chandeliers, diamonds, and candles, etc.

The circle of confusion is the standard reference for the resolving power of lenses, films and prints. (Standards may also refer to the number of lines per millimetre that can be reproduced, but it boils down to the same effective scale.) When it is too large, the image is blurred—out of focus. The point at which the human eye can first distinguish any differential in the magnitude of these circles of con-

fusion varies from person to person. Since some lenses provide circles of confusion that are measured in a few thousandths of an inch, it is clear that any failure to focus accurately is more likely to be the fault of the worker than his tools. Similarly, most films and papers perform beyond the standards of perception of the average human eye, and, once again, failures are more likely to stem from us than from our materials.

In a sense, we are back where we started from: subjective judgments. But we can now turn to a consideration of depth of field, which hinges exclusively on matters of focus, knowing there is one criterion we can refer to: namely, the circle of confusion.

Depth of field—*the extent of the distance, near and far, over which sharp images can be achieved for any given specific best point of focus* —is a major weapon in the photographer's armoury and you should look at all the illustrations in this book, at some time, with an eye trained to look for nothing more than their depth of field.

When you focus a lens at, say, 10 ft all objects at that distance from the camera will be in focus and will be imaged sharply. Objects that are closer to or more distant from the camera will, as their distance from the 10 ft mark increases, be rendered less and less sharply in focus. While their image is still acceptably sharp they are within the depth of field.

Depth of field is influenced by the following factors:

(a) The larger the circle of confusion you are prepared to tolerate (or wish for) the greater will be the depth of field (and remember, the effective depth of field is what will appear on the final print, so your standards and techniques will be relevant and reflected at all stages of handling the camera, lens, negative and print).

(b) When lens aperture and subject distance are constant a lens of long focal length will yield less depth of field than one with a short focal length.

(c) As the lens aperture is closed the extent of the depth of field increases.

(d) When the lens aperture is constant the extent of the depth of field increases with the distance of the subject.

(e) The extent of the depth of field is greater on the far side of the point of focus than it is on the near side.

There are two ways in which you can approach depth of field:

(a) Using the scale on the lens or a separate calculating instrument or the depth-of-field table for the lens you are using; this method enables you to achieve exactly those images you want to be in focus, but will give you little indication of the shape and texture of what is out of focus.

(b) Using a camera with a pre-view device so that you can actually see the results of the extent of depth of field you are working with.

The second method is obviously the more convenient, but persevering practice with the first will enable you to assess fairly well the results you will obtain. You can always safeguard your final results by decreasing one or two f stops on the recommended setting to ensure you throw your unwanted detail completely out of focus, or by reversing the process to ensure that everything is covered.

It is the controlled use of the selective techniques permitted by depth of field that enables the photographer to represent the world through emphasis, contrast and suggestion. By this means he can direct attention to exactly where he wants it on the final print, thus guiding the viewer's eye with almost hypnotic skill.

Differential Focus

If you are intending to master such sensitive control over your viewer's gaze on your print, you will be using minimum depth of field and gaining optimum impact (and sometimes maximum and dramatic contrast) by the intensive exercise of differential focus. This technique requires you to pay as much attention to the abstract within your image as to the concrete. The sharp focus of the latter will catch the viewer's eye and speak, initially, for itself. Its full significance will emerge a little later when it is seen in the context of its full framing or presentation. This can be just a blur of graded middle tones producing a totally neutral background. It can also be a carefully arranged composition combining abstract projective shapes and shades to give powerful psychological and emotional overtones that will work on the viewer's imagination, creating realistic and surrealistic interpretations.

Plates 5.1–5.6 show something of what the controlled use of depth of field and differential focus can achieve. Look at them until you are confident you know exactly how they might have been obtained and, more importantly for you, how you can surpass their effects. Then go and do it, because practice in this, one of the most significant, central and creative parts of the photographer's world, is the only way to achieve satisfaction and development. The only rule in the techniques of differential focus (and it is a real one) is that there is no rule.

Summary

The aperture of a lens controls the amount of light that can actually pass through; f numbers are measures for this amount and they progressively halve illumination as they get bigger. The shutter of the camera is a moving mechanism which controls the duration over which

Plates 5.1–5.4. Depth of field and differential focus.

the light passes through the lens and on to the film, and its speeds are matched to the *f* number scale in that they progressively halve effective illumination as they increase.

Plate 5.5

Plate 5.6. Controlled focus effects.

Aperture size and shutter speed are combined to get the desired quantitative and qualitative exposure values: the first affects depth of field and the manipulation of any differential focus; the second affects freezing or blurring of images because of subject or camera movements.

Exposure meters, whether in the camera or separate, measure the amount of light falling on to the subject (incident light) or being reflected from it and falling on to the lens (reflected light).

Focusing is achieved by the use of a scale on the lens barrel; a rangefinder device; or a viewing screen. It is effectively measured by the circle of confusion—the size at which a 'point' is no longer acceptable as such.

Depth of field is the distance over which a subject can move towards and away from the lens before the focus becomes effectively unsharp. Differential focusing exploits a minimum depth of field to achieve optimum contrast between subject and background, or selected parts of the subject itself. It is one of the most important and subtle instruments at the photographer's disposal and command.

LIGHT AND LIGHTING

Chapter Five dealt with ways of ensuring that the amount of light reaching the film surface was correct for the level of exposure wanted. It also considered how best to guarantee that the light rays would form the particular image that the photographer wanted. Controlling or amending the sources of light—whether natural or man-made, direct or reflected—was not considered. It is now time to do so.

Natural Light

It goes without saying that we have no control over the source of natural light. We can, however, control its effect through selection and reflection.

The direction, intensity and colour of the light from the sun vary with a regular and predetermined pattern throughout each year and throughout each day. They also vary, in Britain particularly, at the whim of the weather. All these variations can be put to good use by the photographer. They all provide opportunities to catch one subject or another in a unique manner. The colour of the light may be warm (with a lot of red in it) or cold (with a lot of blue or green); the sun may be high in the sky (casting short shadows) or near the horizon (casting long shadows); there may be no shadow at all because of a fully overcast sky or thick mist. The variations are endless and it is no exaggeration to suggest that a single subject, like a tree, a block of flats, or a small patch of back garden can offer fascinating opportunities in almost every daylight hour throughout the year.

There is only one worthwhile way to approach the mystery and magic of the effect of natural light on the world we live in and that is by looking—looking both with your own eye and that of your camera—until you see the world in its continuing ecstacy of sunlight. Once you have fallen in love with what the sun can do for our world, you will never have sufficient time to take all the pictures you will want to capture.

Another area of selection is that of viewpoint. What may seem a rather dull and boring point of view from one position may suddenly come dynamically alive from another, simply because we have caught a slightly different angle of light. This change is seen at its most

dramatic when switching from shooting with the sunlight to shooting against it, with the subject highlighted, silhouetted or haloed. (*Please note*: the sun is a good friend but a dangerous enemy so take the greatest care when looking or aiming your camera straight at the sun. Remember, there is no equivalent to Braille for photographers.)

When using natural light indoors, we can exercise some control over its effect by utilising any window as an additional aperture. A window will let through only a certain amount of the light from outside, and, as the distance from the window of the subject increases, so the intensity of the light falling on it decreases. This provides us with an effective dimming system. Also, curtains enable us to vary the intensity and, to some extent, the direction of the light rays. Since many curtains are coloured, they also act as colour filters or reflectors. Try at all times to capitalise these factors, not merely to 'correct' them.

It is impractical to filter the source of natural light when out-of-doors (we can filter it before it passes through the lens and this is dealt with below). However, it is possible, and most useful, to control its effect by reflection. White walls, green grass and red bricks will all affect the direction, intensity and colour of light rays as they fall upon the subject. The closer the subject is to the reflecting surface, the greater will be the effect. With these reflectors, however, we can control the result only by moving the subject. By using white/grey/black and coloured sheets of card or strong paper we can exercise marginal or extreme influence on the balance of effective light that falls on the subject. Sheets of newspaper or old brown paper (the glossy side reflecting more than the matt) can, in emergencies, be pressed into service.

Surrounding objects, indoors or out, should also be assessed for their ability not only to reflect light, but also to absorb it and cast shadows. Careful placing of the subject will give effective control of the result of the lighting (in real terms for exposure factors and comparative terms for gradations of light and shade for aesthetic considerations). Trees, lamp-posts, doorways and archways, motorcars, umbrellas, hats, etc., should all be considered as objects that will usually adjust and mould the light.

Artificial Light

The adjustment and moulding of light can be carried out to the most critical of standards when using artificial light. This immediately gives rise to the thought of expense in rigging up or hiring a studio, but the easy availability of photographic backing papers means that any lounge or dining-room can offer you facilities to start, if you really want to. Even if that approach is not possible for you, a plain table top with one or two lights is an effective studio for still-life and close-up work.

Whatever the conditions, the three factors of lighting to be considered are: *direction, intensity* and *colour*.

Direction

There are three kinds of light source available: *open, flood* and *spot* (flash is dealt with separately below).

In the first category come most tungsten and fluorescent fittings in the home. They give an *even spread of light in all directions*. The main variation usually to be found with this source of light come with its shade, which may be transparent, translucent or opaque, with the former sometimes being coloured.

The second category consists of devices which have a single (fixed) reflector to control the spread of light with no variation. Their function is to *illuminate the subject evenly from any given position*.

The third category is made up of units designed to *concentrate the light on a given area at high intensity*, and consisting of an optical system with focusing that can be varied so the spread of light is controlled. The intensity of the source and the size of the area covered depend upon the design. They are available as profile models to produce hard clear-cut edges to the beam, or as fresnel models to give soft edges.

Combinations of any or all of these sources will give you total control over your lighting and also provide an area of activity that can intrigue for a lifetime.

Intensity

There are two main ways you can control the intensity of your lighting: *the number of sources and their individual brightness*. There are two ways to control the brightness of any individual source of light: *choice of wattage power for the lamp and varying its output by means of a dimmer*.

The second method is undoubtedly the more flexible and convenient. It will give you infinite variation over output from 0 per cent to 100 per cent. It is, however, expensive.

You can approximate to this flexibility by using the 'step' method of varying the number of sources and the type and power of their lamps.

You can choose from a vast range of fitments and lamps designed for stage, television, cine and still film use. Remember that for colour, the colour temperature of the light source will need to balance with the film you are using. An important factor is the low level of blue in the normal tungsten lamp bulb—a tungsten-halogen source overcomes this deficiency. The notes supplied by the manufacturers of films and lamps will give you the necessary information.

The expense of moving into this area is not necessarily high. You can start with one or two simple reflectors and lamps for a few pounds only.

You can then add extra equipment (including stands, booms, umbrellas, etc.) as you discover your need for it.

Plates 6.1 and 6.2 show a range of medium-priced equipment, and Plates 6.3–6.13 some of the effects of changing the direction and intensity of light sources and shadow-makers.

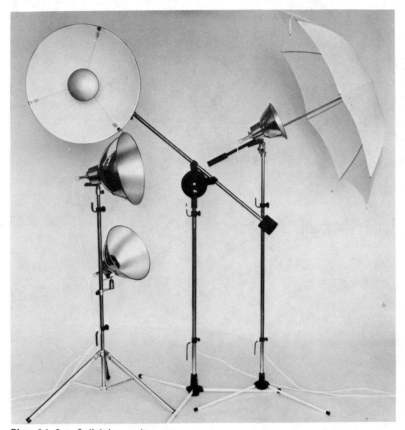

Plate 6.1. Interfit lighting equipment.

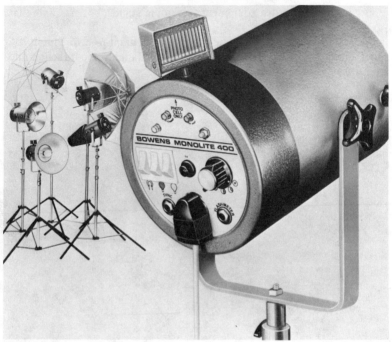

Plate 6.2. Bowens lighting equipment.

Plate 6.3. Overhead light.

Plate 6.4. Front side light.

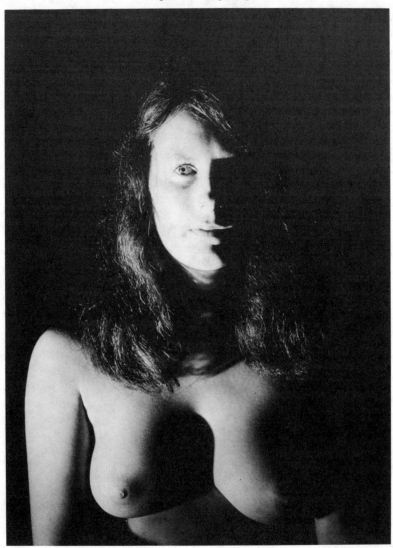

Plate 6.5. Side light.

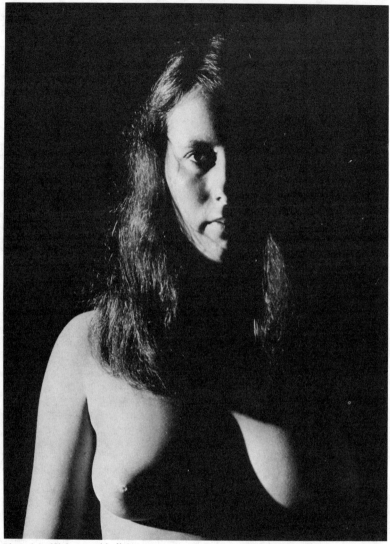

Plate 6.6. High rear side light.

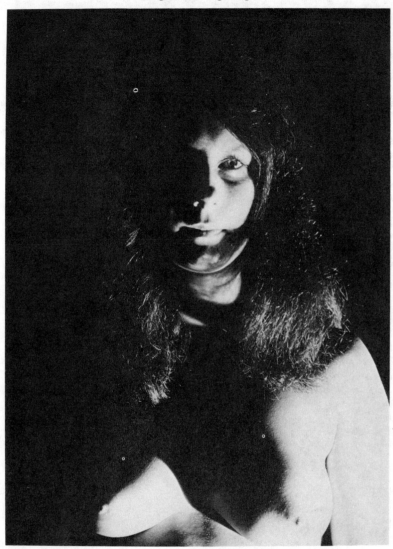

Plate 6.7. Low side light.

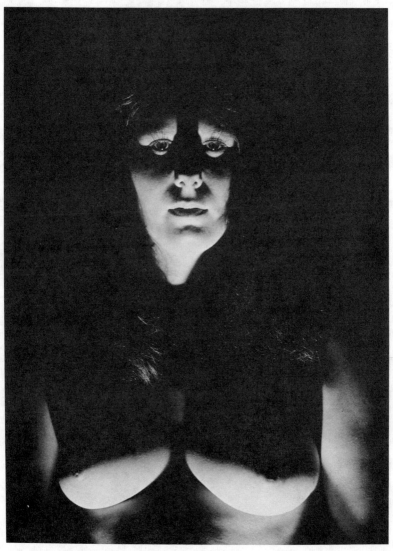

Plate 6.8. Low front light.

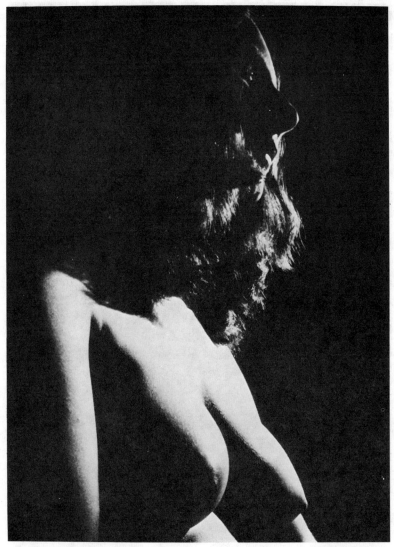

Plate 6.9. High side light: low camera.

Plate 6.10. Rear lighting: silhouette.

Plate 6.11. Low-level sun.

Plate 6.12. Dancers in performance.

Plate 6.13. Sun on wood.

Colour

The range and impact of the colours in your final print or transparency will be affected by a combination of the colours of the surfaces of your subjects and the colour of the light falling on them (see pages 71–73).

Emotional response to colour is subjective, and the following notes are offered only to give you a starting-point for exploration:

Warm colours tend to advance
Cold colours tend to recede
Reds and oranges are powerful and strong, assertive, aggressive and warm
Yellow is gay, happy and cheerful—it stimulates
Blues and greens are tranquillising, restful and cold
Purple and magenta are pompous, regal, powerful and stimulating
White stimulates (easily overstimulates)
Black depresses (easily overstimulates)
Grey neutralises

If you begin to experiment with colour-mixing as outlined on pages 71–73, you will soon discover that there is more to intrigue and absorb you than would appear from a study of those books and magazines that devote pages to coaxing and coaching you into reproducing 'normal' flesh tones. True, it is an important area of interest and a necessary standard, but your preoccupation as a photographer should be with presenting the result of your insight, not exclusively aiming at what the average eye will see as 'normal'.

Use colour filters in front of your lights to experiment. Sheets of gelatin are inexpensive. They come in vast range of colours and can also be useful as lens filters (see below). Bathe the whole subject in different tints or use a white background flooded or spotted with sympathetic or antipathetic colours. (Colours are sympathetic when in the same segment of the colour wheel and antipathetic when in opposition across a diameter.) Experiment with the 'coloured shadows' you will get from three separate light sources, each filtered by a primary colour. Remember, it is your vision and your view. Its acceptability to the common denominator in human powers of visual perception will merely confine your terms of creativity and expression.

When you are considering how best to combine the direction, intensity and colour of your light sources, give a little time to thinking about the *constructive use of shade and shadow*. Time is often given to eliminating unwanted shadows at the expense of constructive thought about creating significant ones. By all means spend time balancing your lighting, but sometimes approach it, as it were, from the rear. Take

your lighting by surprise by building up the right shadows. It can be stimulating and rewarding.

Filters

We have considered how filters can be used in front of light sources to control colour values and intensity. Now it is time to consider their use in front of the lens.

Most filters are thin discs of coloured glass, or two discs of transparent glass sandwiching a layer of coloured gelatin, and their purpose is to alter the tonal reproduction of different colours in the subject. They can be used for colour or black-and-white films, and can be classified in two main groups:

(a) Filters to give '*correct*' *renderings* on black-and-white or, more often, colour films (when shooting in artificial light with a natural light film, for example).
(b) Filters to increase the '*contrast*' *renderings* (usually on black-and-white films).

Before spending a lot of money on filters for your lenses (and the price of a filter can vary from under £2 to over £30), it is worth experimenting with pieces cut to size from the gelatin filters you may be using in front of your light sources as mentioned above. It is worthwhile buying them in this way exclusively for use with lenses since the range of colours is tremendous (far greater than most photographic suppliers can offer) and the cost is very low, especially if you can persuade friends to share the small sheets of gelatin with you.

The effect of the filters is non-selective, of course, and there may be only a few occasions when you will need them for colour prints or transparencies. (Nude models against black or white backgrounds or out of doors are susceptible subjects.) They are, however, of constant interest for the *black-and-white film* user. There are many tables drawn up by manufacturers to outline the effects of their filters upon the tonal renderings of sky, cloud, skin, petals and leaves, etc. They leave little to the imagination and less to creativity. The basic information you need to consider is given in the chart below and you are recommended to use it as a basic starting-point only, and discover the effect of the filters in action for yourself.

Filter	*Subject (with black-and-white film)*		
	Red	Blue	Green
Primary Red effect	light	dark	dark
Primary Blue effect	dark	light	dark
Primary Green effect	dark	dark	light

If you remember that the secondaries lie halfway between the primaries, you can quickly make up your own chart for them. (For example, yellow passing some red and some green will reproduce each of them as half-light tones; allowing no blue to pass it will have a similar effect as a red or green filter and will reproduce blue as dark.)

As was mentioned earlier, in terms of colour, a filter will enhance like colours and destroy unlike ones. *In black and white terms, a filter will have the effect of lightening* (in black and white tones) *like colours and darkening unlike ones.* Plates 6.14–6.18 show the effect of some colour filters on black and white images.

There are three other filter types with special functions:

(a) **Neutral density**: These filters affect only the *intensity of the light* that passes and are useful if you are caught in bright light with only fast film. They enable you to bring the effective light within the exposure limits of aperture size, shutter and film speeds.

(b) **Ultra-violet**: These filters are colourless and do not reduce the intensity of light reaching the film. They *filter out the ultra-violet* radiation which often shows up as haze in black and white and a slight blue cast in colour.

Plates 6.14–6.18. Effects of some colour filters on black and white images.

Plate 6.15

Plate 6.16

Plate 6.17

Plate 6.18

(c) **Polarising:** These filters have no effect on *direct* light but pass *reflected* light from water and glass (and some other reflective surfaces, but not metal) at only certain angles, dependent upon how those reflected rays meet its 'letter-box' screen. They are *used for eliminating unwanted reflections* and also cut down the intensity of the light.

(Reflections can be fascinating, whether from shop windows, pavement pools or quiet lakes. Use the polarising filter only after careful thought. Polarising filters are less well-known for the dramatic effects they can bring about with black-and-white and colour film when they are placed, one between the light source and the subject, and another between the subject and the lens. Interested readers are recommended to turn to specialist literature.)

Flash

Because of its very nature, 'flash' does not allow the user to set up his lighting and view its effect before making an exposure. This robs him of an essential facility. Because it is convenient and techniques are improving year by year, it continues to grow in demand. It has special applications which allow of creative work in, for example, balletic movement, where, with electronic flash that approximates to strobe lighting in its speed, the subject is shot in a number of highly mobile poses. The techniques are somewhat complex and frequently require a motor-drive attachment for the camera.

There are three main types of flash: *bulb, cube* and *electronic units.*

Bulbs flash once only and are then discarded. They need separate reflectors and generally emit a blue-tinted light that is similar in colour temperature to daylight.

Cubes are four self-contained bulbs within the same unit—each with its self-contained reflector—and can be used four times before being discarded.

Electronic units contain gas that glows so brightly when an electric charge passes through it that it appears to explode in a flash. Each unit can be used thousands of times and is powered from the normal mains supply—either direct or through a storage battery.

There is little doubt that if you have need of flash, the *electronic unit will serve you most flexibly and best.* There are units to fit the camera body, to be hand held, and to fit studio stands. This adaptability makes them superior to bulb and cube, which require an appropriate attachment to a mechanism on the camera body.

There are many varieties of electronic flash (with optional extras of 'slave' units, umbrellas) and even one fully-automatic, exposure-calculating, self-timing model. The price bracket ranges from under £10 to

well over £100. They are recommended by many authorities for their traditional 'bounce' and 'fill-in' effects, and specialist literature abounds regarding exposure and synchronisation techniques. You may care to consult these if and when you decide you must turn to flash. However, the more you consider it, the more you may decide against it.

Painting with Light

It is worth remembering at the end of a chapter dealing with lighting that the word photography itself means '*writing with light*' or '*light-writing*'. There is an interesting technique which might be called '*painting with light*' which is much more delicate and fascinating than most work with flash. It involves the use of a small light source as a kind of long-distance 'light/paint' brush/finger. You place the camera on a tripod, facing whatever subjects you are to photograph, in a room that can be fully blacked out. In the black-out, you open the shutter and 'paint' or 'bathe' the objects in the room with as much or as little light as you wish, from a small flood or spot held in your hand. You will find out by experiment the appropriate wattages and times to use, but you must, of course, ensure that no light from the source falls directly on to the lens. An on-off switch on the lamp itself is most convenient.

We live in a world of light, and are so accustomed to it that we frequently take it for granted. Its effect can transform a mediocre space into a place of delight. It is the responsibility and privilege of the photographer to use light wisely and well to help open the eyes of his viewers who will otherwise spend most of their lives looking without seeing a thing.

In the country of the blind, the one-eyed man is king, and the single eye of the camera gives to the photographer more power than Cyclops ever dreamed of.

Exercises

1. Watch sunrises and sunsets, and look out particularly for changing cloud formations on moon and starlit nights.

2. Watch the same or different panoramas, near scenes, houses, people, objects the size of a mug, through the changing lights of night and day.

3. Look out for restaurants, discotheques, hotels, shops and shop windows that make a feature of lighting.

4. Look at films, plays, television, paintings and photographs with special reference to the artists' impressions of natural and artificial light.

5. Experiment with room lighting—candles, torches, fire-light, matches and mirrors, as well as table, standard and pendant or ceiling lights.

6. Look carefully at streets at night, noting the effects of the different positions, intensities and colours of street lighting and house and shop windows.

7. Practise with a friend, lighting his or her face: (a) with different single light sources (candle, torch, spotlight, floodlight) used in different positions—particularly from immediately below, above and at right angles to the sides; (b) with a number of light sources.

8. Practise with a number of friends, lighting them as a group as in 7 (a) and (b).

9. Practise on a blacked-out stage or large space, lighting pillars, blocks, steps, pieces of furniture, curtains, ropes, ladders, clothing, brickwork, woodwork, etc.

10. Light a matt-white and a glossy-white sphere or cube, or a friend's face, in as many contrasting ways as possible. Do the same for small objects (for example, a tumbler, a pile of matchsticks or bent pipe-cleaners, dried flowers, a dry sponge, a wet sponge).

11. Repeat the exercises in 10 using colour filters in front of (a) the light source(s), (b) your eye.

12. Practise colour mixing on a white wall or screen, **but** before you experiment too much with electric light sources or dimmer units, learn about electricity. Above all: **take care—take advice.**

COMPOSITION

Some Basic Principles

Photography is a combination of art, craft and technique. The technical elements can easily be isolated and validated by reference to objective standards and tests. Into this area comes the manipulation of the controls outlined in Chapters Two to Six. The artistic elements are not so easily isolated and cannot be validated. They can only be measured by their impact on the viewer.

There are three major aspects to a photographer's artistic capability: *the creative, the expressive and the communicative.* The first two relate exclusively to the individual photographer's needs, growth and fulfilment. Only he can tell if he is being creative or expressive. No one else can ever know. But when the urge to create and express grow, as they often quite naturally do, into a need to communicate, the photographer moves into an area that relates exclusively to the impact of his efforts upon an audience. The need to communicate manifests itself over a wide spectrum. At one extreme are the photographers whose only aim is publication or exhibition (be they national or local). At the other, are those who quite simply want to show their pictures to their friends.

In this area, involving the impact upon an audience, the technical execution (which can be objectively validated) is not expected to be faulted. You do not listen to a violin solo expecting the instrumentalist to play a wrong note. You listen in order to hear *how* he plays the right ones. And so it is in photography. The audience will look at your pictures to see how you have used your technical expertise, and their responses will be wholly personal. *It cannot be over-stressed that the criteria in artistic conception, realisation and reception are totally subjective. The photographer and his audience are both on their own when creating and assessing artistic achievement.*

This achievement (be it by selective impact or comprehensive effect) is usually measured in overall terms, but it does contain component parts that can be separately considered.

The major components that go to make up a photographic image are: **line** (and therefore *shape*), **tone** (and therefore *texture*) and **colour**. But while these elements can be isolated for discussion and analysis it is their

individual welding that carries the message on the final print. The welding of the component parts into a final composition or arrangement is subjective both in its creation and its reception, and a photograph only becomes a work of art as and when its total impact surpasses the sum of its individual parts and has an effect upon its audience that will be measured by the number of people who see it (quantity) and the way in which they respond to it (quality). *Any work of art can be judged by the number of people it has affected and the quality of the experience they have gained from it.* By the time the photograph is seen, the photographer will have synthesised his separate components and, at that stage, analysis can often be fruitless and even destructive.

This chapter deals with those elements that are controlled mainly at the time of taking the image—namely the manipulation of camera, lens and subject. (The manipulation of film negative and paper print are dealt with in later chapters.)

The Aesthetic

The control of the component parts of an image (line, tone and colour) through the manipulation of the camera, lens and subject is exclusively in the hands of the photographer. He is, in turn, in the hands of his personality and temperament. Every artist knows that his work frequently transcends any clinical or logical preparations he might have made. This is sometimes called inspiration, and that special gift is a combination of concentration and absorption, intuition and insight, and sensitivity and awareness. The end-product of the photographer's work is always a combination of creation by accident and development by design. 'Chance enters the prepared mind.'

Of course it is not all chance or accident, but the gifted photographer sees his chances and capitalises accidents—and accidents are not always mishaps. Chance will come his way while he is consciously exercising his choice over his subject and his viewpoint and this latter is, of course, a combination of *physical position* and the *focal length of the lens*.

At the same time as exercising choice over subject and viewpoint, the photographer will be moving towards a judgment on the kind of rhythm he wants in the image.

Rhythm surrounds us every minute of our lives. It influences us daily, monthly and annually through the movements of the planets and the changing patterns of day, night and the seasons. It is present in our cornflake packets and our daily papers; the lay-out of motorways and supermarkets; and in the movements of buses and football crowds. It inhabits the whole range of body movements, from the total involvement of running or dancing to the fine and specific detail of striking a match or filing a fingernail.

Rhythm is that flow and movement, or the appearance of flow and movement, sufficient and necessary to give a natural impression of life and vitality.

With expert dancers and athletes the actuality of the movement is obvious. In photographs, paintings and sculpture, trees, earth, cloud and rock formations, it is the *appearance only* that informs the subject with its rhythm.

Whether the subject is in motion or at rest it will have its essential peculiar rhythm, and its abstraction is one of the photographer's main tasks.

The rhythm of any image stems from what appears to be motionless and what appears to have life—what seems to be in balance or in imbalance. In brief, it is *stillness or movement, symmetry or asymmetry.* But just as in music, a rigid application of the time-beat from a metronome will not guarantee rhythm in sound, neither will a rigid application of the laws of symmetry or balance guarantee rhythm in an image.

Once again we are in an area where there is no rule, simply because every image always is:

All in the Eye of the Beholder

Initially the image finds its concept in your awareness and later in your eye. You have then to transport it into the viewer's eye and later into his awareness.

For you and your potential viewers, the law is the same: *the human eye rests on what interests and pleases it.* The bright highlight or the swift action will catch the attention, but personal interest will control how long it holds, and the human eye can assess, judge and flip literally instantaneously. But even when the eye has finally rested, the viewer will get from it *only what his powers of perception will allow to pass.* Our perceptive faculty is an extremely efficient filter, selecting and rejecting sensory messages (in this case from the eyes), according to our temperamental condition.

We see not what is there but what we can see, and at any one moment our visual perception is conditioned by our lives to that moment. All our previous sensory experiences (and particularly the visual ones), our parental background, our education, our prejudices, wishes, hopes, fears and feelings of the moment all govern what we *make* of what our eyes tell us.

The major elements that govern how we interpret sensory messages are as follows:

(a) Our personal hopes, fears and ambitions.
(b) Our previous sensory experiences.

(c) The environment of the event.
(d) The essential nature of the sensory message.

It is important in a photographer's growth that the four elements above are rearranged as much as possible so that he is accustomed to change and the changing vision that that can bring. It will also help him to create images with sensitivity and finesse and to reproduce them with flair and insight.

However, between the eyes of the photographer and the eyes of his viewer there is an intermediary: the single eye of the camera; and the eye of the camera speaks in its own language and tells its own story. It differs from the human eye in the following ways:

(a) The human head has two eyes and sees with *binocular vision* (the stereoscopic facility feeding it information about distance), while the camera head, having only one eye, is *monocular* and without stereoscopic sight.
(b) The human *eye has no effective framing device* to delineate in hard and fast terms what is seen and what is not: the eye of the camera creates its image on a *frame that is totally selective* and with hard boundaries (with any single ordinary lens, this boundary demarcation is fixed and rigid).
(c) The eye of the camera is not influenced by the *temperament of the body that contains it* as is the human eye (see above); what it senses it also 'perceives' and registers as it is.

There appears to be no way of completely overcoming the differential in (c), but those in (a) and (b) can be overcome. If you use your hands as a viewing device (see Fig. 1.15) or, better, prepare a large piece of card with a square or rectangle, to match the format of your camera, cut in the centre and view your subject through that 'viewfinder' with one eye, you will obtain an excellent impression of what your camera eye will see. By moving the card nearer or further from your eye you will be able to match the focal length of most lenses you regularly use. Until technology brings us convenient and effective devices to create or reproduce three-dimensional images, the method described should serve you well.

The composition of images, then, is made up of the following components: *line and shape; tone and texture; colour—namely, perspective and contrast in their many forms*. These components fuse into an integral whole image to create symbols of rhythm: stillness, motion, symmetry and asymmetry.

Plates 7.1–7.16 give a number of examples for you to consider and analyse.

Plate 7.1

Plate 7.2. Dynamic movement in tranquillity.

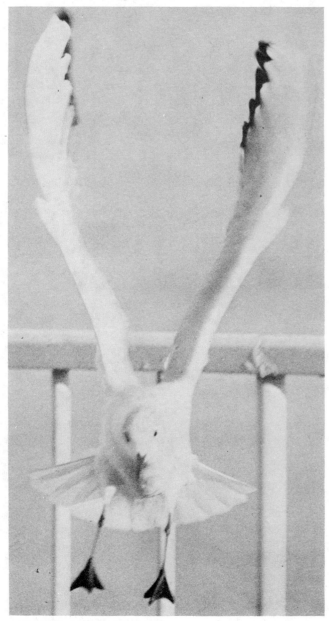

Plate 7.3. Tranquillity in dynamic movement.

Plate 7.4. Textures of flight.

Plate 7.5

Plate 7.6 Feelings of night.

Plate 7.7

Plate 7.8. Boom!

Plates 7.9 and 7.10. Fungoid frost or frozen fungi?

Plate 7.11. Two views of a tree.

Plate 7.12

Plate 7.13. Still water: still life.

Plate 7.14

Plate 7.15. Absorption.

Plate 7.16. Concentration.

The intention is that they demonstrate visually some of the choices of subject and viewpoint that the photographer commands. They are offered as examples and starting-points for your journey into composition. They have as much or as little virtue as you invest them with by moving from them with your own camera and your own eye. Scan them or study them as you please.

All aspects of composition, from creators' or critics' viewpoints, are exclusively subjective. Some critics may agree about one particular picture, but their agreement is merely coincidental to its merits as a work of art—they can be definitive only about themselves and their responses. In the final analysis, photographic composition is no more and no less than the *organisation of tones and hues to purpose and design*. This is square one for the photographer and he shares it with painters and all other graphic artists, although processes and techniques may differ. They are all striving towards the *imaginative communication of significant experience through two-dimensional impressions* and in that area, every man is by himself. You are your own most important and effective creator and critic.

CHAPTER EIGHT

THE DARKROOM

Dark or Light?

There are two main reasons for having access to a darkroom: it gives you *total control* over the pictures you want to make and it *saves money*. These advantages would appear to be massive and self-evident.

Whether you view the workroom as a darkroom or as a lightroom there is no need for it to be painted matt black, although this is a widely held belief. Provided the immediate surrounding area to the enlarger and the temporary working and permanent store for your films and papers are matt black, you will have no problem. The rest of the room can be as light and reflective as you wish. If walls and ceiling are painted in white gloss, your safe-lamp will cast an even light throughout the room —useful whether your room is large or small.

Disposing of the dark/light, black/white dilemma has taken us in at the deep end, presuming that you have or wish to have your own darkroom. A darkroom of your own has so many advantages that it must rate high in your priorities if you take a lively interest in what happens to your work after you have exposed the film. Indeed, it is impossible to approach photography as an art if the photographer does not have the proper tools to enable him to manipulate his negatives as he wishes.

The Basic Requirements

Your first aim must be to gain access to a properly laid out and equipped darkroom. Initially you may be able, and content, to use the darkroom of your school, college, society, club or friend, but the time will surely come when you will want free access, and also the freedom to leave equipment and materials in their places, knowing exactly where they are and that they will not have been moved or otherwise interfered with in your absence. To have a room exclusively set aside is a high ideal, whether it is a spare bedroom, part-garage, attic or basement, and you may not be able to achieve that ideal straightaway.

Many books and magazines claim that you can work efficiently in a built-in wardrobe or a cupboard under the stairs. Such places have the merit of easily being made light-tight and, more than probably, offering you exclusive use. There are other basic needs to be met and these are outlined below, but apart from not meeting their demands, the

134

'cupboard-under-the-stairs' syndrome seems to fail also on the following counts: it will in all probability be difficult to clear of dust; there will be little space for movement, with headroom even being cramped; it fails to reinforce the image of the technical artist/craftsman at work. Noting these points, and those mentioned below, you may decide the best way to work at home is to gain the full support of your family and share the use of the bathroom or kitchen. Those rooms may need some adaptation, but most bathrooms and kitchens contain the essentials and can therefore be used as satisfactory starting points.

The basic needs for any darkroom are:

(a) It must be light-tight.
(b) It must be well ventilated.
(c) It must have an electricity supply.
(d) It must have a water supply.
(e) It must have a waste outlet.
(f) It must have working surfaces.
(g) It must have working space.
(h) It must have an appropriate floor surface which will be resistant to water and chemicals, and will not harbour dust.

A Typical Lay-out

The way you plan the detail of your darkroom will depend upon the local conditions in whatever space you choose, but Figs. 8.1 and 8.2 give typical lay-outs.

You will notice two main features: *separation of dry and wet areas*; and a *natural 'movement' reflecting the order of processes*. The first of these helps prevent contamination of materials and therefore spoilt work. It also separates electricity from water and chemicals, which is an essential safety factor. The second provides the basis for planned work-sequences which lead to orderly routines and allow memory to help you place your hand on any needed piece of equipment without thought or delay. There is particular merit in the darkroom, in following the edict of Samuel Smiles: 'A place for everything and everything in its place.'

Equipment

There is no end to the list of equipment you can cram into your darkroom, nor to the money you could rationalise spending on it. However, most of the essential requirements are not expensive and they enable you to save a lot of money by doing the work for yourself. The most costly item is also the central one—the enlarger—and this is dealt with separately in Chapter Ten, where materials—chemicals, paper and film—are also considered in their own right.

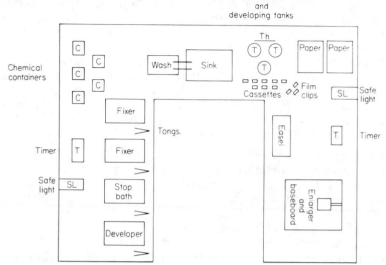

Fig. 8.1. Darkroom layout.

The following is a list of basic equipment with some notes on quantity and cost. Use it as it is intended: a checklist or starting point for your searches through the manufacturers' catalogues. Only you can tell what you really need.

Safe-lights

There are many models of safe-lights and most have universal mountings so that they can be fitted to walls, ceilings, benches, cupboard doors, etc. Most models will accept interchangeable screens or filters so that you can adapt the light source to suit the materials you are using. Price range per unit: £4–7.

(It is a sensible precaution to mount a small warning light outside the darkroom—perhaps switched together with your safe-light—in addition to the necessary lock or bolt.)

Developing Tanks

There is a large variety of developing tanks. Tanks and reels are made in plastic, nylon and stainless steel; some reels are 'self-loading'; some are daylight loading; some contain built-in thermometers; some will take one film only at a time and others more, the number depending upon the film size. Price range: £4 upwards.

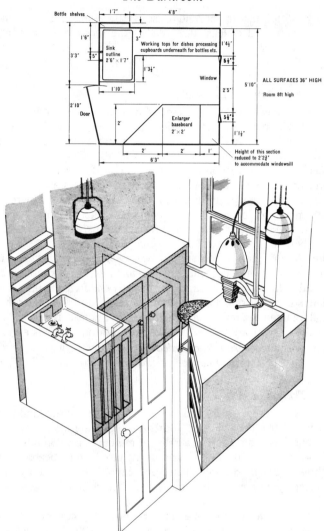

Fig. 8.2. Darkroom layout.

Dishes

Sizes vary from $3\frac{1}{2} \times 4\frac{1}{2}$ in. to 24×20 in. They are available in plastic, perspex, enamelled and stainless steel. Price range per dish: $3\frac{1}{2} \times 4\frac{1}{2}$ in., 50p–£1; 24×20 in., £7–10.

It is wise to start in the middle size (10 × 8 in. or 12 × 10 in.) and since you will need at least three dishes the following price range will apply: 10 × 8 in. (set of three), £3–15; 12 × 10 in. (set of three), £5–20.

Measures, Containers, Funnels

There are measures in the shape of cylinders, beakers and jugs, and they are made in plastic, glass and stainless steel, available in sizes that will measure from a few millilitres to over a litre. The price range is from 75p to £2.

When you come to make up your own working strength chemicals you will need some suitable well-stoppered containers and funnels. The latter cost only a few pence and the former can be provided by retrieving used chemical or domestic bleach containers, etc. You must take care not to use metal that will react with the chemicals. Stainless steel is safe, but it is best to steer quite clear of other metals.

Note: Any original labels should be *completely removed* from these containers and the new contents *clearly indicated*. If your room is shared by any other member of the family, especially children and pets, keep the containers in a separate space well out of reach, and remember that cats and children can get into what you might have considered to be inaccessible spots. If you are using a kitchen or bathroom, this is a vital precaution since *photographic chemicals in contact with food or a more sensitive part of the body can be seriously and extremely dangerous.*

Timers, Thermometers

There are interval timers and sweep-arm second timers, and there are timers to control the enlarger, with or without the intervention of the user. Your basic need is for a reliable minutes and seconds indicator and these are priced at £7–9. For anything more sophisticated than this you should consult the manufacturers' catalogues to discover exactly what meets your needs and your pocket, since prices rise sharply to over £50.

It is a good idea to have a general-purpose thermometer to give you a fairly accurate idea of the room temperature. You will need a really exact and reliable thermometer for the actual processing, especially if you are working in colour. Trying to save money here can quite clearly be a false economy.

Thermometers can be obtained with Celsius (centigrade) and Fahrenheit markings; with wide or restricted ranges (ca. 55–85°F or 60–120°F); with spirit or mercury fillings. Although you can obtain a thermometer for well under £1, it is worth buying from the £2–5 range to ensure you get an accurate, reliable and long-lasting model.

Accessories

There is a whole range of bits and pieces that may appeal to you. The most common and most often-needed are listed below. None of them needs to be expensive and most are obtainable from well below £1. They are: film-clips, film-wiper, forceps, roller/sponge/squeegee, film-washer/filter, scissors, disposable towels.

In addition to the basic requirements outlined above, as your interest and practice build up you will find you want to acquire some, if not all, of the following:

Dishwarmers, Print Dryers/Glazers

Warming of chemicals and drying of prints can be undertaken without recourse to these items, but the process is thereby longer and less convenient, especially if you are working in a room that is not centrally or otherwise easily heated. The items will not themselves necessarily improve your work, but they will make it possible for you to work more quickly and more easily. The price ranges are:

Dishwarmers: from £15 upwards.

Print Dryers: from £8 upwards. (The lower-price dryers take flat-bed glazing plates. Rotary units start at £100 and so are likely to be beyond the needs or interests of the general reader. If you have a special wish for one, you should take advice and then consult the manufacturers' brochures.)

Glazing Plates: from £3 upwards.

(The prices of dishwarmers, dryers and glazing plates are logically dictated by their capacity.)

Proof/Contact Printers, Masking Frames

The use of a proof/contact printer makes for quick and easy identification of negatives and, for 35 mm particularly, gives a quick check regarding comparative negative densities—quite a useful reference point for assessing exposure factors. The price is about £8.

There are many masking frames or easels obtainable, with paper-holding facilities to choice, from about £8.

It is, of course, possible to spend a very great deal of money equipping a darkroom. But if you make your priorities what you need (rather than what you might indulge), take your time over selecting the appropriate model, and think ahead at least twelve months, you need not spend excessively.

DEVELOPING

Since the basic principles and modus operandi for colour and black-and-white films are the same, it is sensible to start with the latter because they are less complicated in application and execution.

On the journey from initial exposure to final print we have now arrived at a stage where an image exists within the emulsion but is not yet visible or permanent. It is now time to consider how to convert that *secret* (known as *latent*) *image* into a *revealed* or *apparent* one. The conversion is called **development** and is undertaken **chemically**. If the image were merely left at that stage, however, it would soon disappear as the left-over crystals turned black with the effects of time and light. These are the crystals that represent the shadows in the original subject. They were exposed to little or no light and *must be eliminated* or they will darken the whole negative. This is done at stage two in the process by the use of a **fixer** which enables them to be dissolved away, and ensures that the image can be made permanent. Stage three brings this about by **washing** away all traces of what are then *soluble salts*, and also the *fixer itself* so that it cannot continue reacting. If the fixer were left, a state of unwanted *over-reaction* would set in and the negative would take on a *bleached and/or yellow-brown appearance*.

To summarise: the first stage is to bring the image to light as it were (although this is the last thing that must be done)—to make it visible and apparent. This is *development*. The second and third stages are to ensure that the revealed or discovered image is not lost or changed— to make it permanent and effective. These are *fixing and washing*. These stages are now considered more fully.

Development

'Development' is undoubtedly the right word for what occurs in this stage of the conversion process, since it indicates two main factors: change or growth, and degrees of change or growth.

Developers consist of four main ingredients:

(a) *The developing agent itself:* Since most agents work equally effectively on exposed and unexposed silver halides, the only useful ones are those that have a practicable differential in the *swiftness with*

which they react to exposed and unexposed halides. The art of success-
ful development comes when we are able to rescue the negative at a
time of *maximum reaction* of exposed halides and *minimum reaction*
of unexposed ones and when that difference is satisfactory in creating
an image. This is one of the reasons for exercising careful control over
time and temperature when developing.

Two generally used developing agents are Metol and hydroquinine.

(b) *Developing agents by themselves are slow to act,* requiring hours,
not minutes, to work. This time problem is overcome by adding an
alkali (generally borax, sodium carbonate or sodium hydroxide), which
accelerates the process of development. The more alkaline the added
agent (the 'accelerator') the more it will increase activity in chemical
reaction. Unfortunately, at the same time it also increases the charac-
teristic of the developing agent to oxidise when in contact with the air.
It then turns brown and loses its essential power to develop. This is
overcome by the use of the third ingredient:

(c) *Preservatives,* very often in the form of sodium sulphite, are
added to help *prevent the developing agent from oxidising,* thus enabling
it to be accelerated in its powers of development without a one-to-one
increase in deterioration.

(d) To help ensure the developing agent *works most effectively on the
exposed halides* and not the unexposed ones, a **restrainer** is added—
generally potassium bromide. This *prevents over-development,* especially
to the stage of 'fogging', taking place in spite of the best efforts of the
user.

The possible combinations of these four ingredients are obviously
endless, and some developers contain a mixture of two versions of one
ingredient to add to the variation. For example: two developing agents,
Metol and hydroquinine, are often used to complement each other in
the same solution. Metol works quickly but gives only low contrast and
density in the image, while hydroquinine works only slowly but gives
higher contrast. It is the choice of chemicals and the proportionate
quantities that give each developer its particular quality; i.e. general
purpose, fine grain or high contrast.

Control Factors

Since there is considerable control available to you by varying the
dilution of the developer, and the *time* and *temperature* of the process
(see below), you will find plenty of scope at first with a **general purpose
developer.** After some experience you will know more about the effects
you want to achieve, and that will be the time to turn to the use of **high
contrast** and **fine grain** developers. For further information in this area
you should consult the manufacturers' data sheets and specialist litera-
ture. In any case, whichever type of developer you use, the actual

quantity and quality of the image produced on your negative will be affected by the following factors:

Film Speed

Generally speaking, the *faster* the film the *longer time* it will need for *development* because of the bigger crystals and the thicker emulsion. (For example, compare the emulsion thicknesses of the following films:

Isopan IF ASA 40	10 μ
Isopan Ultra ASA 400	17 μ
Agfapan ASA 100	9 μ
Agfapan ASA 400	13 μ

(1 μ = one millionth of a metre)

Condition of Developer

This will be affected by its *concentration* or strength in *preparation* (be it initial or working) and the *number of films developed* by it. Any given quantity of developer can only chemically change a given quantity of crystals and since there is no way of determining exactly how much chemical change occurred in any one film, this is in practice best judged by the number of films treated. Overworking a developer until it is literally exhausted, is a *false economy*, since there is a real risk that the negatives may be unevenly or underdeveloped, or spoiled by impurities in the solution.

Manufacturers always supply figures well within the safety zone to indicate how much film may be processed by a given amount of developer and it is foolish to disregard them. Using commercial 'one-shot' developers or making your own stock solution and diluting each time you develop, requires you to discard the used solution and thereby prevent any such problem arising. If you are handling quantities that make this approach impracticable, you should *make a careful note each time you develop a film* or batch of films in the particular solution.

Time

The longer a solution is allowed to work on a film emulsion, the more crystals will be chemically changed and the more developed the image will become. This is to over-simplify, as will be made clear below, but only in the interests of making the point that, in the development process, *time is probably the most flexible and important single factor the photographer has at his disposal*. It is certainly usually easier to control than temperature.

If a negative has received too little or too much light at the exposure stage (and is under- or overexposed) this can be compensated to a large

degree by allowing more or less time than the norm at the development stage. This does not work on an exact one-to-one basis, since there are two elements to be considered—*contrast and density*—and they do not progress in the same way, nor is their individual rate of progress constant. The variations of build-up of contrast and density, actual and comparative, are best reflected by what is known as a *'gamma-time' curve*.

If measured dosages of light are plotted (horizontally) against the opacity (0–100 per cent) they produce in any one emulsion (vertically) the resultant tangential *slope at any point on the curve will indicate the contrast achieved*. This tangential slope is known as the *gamma (γ)* measure, and every developer has a gamma maximum that it can achieve. Its progress towards this gamma maximum with any given film emulsion is shown by a gamma-time curve. These curves are available on data-sheets from developer manufacturers. Typical curves are illustrated in Figs. 9.1–9.3.

Development times recommended by manufacturers usually refer to a gamma of 0·7–0·8 and controlled variations from this standard can be achieved by consulting their graphs. It is important to note that any *development time beyond the gamma maximum will merely produce 'fogging'* due to the development of the unexposed halides, thus reducing the effectiveness of the required image. It is also important to note the relative steepnesses of the curves and to try to *avoid a development time that ends at a steep point*, otherwise the tolerances between success and failure will be measured in seconds. Such timing is too critical for convenience. The marked difference in the steepness of the slopes, and what that means in time, can be seen by comparing the gamma-time curves of Figs. 9.1, 9.2 and 9.3.

Readers who are interested in the mathematics of processes discussed here or who wish to explore the subject further should consult specialist literature.

Temperature

The temperature norm that is almost universally accepted is 20°C. This gives comfortable working conditions and convenient processing times, and is not difficult to maintain as an ambient temperature in a darkroom.

All chemical reactions are speeded up by heat, and photographic processes are no exception. Below 15°C they *slow down appreciably* and above 25°C *they race away*—both equally inconvenient. In addition, at the higher temperature the gelatin itself becomes soft and therefore easily damaged. *Between 15°C and 25°C, time and temperature can be varied to produce an optimum process for your needs.* Time-temperature curves are produced by manufacturers to enable

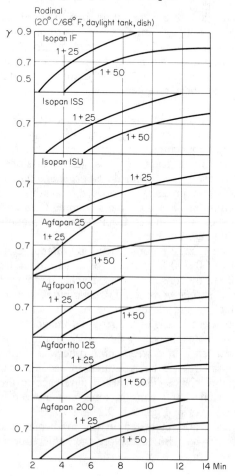

Fig. 9.1. Gamma-time curves for Rodinal.

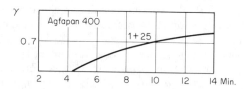

Fig. 9.2. Gamma-time curve for Rodinal.

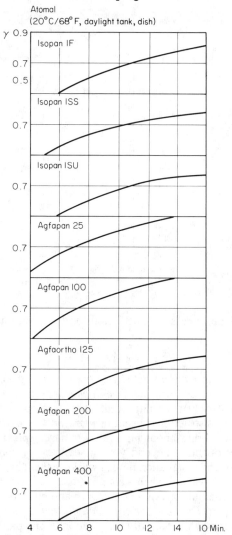

Fig. 9.3. Gamma-time curves for Atomal.

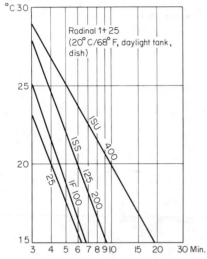

Fig. 9.4. Time-temperature curve for Rodinal (at 1 + 25 dilution).

Fig. 9.5. Time-temperature curve for Rodinal (at 1 + 50 dilution).

you to make the necessary calculations and two are illustrated in Figs. 9.4 and 9.5.

Agitation

Any increase in *physical activity of the developing solution* is accompanied by a correspondent increase in *chemical activity between it and the film emulsion.* It is important, therefore, to take note of the manufacturers' instructions, because *more or less agitation* than they recommend will bring about *more or less development* from the norm and the effect of this is beyond your assessment or control.

The recommended agitation figures will keep the solution *homogeneous* by ensuring any used-up chemicals are equally distributed. Thus, every part of the film emulsion will get a proper and equal share of the power of the developer. *The need for care in agitation is no less critical than for care in time and temperature.* Agitation is one part of the development process that engenders little enthusiasm or excitement and consequently it gets less attention than it should. The same applies to the next three stages, although they are of equal importance in the whole process.

Fixing

Having converted a previously secret and latent image into an apparent and discernible one, it is now essential to *render it permanent*

and therefore useful. What is first needed is an agent that will *leave the converted black silver untouched and remove the unconverted halides,* for it is the latter that represent the unexposed portions of the negative that will let through the light for later printing and thus create the shades and shadows. Sodium thiosulphate does precisely this, changing the unexposed silver halides in the emulsion into salts that can be conveniently taken into solution and removed by washing away.

Most negatives are fixed in 5–10 minutes and there are marketed many 'speed' versions that complete the process in 2–5 minutes. If anything, films tend to get too little rather than too much fixing and, while there is a danger of bleaching the image if the film is left in the fixer too long, it is better to err on that side, especially if your fixer has been used before. *Fixer, like developer, has only a certain amount of conversion power and will eventually become exhausted.*

When the fixer-converted salts begin to move into the solution at large they will immediately *react with any trace of developer that is left in the solution*—perhaps carried there by the film. If this should occur it may cause minute deposits of blackened silver to be spread evenly and surely over the whole emulsion surface giving rise to an unwanted 'film' on the film or skin on the surface of the emulsion. This is another example of 'fog'—this time dichroic fog. This precipitation can be *prevented by the use of a stop-bath,* and the simplest version of all is *clear water.* It gets rid of unwanted developer simply by washing the film after it comes out of the developer and before it goes into the fixer. As it eliminates the developer it also *slows down* the final but still continuing stages of development.

Although convenient and satisfactory in preventing the fixer from being contaminated by developer, *the clear water bath does not bring development to an immediate halt,* and you may wish to do this when your processing schedule is critical. In this case an acid stop-bath is used. The slowing-down only of development by rinsing or washing in clear water is particularly useful when developing prints.

Since alkalis are used to accelerate the development process, it is logical that acids will slow it down and even stop it. The acid required must act only on the developer and have no harmful side-effects. The following are both suitable: a 4 per cent solution of sodium metabisulphate or a 2 per cent acetic acid bath. The *advantages of a stop-bath* are therefore two-fold: to *arrest development* of the image exactly when wanted; and to *prevent loss of quality* through reaction in the fixer.

To ensure that the fixer permeates all the emulsion and reaches all the unconverted halides in an active state, *agitation* should be conducted in accordance with the makers' instructions.

Some fixers contain a hardening agent, very often potassium alum,

to prevent the gelatin from being damaged in the later stages of its treatment and use. Hardening agents may also be obtained separately and added to the fixer.

Washing

Having now made the image fully apparent and less unstable, the next stage is to make it *completely permanent*. If the fixed negative were left unwashed, it would tarnish or fade away due to the chemical action of the remaining salts or the effect of any air-moisture upon them. To prevent this from occurring, the negative should be *thoroughly washed for at least half an hour in clear water*. Many developing tanks have a built-in facility that will ensure the flow of water actually comes into contact with the surface of the emulsion—where it is needed—and carries away the unwanted deposits rather than leaving them to collect at the bottom of the tank.

If you have no convenient way of arranging such a water-flow, it will be more than adequate if you fill the film tank or container with clean water and change it completely every few minutes.

An *alternative* method to clear-water washing is to *clean the film chemically*. This is done by a 'hypo-eliminator' of which there are many on the market. They are efficient, fast and inexpensive, and the process is usually sandwiched between short washing periods in clear water.

A final process at the wet stage is the use of a wetting agent. The agent becomes the final bath—after the last wash—and prevents uneven drying by ensuring that all the liquid drains smoothly from the film surfaces. The treatment takes less than a minute and is a *worthwhile safeguard against drying marks*, which can be disastrous since they are almost impossible to remove even with intensive re-soaking of the film.

Drying

Drying is the final stage in the processing of the negative. *The emulsion is still highly sensitive to touch and must therefore still be handled with extreme care.* It is possible that this will be the first time you will have actually handled the developed negative, and it requires just as much delicacy of touch now as it ever did.

A film-clip should be attached to each end of the negative. It should then be placed in a *warm, dry, dust-free atmosphere* for at least an hour and a half. The negative should not be exposed to direct heat or dust-carrying air-currents. Ideally, the best place is a film-drying cabinet, but they are expensive. The centre of your darkroom may be the best compromise or you may be able to clear a tall cupboard and polish its

sides well or paint them with a gloss finish to inhibit dust and fluff collecting. Dust and fluff are the main hazards and it would be tragic and nonsensical to get to this, the final stage in processing, to find that they have dried on to or into the gelatin. Although they can on occasions be removed by assiduous and delicate re-soaking and washing, as with all the stages in processing, prevention is better than cure and involves no waste of time or effort.

Step-by-Step Summary

Processing black-and-white films—converting the transient, latent image into a permanent, visible one—is a simple technique. *It does not require extraordinary dexterity or mental skills but merely the strict application of care, cleanliness and systematic method.* You should make your first aim, therefore, the consistent production of good negatives from normal exposures made on average films processed in standard chemicals. You will then have a yardstick and a secure base from which to journey into creativity and experiment and a much better chance of making any successful, novel effects repeatable.

The following notes are a brief reminder of the equipment and materials you need and what you do with them.

Preparation

Make sure all your equipment and materials are laid out in an accessible and orderly manner. The essentials are:

(a) Equipment

Developing tank—as good as you can afford, and think ahead regarding the size and number of films you may wish to process.
Timer—interval or sweep second.
Thermometer—as good as you can afford.
Measures—3 large (600 or 1200 ml).
 1 medium (300 or 600 ml).
 1 small (50 or 100 ml).
Containers—opaque plastic or glass storage bottles for chemical solutions.
Funnel.
Film-washing devices.
Film-clips.
Temperature stabilising bath—large water container to accept the chemical storage bottles and the developing tank.

(b) Chemicals
Developer
Stop-bath.

Fixer and hardener.
Hypo-eliminator.
Wetting agent.

(c) Film Handling

The film is loaded on to its spiral and into its tank in complete darkness. Whether the film was taken from a cartridge, cassette or paper-backed roll, it will not be difficult to handle and load. The main problem may be your attitude to handling and loading in complete darkness. Do not be overcome by any psychological tension—take time and take care. Handle the film only at the edges. As an additional precaution you can wear gloves suitable for film handling. Make sure the lid of the tank is firm and secure.

(d) Temperature of Chemicals

The amount of chemicals you need will depend upon the make of the tank, and the size and number of films to be processed. Prepare the appropriate amount of each solution in their separate containers. If the ambient temperature of your darkroom is about 20°C you will have no difficulty in keeping the solutions at that temperature throughout the process and you can calculate your timings accordingly. If there is a difference of more than one or two degrees centigrade, you should bring the solutions, in their containers, to the desired temperature by running water from the hot or cold tap over the containers. Then place them in a small bath with sufficient water at that temperature to keep them stable throughout the processes. If the ambient temperature is markedly different, you will need to adjust the bath by adding cold or hot water as the temperature changes. (If the ambient temperature is considerably lower than what you need, you can make use of a dishwarmer to keep the temperature constant.) Under such temperature conditions you will also need to place the tank itself in the bath, since the temperature will change significantly in the ten minutes or so required for the processing stages. This would invalidate your calculations and result in incorrect processing.

Processing

The developer, at the appropriate temperature, is poured into the tank and the timer started. Each type of tank has its own methods and you should follow the maker's instructions to ensure:

(a) The developer gets to the film as quickly, smoothly and evenly as possible.
(b) No large air bubble is created.
(c) Any small air bubbles are removed from the film surface in the manner suggested by the makers.
(d) Agitation is properly carried out.

Approximately ten seconds before development is complete pour the developer back into its bottle or discard it, and immediately pour in

the stop-bath. Agitate according to the instructions for the tank and the solution, then pour it back into its bottle or discard it.

Pour the fixer-hardener into the tank and agitate according to the instructions for the tank and the solution for the recommended period. Pour the solution back into its bottle or discard it.

The film is now ready to be washed. If you wish to wash it in the tank with water from the tap you should use a mixing control for the hot and cold taps to ensure the water is at the same temperature as the other solutions. If this is not possible, wash the film in successive single doses of water—reducing the temperature each time by 1–2°C until it reaches that of water from the cold tap. Continue the washing process for about 30 minutes, either by running water or by changing it completely every $1\frac{1}{2}$–2 minutes.

The washing time will be considerably shortened if you use a proprietary hypo-eliminator. In this case you should follow the manufacturer's instructions.

After the final wash the film should be thoroughly treated with a proprietary wetting agent. Take care to prepare the correct dilution. An over-diluted solution will not work satisfactorily and an over-concentrated one may leave a deposit on the film.

This method of preparing the film for drying is probably to be preferred to the use of squeegees or sponges, since these, even with the most careful handling, can damage the emulsion.

Clips can now be attached to the film at the top and the bottom. The film should then be hung up to dry in a warm, dust-free atmosphere.

The last job in the darkroom is to clean up everything that has been used. This prevents deterioration and prepares for the next time.

After drying, the film should be cut into lengths for safe-keeping and filing in the transparent sleeves specially provided for this. These can be kept in folders together with contact prints for quick reference (see page 139).

As will be seen from the above, the procedure is essentially routine, and the most important factors are *care, cleanliness and systematic method*. Theoretically, if your equipment is reliable and your methods careful and exact, by this stage you will have produced:

The Ideal Negative

There is, of course, no such thing, except in dreams and books. There are, however, some characteristics your negative should have and some it should be without. Not one of them is arbitrary. They all influence the way in which you will have to manipulate your negative to create the final print you want. In effective terms, your negatives must be judged by the ease or difficulty they present when you come to print

from them. Like the camera and the lens, they are not ends in themselves, but only means to an end.

The negative image should contain a *full range of tones* reversing, on a one-to-one basis, all those in the original subject. The wider the original range, the more difficult it will have been to capture them on film, but there should still be useful, *significant detail* even in the *darkest and lightest parts.*

The image should be *crisp and clear.* This is especially important in small format negatives, since the degree of enlargement required will magnify even minor errors into totally unacceptable proportions.

Negative Faults

There are three areas in the making of the image that can give rise to characteristic negative faults. They are: *camera techniques, chemical processing* and *physical handling.*

Camera Techniques

(i) *Over-exposure* will produce too much black silver and therefore too dark a negative, whilst under-exposure will produce the opposite effect.

(ii) *Unsharp focus* can be caused by camera or subject movement at too slow a shutter speed to arrest or compensate; dust, condensation, grease or finger marks on the lens; inaccurate use of focusing or depth-of-field instruments; failures within the camera to hold the film in its correct position.

(iii) *Fog* on the image section of the negative, but not the sides, indicates a light leak in the camera or the lens.

Chemical Processing

(i) *Over-development* will produce too much black silver and therefore too dark a negative, lacking the proper density and contrast to create a good image, while underdevelopment will produce too light a negative which also fails to create a good image.

(ii) *Uneven density* in the negative, showing up as streaks or blotches of high and low density across the image, can be caused by pouring the developer too slowly into the tank; contamination of the tank or solutions; using insufficient or exhausted solutions; insufficient or incorrect agitation.

Physical Handling

(i) *Scratches and fingermarks* tell their own story: faulty handling when loading and unloading the tank. Regular thin lines along the film indicate a failure in the film transport system in the camera.

(ii) *Regular, curved, diffuse patterns* of low density indicate the film was loaded on to a damp spiral or buckled by being forced on to it.

(iii) *Fog* on the sides of the film as well on the image area indicate light leakage during loading the tank.

It will be obvious that these *faults can be prevented by a disciplined method of working*. Some of them can be cured by later treatment (for example, intensifiers and reducers to help reclaim images after incorrect exposure or development) but this always represents a wastage of time and money, and results can never be guaranteed. It is clearly better to put your efforts into creating the best negative in the initial stages, no matter how routinely boring some of this may seem at the time.

Economy and Economics of Chemicals

Photographic chemicals can be purchased as liquid concentrates or as pre-mixed powders. They can also be purchased separately and in bulk, but bulk scale and technique of operation is beyond the scope of this book.

Liquid concentrates are *easy and quick to prepare*. There is no real likelihood of error, since the only process to be undertaken by the user is one of dilution.

Prepared powders, some completely mixed and some in two or three packs, *take a little more time and care* in their preparation, but even they are not difficult. Manufacturers always provide detailed instructions for mixing, and special attention should be given to mixing the chemicals thoroughly and doing so in the proper order and at the recommended temperatures. If you *depart from the instructions you are likely to make up an unusable solution*, the chemicals having reacted in an unwanted manner to create an entirely different and useless liquid.

A combination of economy and convenience to suit your personal needs will dictate in what form and quantity you should buy your chemicals. It is *cheaper to buy large quantities*, but this is a waste if the shelf life of the solution is too short for you to use more than half you have prepared.

Factors to consider are:

(a) How many films you are likely to process in any given period for the life of a solution.
(b) How many films you are likely to process at any one time together.
(c) How many films the made up solution will yield.
(d) How long is the shelf life, in concentrated, stock or working solution.

You may decide to settle generally for making up your own stock solutions from powders and keeping small quantities of liquid concentrates for emergencies. Personal temperament and choice will significantly affect your decision (some photographers actively enjoy the

process of mixing chemicals and economy does not enter into their attitude), but *the more you are prepared to mix your own materials the less you will need to pay for them.*

The manufacturers' instructions for storage of chemicals—in whatever form—should be followed exactly. They will indicate the different 'lives' of the concentrates or made-up solutions. Before you embark on making any solutions, make sure you have enough opaque plastic or glass containers with air-tight fasteners, and a proper store cupboard for them. **Note: The safe-keeping of chemicals will ensure they neither cause nor receive injury.**

While it is probably wisest (certainly at first) to purchase proprietary materials to make up your solutions (especially the developer), some can easily be prepared from raw chemicals. For example: a 2 or 4 per cent acetic acid bath can be made up easily and cheaply and a few test papers will act as 'indicators' for its state of exhaustion. This will cost you less than a tenth of the average name brand. This is only one example and you may wish in the fullness of time and the light of experience to prepare all your own solutions, including 'experimental' developers. At this stage it will be appropriate to consult specialist literature.

Special chemicals and techniques are required for reversal processing: that is, to provide a positive transparency on black-and-white negative film. This process is outlined below. It is mentioned here to bridge the worlds of black-and-white and colour films and to reinforce the idea that, instead of being mutually exclusive as many people see them, they have much in common.

Colour

The basic working procedures for producing colour negatives are the same as for black-and-white negatives. Processing colour reversal films to produce positive colour transparencies (slides and film-strips) is also basically the same as for black and white reversal procedures.

The main difference between negative and reversal techniques is simple and basic. The negative process essentially uses the originally exposed silver halides to create an image that is at the first stage latent. The reversal process essentially uses the originally unexposed silver halides to create an image that is at first 'doubly-latent', as it were. Another way of describing it is to say that the *reversal process is a means of providing a positive replica of the subject on film and the negative process stops halfway.* Both methods depend upon the silver halides reacting to more or less light. If the subject were exclusively mid-grey, negative and reversal processes would produce exactly the same result.

The main feature of the reversal technique is that it uses a *second*

major process—usually another exposure to light—to reveal the latent positive (or reversed negative). This is undertaken during the development stage.

To obtain colour film negatives or positives three layers of emulsion are used. They are basically the same as in black-and-white films, but each layer is sensitised to relate not to all the wavelengths of white light, but to only one of the three primary colours: red, blue and green. Since silver halides when reduced to black silver will only produce black to white tonal control (from 100 per cent transparent to 100 per cent opaque) each emulsion layer in the colour film contains a colour coupler tied to dyes as follows:

blue sensitised emulsion	colour coupler for yellow
green sensitised emulsion	colour coupler for magenta
red sensitised emulsion	colour coupler for cyan

i.e. the complementary colours opposites on the colour wheel.

Through fairly complex chemical reactions the silver negative images provide dye-coupled images. The silver is then eliminated altogether, leaving only the dyes.

In the negative film not only is the image dark in tone where it will be light (the opposite) on the print; it is also in the complementary (the opposite) colour.

The key factors are:

(a) Three emulsion layers sensitised to the primary colours.
(b) Colour couplers to relate the silver halide density to the appropriate strength of the appropriate dye.
(c) Elimination of the silver (this is confusingly referred to as bleaching —it is best remembered as 'silver-bleaching').

 ... and in the case of reversal processing only:

(d) The second exposure or treatment to reduce the unexposed silver halides to black silver.

Although the basic working procedures for processing colour films are the same as for black and white, there are measures to be taken that differ, not in kind but in degree. They are as follows:

(a) Temperature control is critical to within $\frac{1}{2}°$C.
(b) Process-timing and solution-agitation are critical.
(c) **Control of chemical solutions is vital on two counts:**
 (i) **They will quickly and disastrously contaminate one another;**
 (ii) **They will cause damage to the skin very easily,** so care and cleanliness are essential, and it is a good idea to protect your

PROCESSING: CN 5

| Darkroom lighting | Total darkness or Agfa Darkroom Safelight Screen G 4 (formerly 170), 15 watt lamp in. away. |

Processing table

Baths	Code	Processing time in min.	Temperature in ° C	Working capacity, films per litre	Useful life of fresh baths
1. Agfacolor Film Developer S	NPS I	8 [1]	20 ± 0.2	6	6 weeks
2. Agfacolor Intermediate Bath [2]	NZW	4 [3]	20 ± 0.5	6	6 weeks
3. Thorough wash	—	14	14 — 20	—	—
4. Agfacolor Bleaching Bath [4]	N II	6	20 ± 0.5	6	3 months
5. Wash	—	6	14 — 20	—	—
6. Agfacolor Fixing Bath	N III	6	18 — 20	6	3 months
7. Final wash	—	10	14 — 20	—	—
8. Agepon Bath (1 + 200)	—	1	14 — 20	10	—

Notes:

[1] The development time may be varied between 7 and 9 minutes, depending on the result of sensitometric tests.

[2] To achieve uniform results 30 ml Film Developer S must be added to each litre of Agfacolor Intermediate Bath.

[3] If necessary the time given in the intermediate bath may be varied between 3 and 5 minutes for adjustment to the number of cycles and cycle time of frame type processing machines.

[4] As the masks form in the bleaching bath care should be taken to see that the processing time and temperature of the original bleaching bath are maintained exactly (at 20° C ± 0.5).

Only original Agfacolor processing baths should be used for development and replenishment of this film.

| Prints | The best prints and enlargements are obtained from CNS negatives by using Agfacolor Paper MCN 111 (colour album prints) or Agfacolor Positive Film M (colour transparencies). Both materials are specially adjusted to CNS negatives by their increased sensitivity to blue and green (see appropriate data sheets). |

Fig. 9.6. Processing table.

skin (rubber gloves are essential); clothes (an apron or overall is sensible); working surfaces—including the sink (frequent washing down is desirable); family and pets (keep the chemical solutions locked away).

Even more than with black and white films, care, cleanliness and systematic method will pay rich dividends.

The processing tables above for Agfa CNS colour negative film and Agfa CT18 colour reversal film summarise the stages of the processes and indicate the time and temperature controls required.

PROCESSING: CT18

Development	Films are developed by the Agfacolor reversal processing stations whose addresses are included in the film cartons. The cost of processing roll, miniature and PAK films is included in the price of the film but **not** in the case of 70 mm wide bulk film. No reimbursement of these costs can be made if films are user-processed.
Mounting	In Agfacolor service frames. Mounting included in the price of the film: in the case of CT 18 miniature films suitably marked on the carton (see above) and CT-PAK. Mounting on request (in return for vouchers): in the case of 35 mm miniature and Rapid films 24 × 36, 24 × 24 and 18 × 24 mm transparencies on sending in a special voucher obtainable from photographic dealers.
User processing	The following chemicals are necessary: First developer (code CU I) Stop bath (code CU II) Colour developer (code CU III) Bleaching bath (code CU V) Fixing bath (code CU VI)

Fig. 9.7. Processing table.

Kodak colour film processing chemicals Process 22 for Kodacolor-X use six different chemical solutions in ten steps taking 53 minutes. Kodak 'Ektachrome' process E4 for Ektachrome X and High Speed Ektachrome use nine different chemical solutions in fourteen steps taking 54 minutes.

The main advantages of processing your own colour films are that you get the films completed when you want them and you can exercise as much local control as you wish in terms of quality and creativity. Once you have mastered the basic skills—and they appear much more difficult than they really are—you will soon want to move on to experiment. The opportunities for interchanging films and processes, varying the development stages, changing the colour of the light you use for the second exposure of reversal films, and working with infrared colour film, are endless.

Processing table

Bath	Code	Processing time (in minutes)	Processing temperature (in °C)	Working capacity per litre
		Processing in the dark		
1. First developer	CU I	17—19 (see note)*	20 ± 0.5	6 films 135-36 7 films 120
2. Wash	—	brief rinse	14 — 20	—
3. Stop bath	CU II	4	18 — 20	12 films 135-36 14 films 120
		Processing in white light		
4. Wash	—	10	14 — 20	—
5. Second exposure		1 min. on each side (500 watt lamp 40 in. away)		
6. Colour developer	CU III	14	20 ± 0.5	6 films 135-36 7 films 120
7. Wash	—	20	14 — 20	—
8. Bleaching bath	CU V	5	18 — 20	12 films 135-36 14 films 120
9. Wash	—	5	14 — 20	—
10. Fixing bath	CU VI	5	18 — 20	12 films 135-36 14 films 120
11. Final wash	—	10	14 — 20	—
12. Agepon bath	—	1	14 — 20	—
		Total processing time: 92-94 min.		

* Note: As exhaustion of the developer solutions proceeds the time given in the first developer should be increased by a given length; this depends not only on the number of films already developed but also on the age of the developer and the working method adopted by the user; it is not therefore possible to give generally applicable particulars. The CU I and CU III developer solutions should be used up within 3 days of being used for the first time.

It is advisable to develop exposed films or send them in for development as soon as possible after exposure, since any lengthy storage of the latent image can disturb the colour balance, particularly under unfavourable climatic conditions.

Fig. 9.8. Processing table (continued).

Colour photography is still young and there is ample scope for experiment. Once you have established a pattern that will give you consistently good images, you will be free to vary and distort your colours at will, not only in the processing of the film but also in the creation of the final print.

PRINTING

It was stressed earlier that the camera, the lens and even the processed negative are not ends in themselves but only means to an end—stages on the journey towards the end-product. We are now ready to consider the creation of the end-product itself: actually making the final print.

There are two basic methods in black and white. Both require the use of a light-sensitive material, and while there are many forms in which this can be presented, we shall consider the best-known one: *a silver halide emulsion spread evenly on to a paper base.* This photographic printing paper is then treated in the same way as the negative was: exposed to an image, developed, fixed, washed and dried. The two methods of exposing the emulsion to light are **contact printing** and **projection printing**.

Contact Printing

In this method the negative is *placed on the surface of the paper*, in direct contact with it, emulsion to emulsion. The technique does *not allow any selectivity* over printing only part of a negative and creates a *final picture that is the same size as the negative.* With small format negatives this restricts their use to proofing and filing for reference.

This can, however, be useful. If a set of these negatives is proofed on to one piece of paper (generally 10 × 8 in.) the prints will provide a quick and easy guide for later identification, and if you always use the same exposure and processing techniques they will also próvide a *comparative guide* to the effective density and contrast of the negative. This can be convenient when it comes to the stage of selective enlargement. Any such inspection must be undertaken with the aid of a magnifying glass if the format is $2\frac{1}{4} \times 2\frac{1}{4}$ in. (6 × 6 cm) or less, since the naked eye will not be able to detect minor flaws that could become major by enlargement.

Projection Printing

In this method, the negative is *lit from behind and its image projected* through a lens on to the emulsion side of the printing paper. The technique is similar to that used for the projection of slides, except that most printing is done with the enlarger shining down. There is no longer

the restriction of the final print being the one-to-one reproduction of the size of the negative, and it is possible to *select specific portions only* of the negative for printing. In fact, the projected image can be larger or smaller than the original, but most readers will be interested mainly in enlargement, and that is what we now turn to.

The Enlarger

The enlarger and its lens are key features in the last stages of creating a picture. The main components are:

The Head

The head houses the following:

(a) *A light source*, which should be a photographic lamp since its filament will stand much switching on and off and its bulb does not carry the printed information to be found on domestic bulbs; the latter would seriously interfere with the clarity of the image, if not indeed print clearly on to the paper.

(b) A system of securing the light rays from the lamp evenly and efficiently on to the negative. This is achieved by:

(i) *A diffuser*. This spreads the light evenly but there are two limiting characteristics: considerable light is wasted and exposure times are consequently lengthened; the diffusion itself makes critically sharp images and dramatically strong contrasts almost impossible to achieve, but equally does not draw attention to minor blemishes such as dust spots and tiny scratches.

(ii) *Condenser lenses*. These gather the light to focus it evenly and efficiently on to the negative, and they too have limiting characteristics: they produce crisp images and high contrast but accentuate failings in the negative. They bring out the best and the worst to a marked degree.

(iii) *Combined diffuser-condenser*. A logical attempt to reach optimum performance by compromise.

(c) *A negative carrier* to ensure that the negative is held still and flat in its proper position. This may consist of a glass sandwich or an open frame. The former must be kept scrupulously clean and especially free from grease and dust. Some enlargers have masks built into the negative carriers to enable the image to be exactly framed so that the possibilities of flare and reflected light on the paper are reduced to a minimum.

(d) A *lens* to organise the light rays to throw an image on to the printing paper and a *diaphragm* to control the amount of light passing through. Lenses can usually be purchased as separate items. Your lens should match the size of the negative format you are using: approx. 50 mm for 35 mm film and 75 mm for $2\frac{1}{4} \times 2\frac{1}{4}$ in. and so on.

(e) A *focusing control* for the lens.

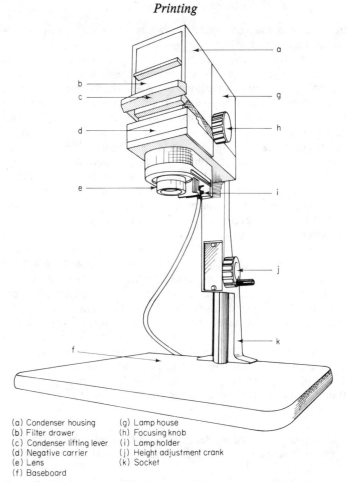

(a) Condenser housing (g) Lamp house
(b) Filter drawer (h) Focusing knob
(c) Condenser lifting lever (i) Lamp holder
(d) Negative carrier (j) Height adjustment crank
(e) Lens (k) Socket
(f) Baseboard

Fig. 10.1. Durst M 301 enlarger.

The Baseboard and Supporting Column

The board provides a secure base for the whole unit and it goes without saying that it must be *absolutely stable*. The slightest possibillity of movement will inevitably spoil your chances of getting the print you want. Most boards are white and will provide a useful surface to accept the projected image for early preparatory work.

The supporting column is attached firmly to the baseboard and carries the enlarger head so that it can be in the vertical plane to provide

control over the size (not focus) of the image. Fig. 10.1 illustrates the typical features of an enlarger.

When you come to purchase an enlarger it is sensible to think ahead. Even if you are at the time apparently dedicated only to black and white photography in 35 mm format, it will be less costly to ensure that your initial enlarger will accept filters for colour printing (or even take a colour head with fitted filters) and negatives up to $2\frac{1}{4} \times 2\frac{1}{4}$ in. Amendments or part-exchanges at a later stage can waste a lot of money.

As with cameras, the lens is a crucial feature, but, differently, requires tolerances that are critical only in the restricted distance ranges of negative to lens to baseboard. The main requirement is that they shall give an image in one plane that is sharp over the whole area, and do so when the lens-to-image distance is much greater than that of lens to subject. This is the reverse of what most cameras are required to do, except when taking extreme close-ups.

You should choose a lens for your enlarger that is as good as or a little better than the lens you use with your camera. You will not be able to put more contrast and detail into the print than the camera lens has put into the negative, no matter how much you pay, but by not paying enough you will certainly be able to take them out.

You can pay as little as £10 for a lens and under £30 for an enlarger, but you will probably find you need to spend about twice those amounts to obtain satisfying and reliable instruments; that is, if you buy new. Since enlargers can cost up to £1,000 and lenses up to £100, there is plenty of scope for expenditure. There is also plenty of choice of equipment and no need to spend much in excess of £75.

Paper

One of the most striking features about photographic papers is the wide range of sizes, surface textures and tints, and contrast grades that are available.

Sizes are straightforward and self-descriptive. These are the usually obtainable sizes:

$2\frac{1}{2} \times 3\frac{1}{2}$ in., $3\frac{1}{2} \times 4\frac{1}{2}$ in., $3\frac{1}{2} \times 5\frac{1}{2}$ in., $4\frac{3}{4} \times 6\frac{1}{2}$ in., 8×10 in., 10×12 in., 12×15 in., 12×16 in., 16×20 in.

Papers come in two *thicknesses* only and are designated by *weight*: Single Weight (SW) and Double Weight (DW).

Contact (or chloride) papers are slow to react to light but quick to react to the developer. They usually contain an agent to provide a blue-black finish instead of what would naturally be a brown-black one. *Bromide* papers are faster in their reaction to light but slower in their reaction to the developer; they give a neutral-black finish. *Chloro-bromide* papers, as might be expected from their name, come between

the first two, but are closer to the latter in speed and to the former in its natural brown-black finish.

Papers can be obtained with *bases* 'coloured' white, ivory or cream. Other base treatments are available for various specialist effects: emulsion coated linen and plastic (for making table mats and lamp-shades, etc.); colour bases—blue, green, orange, yellow, red; fluorescent dayglo colours—lime, peach, pink, primrose; metal tinted—green, pink, silver, gold. You should know exactly what effect you want to obtain from these materials, since the vehicle can easily become *dominant* and the message lost.

Paper *textures* come in a large variety: smooth glossy, smooth lustre, velvet lustre, fine lustre, silk, etc. They are usually identified by manu-facturers' code letters. *If you want clean, clear prints that give you maximum detail and contrast, use white, glossy bromide paper*, and use their performance as your norm. Use the other textures and colours to obtain effects that diverge from the norm when you have a special need. If you use any other paper than white, glossy bromide as your regular choice, you will never have a really effective yardstick for your technical success or failure.

Papers also come in a range of emulsions that give different *contrasts*; just as in the negative, they will be high, medium and low. By tradition, contrast grades are numbered and the higher the number the higher the contrast. Most papers are available in six grades. The purpose behind the grading is to allow you the maximum control when it comes to print making. You can exercise this control on two counts: to achieve *creative effects* from any negative and to *compensate* for negative failings.

If you have a high-contrast negative you will be able to make a normal-contrast print by using low-contrast paper (a low number grade, generally referred to as soft) and if you have a low-contrast negative you will be able to make a normal-contrast print by using a high-contrast paper (a high number grade, generally referred to as hard). The main attraction of the different contrast grades should not be their compensating facility (though being able to make 'normal' prints should be your first aim, in order to set a standard for your achievement) but the local control they offer you in making uniquely expressive prints.

When you order paper remember to specify clearly the following information: *size, weight, emulsion, colour, texture, and contrast.*

Chemicals

You need the same types of agents for processing papers as for negatives, i.e. developer, stop-bath, fixer, hypo-eliminator. The steps are also similar: develop, stop, fix, wash, dry. The major difference is

that you generally work with a safe-light and actually see what is happening to the emulsion at every stage after the first few seconds in the developer.

The size of the paper and its lack of sensitivity to the safe-light mean that the chemical processes from development onwards can be carried out in flat, open dishes.

Paper developers are available to create neutral-brown-black (warm) or neutral-blue-black (cold) tones. Most can be used in two strengths, the weaker being an 'economy' solution requiring longer development times. Developing solutions can be made up from liquid concentrates or powders, and, as with negative developers, it is cheaper to make up large quantities from powder if you have the turnover to justify it, since the active life of working and stock solutions is limited.

There are universal developers available and, as their name implies, they are suitable for negative and paper processing. They are convenient and satisfactory, but do not offer the flexibility and local control of the specialised developers. Paper manufacturers supply full recommendations for developing and you should consult these before purchasing processing materials. Needless to say, manufacturers' recommendations relate to their own make of chemicals.

You can use the same fixer-type for papers as for negatives, but the usually recommended solution is more diluted.

A standard stop-bath of 2 per cent acetic acid is satisfactory after development and a 1 per cent solution of sodium carbonate (soda solution) or other hypo-eliminator will facilitate washing.

Some of the equipment needed for paper printing is the same as for film processing. The important items are:

Enlarger and lens
Timer and thermometer
Safe-light
Dishes (four): 8 × 10 in. or larger
Tongs
Washing devices or facilities
Chemical solutions
Printing paper and printing easel

Print Quality

Just as the final quality of the negative was influenced by a number of quite different factors in its preparation, so is that of the finished print. The main stages and processes are strategically common (provision of sensible image, creation of latent image in emulsion, image realisation and preservation) but there are tactical variations, and these

are considered below. *The main factors influencing the quality of the final print are as follows:*

(a) Reliability and performance of equipment, especially the enlarger and lens.
(b) Enlarger manipulation.
(c) Type of emulsion and paper.
(d) Exposure techniques.
(e) Processing techniques
(f) Negative quality;

(a) and (b) may be equated with the camera; (c) with the film; (d) and (e) are common; and (f) with the subject. You have less choice over the subject at the printing stage (only a certain number of negatives) and even less control over what you can do with it. There are one or two techniques that will enable you to achieve maximum performance from any given negatives, as described below.

Techniques with the Negative

The first essential is to ensure that the negative is free from marks, scratches, dust and any other foreign body. Ideally, negatives should always be in such a condition, but there is frequently a need for last-minute attention, if not indeed rescue, and it is at this stage that the weakest link in 35 mm work manifests itself: the small size of the negative format. Untouched faults will present themselves on the final print like the obtrusive nastinesses of avenging Furies, and the curing of these faults on the negative calls for delicacy, dexterity, patience and concentration. Blocking out the negative to achieve translucency in certain parts or masking for opacity is hardly possible due to the sheer physical limitations of size.

Pinholes of light and similar sized specks of dust or dirt within the emulsion can be covered or removed at this stage, but only by the most delicate surgery on larger negatives. Dust on the surface of the film, however, can be removed by a fine camel-hair brush (the same as you use for your lens) and the static charge on the film, which actually attracts dust particles, can be eliminated by the use of an appropriate anti-static cloth. This can also be used to remove water stains, grease-marks and fingerprints. *Special care should be taken not to damage the surface of the emulsion or the film, and many photographers refrain from using such cloths because of this danger.*

These steps should be seen as rescues only and never part of your normal approach. It is worth the effort to prevent the faults occurring in the first place. Once the negative is prepared we are ready to move on to the skills of enlarging and printing. There are two main stages: *exposing* and *processing*.

Exposing

1. The first step is to *arrange all your equipment and materials in their places*. You should adopt the same procedures as for negative processing, especially with regard to temperature control.

2. The second step is to place the *negative in the carrier* and the printing *easel on the baseboard*. The negative should be placed *emulsion face down* or the image will be projected laterally *reversed*—an effect you may wish to use from time to time, but not accidentally. Then move the *head of the enlarger up and down* its vertical support column until the *image is the right size*. Finally *focus* the image at *full aperture* when it is at its brightest and *most critical*. If you wish, you can use a magnifying or focusing device at this stage. During this process you should also arrange the printing easel to include only the selected section of the image, since it will not be often that you will wish to enlarge the whole of the negative (see Chapter Eleven).

3. The third step is to determine *how long an exposure is needed* for the particular image you have chosen. This will be affected by the *density of the negative* and the *degree of enlargement* (the distance of the lens from the printing paper). The darker the negative and the greater the degree of enlargement, the longer exposure will be needed for any chosen f stop aperture setting on the enlarger lens.

This step contains a number of separate stages:

(a) In the dark, or by the light of the safe-lamp (check that it is appropriate for the paper you are using), *make a test-strip* about $1\frac{1}{2}$ in. wide from the printing paper batch you are using. Place the test-strip in the printing easel where it will receive a typical cross-section of tonal values. If your enlarger has a built-in red filter, this will facilitate the positioning of the strip.

(b) Give parts of the paper *ascending or descending steps of exposure*. You can start by covering all the strip, but (say) 1 in., with a piece of black card and exposing it for (say) two seconds. Each inch is then exposed separately but in addition for the same time until the whole strip has been exposed. If you were using 10×8 in. paper the test-strip would have been exposed for the following times: 2, 4, 6, 8, 10, 12, 14, 16 seconds (and 18 and 20 if you use the longer side). It is just as possible to work the other way and cover the strip an inch at a time for each two seconds exposure. A safe and reliable method of working is to move the black card only when the enlarger lamp is switched off. This means a lot of switching on and off but it does ensure that each step is exposed for exactly two seconds and is separated from its neighbours by clear, regular lines. If you leave the lamp on all the time and merely move the card at the two second interval, there are more possibilities of error.

There are other methods:

You may prefer to give three exposures only, using $2\frac{1}{2}$–$3\frac{1}{2}$ in. steps with 10×8 in. at 5, 10 and 15 seconds. This gives you a larger area to examine and this is certainly advantageous, but it also means you will have to expose the final print by guesswork (obviously unsatisfactory) unless one of the exposures gives you the right result, or to make a second test-strip within the narrower margins indicated by the first one. Typical strips can be seen in Plates 10.1 and 10.2.

Alternatively, you may wish to obtain one of the proprietary enlarging exposure scales consisting of 'step-wedges' of different transparent densities. They are placed over a test-piece of printing paper and a single exposure is given. When developed, the images carry next to them their appropriate timings. Whichever method you choose, the essential factors are to be accurate in your timings and to expose the strip to a typically wide range of tones. The results of this test come to light in the next step:

Developing

4. The fourth step is to *develop the test strip*. It is absolutely vital that this test-strip should be processed in exactly the same way that

Plate 10.1. Test strip.

Plate 10.2. Test strip.

you will process the final print. Development will be easy and efficient if you:

(a) Arrange for the *ambient temperature* in the darkroom to be a constant 20°C. You will then be able to keep your developing times quite regular.

(b) Ensure your processing dishes are at *least half-filled* with solution. You will then be able to keep the papers fully immersed in the solution without difficulty.

(c) Always handle the paper at an *edge* and use a *separate pair of tongs* for each dish and so prevent confusion and contamination.

(d) Develop the print for a *little more time* than that recommended by the developer manufacturers. You will then reap the benefit of getting full-bodied tones where they should be and know that you are getting from the print all that the exposure put into it.

(e) Take particular care to immerse the print *quickly and evenly* beneath the surface of the solution. Keep the emulsion side up to help prevent air bubbles. (You may wish to insert the paper emulsion side down to counteract the tendency of the print to curl. If you do this it needs to be turned over soon after immersion and you may find this an unnecessary step.)

(f) *Agitate* the dish *gently* during the development period.

(g) *Do not* try to compensate for incorrect exposure during develop-

ment, but make another print and *learn from the full development of the original.*

(h) *Do not* try to handle *too many prints at any one time* in the dish before you are ready for more than one at a time. Learn the routine first. It takes a little skill to ensure each print gets its exact development and correct agitation.

(i) *Do not* allow yourself to be misled by the appearance of the print in the developer or the fixer, especially by the light of the safe-lamp. *Always wait to judge your prints after the full time and in a bright light.*

Fixing and Washing

At the end of the developing time use the developing tongs to take the print from the dish, hold it by one corner and let any surplus solution fall back into the dish. Then drop it gently into the stop-bath and agitate gently for 15–20 seconds.

Remove the print from the stop-bath using the appropriate tongs and let it drain. Then drop it gently into the fixer.

The final print will need to be fixed for 5–10 minutes (follow the makers' notes) and agitated from time to time. Two fixing dishes side by side enable you to use them for half the time each. The first will be exhausted first and can be replaced by the second. The first is then renewed. This will provide a thoroughly efficient and economic method.

Your test print will be adequately fixed for inspection after 1–2 minutes. You can, if you are impatient, put on normal lighting after 15–20 seconds.

The final print will need to be washed, with hypo-eliminator if you prefer, for 20–60 minutes—and no harm comes with more. Ensure the washing is efficient.

The test print merely needs a quick water-rinse, so that you can blot it without contaminating the blotting paper. After this, you should examine it in a bright light and select the exposure time that gives you the print you want. If all the steps are too dark or too light you will need to re-expose. You should use the same times as before, but adjust the aperture one *f* stop up or down. You will soon find you are able to judge the approximate exposure time needed for the image that appears on the printing easel. It is only on the first few occasions that you might be right out of range.

The final print will need to be completely fixed and washed, as already mentioned. It will also need to be dried. Prints cannot be just left to dry because they will then curl unpleasantly. If you have a print dryer the task is easy and quick. Without one, you should let the excess water drip from the print and then place it between sheets of photographic blotting paper with a heavy book, larger than the print, on top.

Glazing

If you wish to glaze your final print you will almost certainly need a *flat bed dryer and a glazing plate*. The techniques for cold glazing are rather tricky.

Glazing is a method of rendering a *high gloss surface finish* to the print, usually by soaking it in a proprietary glazing agent and then drying it in close contact with a smooth surface such as stainless steel or glass. The wet prints are placed face down on the glazing sheet and a roller is used to remove the excess moisture and also to ensure full adhesion between the emulsion surface and the glazing sheet. The sheet and print are then placed on the dryer. Close and secure contact of all three are ensured by drawing a tension cloth over them.

Considerable mystique surrounds the craft of glazing. Some authorities recommend that no additional agent should be used to wet the print while others recommend a few drops of household washing up liquid. Some suggest a drying time twice that laid down by others. In fact, the process is simple but needs care and attention. It is best for you to discover the method that suits you.

Glossy papers are naturally suited to glazing and normally are the only type used. Matt papers, with an intermediary varnish, can be glazed, but the process works against the essential quality and purpose of the matt finish so the procedure is frustrating and the end-product seldom satisfying or satisfactory. If you remember that the technique depends upon the *plastic quality of the wet gelatine*, and the *gloss smooth finish* of a well-used and therefore *fully, gelatin-matured glazing plate*, you should soon find a convenient style. The gloss finish can usually be improved by a second glazing, when the print has become physically stable after its expansion and contraction (after the wetting and drying processes), from development onwards.

Kodak Veribrom paper—in medium-weight and with a resin coating (RC)—curls less at all stages in processing and requires no additional glazing since the glaze is built into the paper during manufacture, and appears automatically during drying.

Mounting

The print is now ready to be mounted. This is usually done on to thick card. The simplest process is known as '*dry-mounting*' and consists of placing a sheet of shellac-impregnated tissue between print and card, and heating the sandwich gently until the shellac melts and binds the two together. All that is needed is a *domestic iron and a delicate touch*. (There are mounting presses available, but they are expensive and not needed until you have a considerable turnover of large mounted prints.) The technique is simple and full instructions

come with the easily purchased dry-mounting tissues. The main *faults* to avoid are *uneven heat and pressure*; *insufficient or excessive heat*; and *moisture, grit or dust* between the layers: once more—merely care, cleanliness and systematic method.

Another simple method of mounting is to use one of the many proprietary brands of *rubber adhesives* that are currently available. They do not provide the same bonded-looking finish but have the merit of being easy, quick, efficient and requiring no equipment at all. The aesthetics of presenting the finished print are considered in Chapter Twelve.

In spite of all the care and concentration you might have put into all the processes, the final print may still need some remedial attention. This is now considered.

Finishing

Enlargements are sometimes marred by the presence of small black and white spots caused by particles of dust and dirt interfering with the process, somewhere between camera and printing paper. (Undoubtedly, dust is the photographer's worst enemy!)

White spots can be removed by the application of a re-touching medium—dye or water colour pigment in the appropriate warm (brown) or cold (blue) black tone. A thin applicating brush and delicate touch are essential and many photographers find it best to build up the camouflage either by a series of tiny dots that gradually cover up the offending white patch or use a well diluted medium that requires a number of layers to reach the right density. The procedure is not difficult, and practice of the right kind will soon bring its rewards.

Black spots can be treated by carefully removing them with a knife or razor blade or using the procedure mentioned above but with a white medium.

(*Note*: A re-touching pencil will often give satisfactory treatment to white spots on matt surfaces. Knifing is quite inappropriate for glossy prints.)

Print faults

The ideal print is even more difficult to define than the ideal negative. There are, however, certain characteristics your print should not carry:

(a) *Unsharp edges* to the picture where the print is held by the easel, caused by the framing devices not being firm, secure and tight enough.

(b) *Black and white spots and hair lines*, caused by dirt, dust and fluff in the enlarger, on the negative or on the paper.

(c) *Unsharp focus* of the picture (general or local), caused by inaccurate

lens control; the negative not being flat in its carrier; condensation or grease on the glass parts of the enlarger.

(d) *Double images*, caused by movement of the enlarger or printing easel.

(e) *Coarse black and white straight lines*, caused by rough physical handling of the paper with consequent damage to the emulsion, during exposure or processing.

(f) A *blotchy appearance*, caused by insufficient or uneven development.

(g) *Finger marks*: they tell their own story!

Techniques with the Enlarger

When a printing paper is exposed to the image from a negative, the developed picture, although mainly satisfactory, may contain some small areas that are not satisfactorily reproduced by the procedure indicated by the test-strip. They are either too light or too dark. (A typical example is eye detail that gets lost by printing in too dark.) Exposing the whole of the print in an attempt to correct these local areas would lead to deterioration in what was previously mainly satisfactory. The remedies for these isolated areas are techniques known as *shading (or dodging) and burning in.* If the contrasting areas are larger than local (and a typical example here is a landscape with sky or sea areas that give no detail) a different technique is employed; it is called masking.

Shading

In this technique you *hold back some of the light from the area that would otherwise print up too dark* and with insufficient detail. There are many devices you can use. Parts of your fingers and hands are satisfactory if the shading needs to be done at an edge. If it is isolated from the edges you need to use a thin wire holder that will not affect the parts it reaches over. Clipped on to the end of the holder you can use a small piece of black or white card (white will show the image and this may be of help to you), or a red filter (this will allow the image through but it will not affect the emulsion, and this may be of help). It is important to *keep the card or filter and wireholder moving* or they will cause noticeable lines of demarcation on the finished print.

Burning in

In this technique you *hold back some of the light from the rest of the print to adjust an area that would otherwise print up too light* and with insufficient detail. Here it is much more practical to use your fingers and hands since you wish to expose only a small area, and there is the additional advantage that your hands are almost completely flexible in creating the needed shapes for masking. Cards and filters can also be

used in this technique. They now need a hole in the centre and a wire-holder is not essential. The reflective and transparent merits of white card and red filter still obtain.

Masking

In this technique you *hold back some of the light from one or even two larger areas by placing a mask on the printing paper itself.* If the areas are separated by noticeably clear and definite lines (as in rooftops against a sky) the mask will need to be kept steady (absolutely still, in fact) during exposure. If the delineation is less critical, the mask may and probably should, be moved slightly. In either case the mask itself should be an exact replica, and one of the most efficient ways of obtaining this is to cut the masks from a previously exposed (perhaps test) same-size enlargement.

To ensure the best results from shading, burning or masking, it is wisest to make exhaustive *tests for exposure times*—relating to each of the *parts that requires separate treatment.* This ensures that any element of guesswork is completely removed. There are creative aspects to masking as well (some known as printing in or overprinting) and these are considered in Chapter Eleven.

All the principles considered so far have been applied to black-and-white printing but they also apply generally to colour work. As with the negative, the strategy is roughly the same, but there are some differences in tactics. These are now considered.

Colour Printing

With regard to the equipment required, there is little more you need than for black and white.

A major addition, needed to compensate external variables rather than to perform an integral function in colour printing, is a *voltage regulator.* This is usually necessary since domestic electricity supplies vary in voltage from time to time, and a change in a few volts will affect the colour of the light from the enlarger lamp, and therefore the overall colour tone of the final print. There is little point in spending a great deal of time and some money on making sure you have the correct film properly exposed, and projected by the enlarger through a set of filters that will have taken a lot of your concentration, only to have the end-product spoiled by voltage fluctuation. Since colour chemicals and paper are not inexpensive, it is worth investing the £10 or so in a voltage regulator to prevent such a misfortune.

The other main additional requirements are devices to provide exact *control over the colour gradations* on the final print. If you use the *additive system* you will need the *three filters of the primary colours* only. (If your enlarger does not have a built-in heat absorbing glass,

you will need to fit one, since heat will soon damage the colour filters. You may also need regularly to use ultra-violet or infra-red filters to balance the light from your enlarger lamp. Controlled use of exposing and processing techniques will tell you whether you are getting consistently obtrusive colour casts from an excess of these wavelengths.) If you use the *subtractive system* you will need a *set of filters in the complementary colours*. They are obtainable separately or in packs, to provide different densities of each colour. They offer a density contrast ratio of up to 20:1 and in some cases 40:1.

It is possible to purchase colour heads with the filters built in. All you need to do is dial the setting you require for a particular density. They are very convenient but cost upwards of £15 and much more if a transformer is attached.

Colour papers can of course be processed in *standard dishes* but this requires the use of a lot of solution and working for considerable periods in the dark. Methods that use *light-tight drums* and only *small* amounts of solutions for each stage in the processing overcome both of these drawbacks. The *special calculating devices* that accompany some of these drum processes enable you to assess exposure times and colour filtrations from only *one test exposure* and they make colour printing even easier and less expensive. In fact, the methods are so straightforward and simple that it is possible for a person with no previous experience of printing (or even photography) to go into the darkroom and make a successful colour print at the first attempt.

Additive Colour Printing

The essence of this technique is to give three separate exposures through each of the primary filters. The desired effect is achieved by varying the time allowed for each filter. The method is simple and flexible but has a major drawback: it is essential that there should be no movement of the enlarger head, lens, paper or easel during the three exposures. Since the lamp must be switched on and off three times and there will be four filter movements during the period concerned (the first insertion and the last withdrawal are not relevant), the need for exactitude and discipline is critical.

The processing of the exposed papers is the same as for the alternative, subtractive method.

Subtractive Colour Printing

The essence of this technique is to give *one exposure only through a combined pack of complementary colour filters*. (These colours have already been referred to in negative printing and are: cyan, magenta and yellow. It may be helpful at this stage to recall that they are also 'minus red', 'minus green' and 'minus blue' respectively, since they are

the colours left when the individual primary is removed from white light.) The desired effect is achieved by varying the *density* of each colour.

Each filter carries an identification denoting its *density*, e.g. 05, 10, 20, 30, etc., and the appropriate density can be produced by using one or more filters.

Whichever system is used, the basic procedures are the same as for black and white, but, as with negatives, there are measures to be taken that differ, not all that much in kind—although there are additional steps as with colour negatives—but in degree. For example:

(a) Exposure timing and voltage control are critical.
(b) Temperature control is critical to $\frac{1}{2}$°C.
(c) Process-timing and agitation are critical.
(d) *Control of chemical solutions is vital on two counts*:
 (i) *They will quickly and disastrously contaminate one another.*
 (ii) *They will cause damage to the skin very easily, so care and cleanliness are essential*, and it is a good idea to protect your skin (rubber gloves are essential); clothes (an apron or overall is sensible); working surfaces, including the sink (frequent washing down is desirable); family and pets (keep the chemical solutions locked away).

Even more than with black-and-white work, care, cleanliness and systematic method will pay rich dividends.

Colour papers contain *silver halides with couplers to create dyes.* Colour and black-and-white images are developed in the emulsion at the same time, and the black-and-white silver image is removed by bleaching. This leaves only the colour dye. The blue sensitive layer contains yellow couplers; the green the magenta; and the red the cyan. As in negative film the process is complicated, the couplers combining with the products of oxidation to make the dyes.

Whereas in black-and-white printing the major emphasis was on *density control* (from full black to full white), in colour printing this must be shared with an equal ranking emphasis on *colour gradation*. *Density* factors are controlled by *exposure*. *Colour* gradations are controlled by *filtration*. It is the latter that presents the most frequent topic for controversy in colour photography discussions.

The technical causes are straightforward, as the chart on page 176 shows:

Colour to be removed	Colour filter used
Yellow	Yellow
Magenta	Magenta
Cyan	Cyan
Blue	Magenta + cyan
Green	Yellow + cyan
Red	Yellow + magenta

The personal, subjective effects of those causes are not quite so straightforward. Many books and articles in magazines refer to the phenomenon of the subjective (often referred to as 'corrective') manner in which the eye sees, and it is true that a study of the psychology of perception will provide much food for thought. (For example, it is possible for a subject to wear goggles that will reverse his world laterally or vertically and within weeks he can re-adjust to a working vision of the world. It is not at this level of appreciation that the controversy arises.) Examples that are frequently used are: a girl sitting with her face near green grass; a man with a white shirt standing next to a red wall; a white wall at sunset. It is claimed that the human eye subjectively corrects the colours (so that the flesh is seen as flesh colour and the white wall and shirt are seen as white), and the camera-to-print process presents the colours objectively. This is not quite the case as it overlooks two important factors:

The average human eye is too often used at a level well below its real capabilities; it looks without seeing, and failure to note the phenomenon of the colour changes referred to is caused, not only by the uncontrollable whim or comparative inefficiency of the seeing system itself, but also by the user's careless attitude to the visual world.

In the examples quoted, the human eye is observing the colours in their full context; they are not abstracted and framed against a comparative control—but when the human eye looks at a colour print it is seeing it abstracted and framed against objects and lights that may well be antipathetic and certainly offer assertive comparisons.

If you experiment with various colour-cast combinations by projecting coloured images (perhaps from an ordinary slide projector) hugely on to a white wall, and position yourself so that you see nothing but the image and it completely fills your angle of vision, you will soon gain a full understanding of the root phenomenon underpinning any controversy.

By the same token, if you take a colour print and exclude everything but that print from your vision, you will be able to assess accurately whether you are seeing a girl with a green-cast face or adjusting to see 'natural' face-flesh tones. It is all in the eye of the beholder. *It is all in your head and with concentration and application you can learn to look*

so that you see with insight and awareness and not merely react with careless, cliché responses.

If the protagonists of the corrective school of thought were right in their judgments, every man would automatically correct the made-up lips of girls seen in discotheque lighting, to some variation of red. Most girls pay attention to their make-up and they know that men see their lips as black when they are lit by a blue light and they have the sense to take note.

Photographers have the responsibility of looking in order to see (to illuminate not camouflage) and also of helping others to see with clearer and more relevant vision. When this occurs much of the apparent subjective/objective dichotomy about 'seeing colour' disappears and the real issues are noted accordingly.

The major factors affecting the appearance of colour on the final print are:

(a) Colour temperatures during exposure:
 (i) Through the camera lens.
 (ii) Through the enlarger lens.
These will be affected by the temperature of the light sources and the performance of the lenses.

(b) Constitution and condition of the paper emulsion.
(c) Constitution and condition of the chemical solutions.
(d) Under or over exposure of the negative and/or print.
(e) Processing procedures as outlined on pages 155–158.

Since it is essential to follow the makers' instructions when making up the chemicals and processing the papers, there is little place in this book for a detailed analysis of what occurs. It is important, however, to draw attention to the different methods of making test and other prints. The choices are outlined below and the manufacturers' notes speak for themselves. The first two methods use time-honoured techniques and multiple exposures. The third is comparatively new and less orthodox.

Multiple Exposures

No additional device is needed for this method and it follows the techniques described for black-and-white printing, but exploring ranges for both density and colour.

In their excellent brochure 'Developing, Printing and Enlarging in black and white and colour' (Second Edition), Kodak outline the technique for additive printing as follows:

Kodak—Additive Method

Filters

You will need three 50 × 50 mm gelatine filters. These are:
Kodak 'Wratten' Filter No. 25 (red); Kodak 'Wratten' Filter No. 98 (blue);
Kodak 'Wratten' Filter No. 99 (green).
Before using the filters stick adhesive tape along both sides of one edge. When
in use always hold the filter by this edge. Make notches in this edge for identi-
fication in the dark.

Adapting your enlarger for colour printing

The additive method of colour printing requires that the filters be used
underneath the enlarger lens. It is possible to hold each filter in position, but
doing this leaves only one hand to cope with the timer and exposure testing.
If you have no assistance you can make a filter holder for your enlarger.

Making a filter holder out of stiff card

(a) This measurement should equal the diameter of
 your enlarger lens
(b) Spacers–two narrow strips of cardboard
(c) This measurement should be the width of a filter (50 mm)
(d) Filter

Fig. 10.2. Do-it-yourself filter holder.

Making the first test print

Select a colour negative that contains a reasonable area of flesh tone or some
other area of familiar colour. Put the negative in the enlarger (make sure
that there is no dust on the negative, the negative carrier or the enlarging lens).

Adjust the enlarger to give an 8 × 10 in. print from your negative. Focus
accurately.

Adjust the masking frame for a print size of approximately 3½ inches square.
Select the most representative part of the picture (an area with a single colour
of uniform density is best) and position the masking frame accordingly.

Use black card to mask the other parts of the picture area. Do this in
addition to using the adjustable masks in your enlarger (if there are any) to
avoid fogging the rest of the paper.

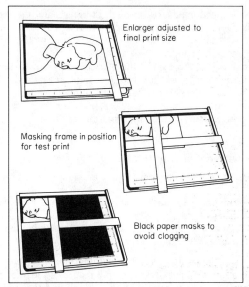

Fig. 10.3. Use of the printing easel.

If you have a 75 watt bulb in your enlarger, set the lens to $f/4$. If the bulb has a higher wattage set the lens to $f/8$. (These lens settings are only a guide, the degree of enlargement, the negative itself and the enlarging system all affect the printing exposure and therefore your choice of lens setting.)

Arrange the filters on the baseboard so that you can find the blue filter in the dark. (If you have a clock-watcher helping, get him to hold the blue filter for you when it is not in use.) Set the timer for 10 seconds, turn on the safelamp and turn off the room lights.

Remove a sheet of 'Ektacolor' 37 RC Paper from the packet. Fold it horizontally and then tear it in half to make two sheets, 5 × 8 in. (Ultimately, you will have two sets of test prints on this 5 × 8 in. sheet.) Return one half to the packet and put the other under the masking frame.

You are now ready to expose. Using each filter in turn give a single exposure through the blue filter and stepped exposures in opposite directions through the green and red filters (do not move the colour paper until you have made exposures through each of the three filters).

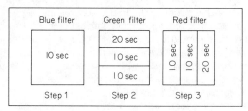

Fig. 10.4. Stepped exposures using filters.

To make the stepped exposures through the green and the red filters, cover one third of the picture area after 10 seconds and two thirds of the picture area after a further 10 seconds. The actual exposure times received by these steps will be 10, 20 and 40 seconds.

Turn the colour paper to expose the second test. Give 15 seconds through the blue filter (don't forget to reset the timer) and repeat steps 2 and 3.

Each of these test prints will contain nine different exposure combinations. Since your tests cover a picture area of fairly uniform colour, the actual orientation of the exposure combinations is unimportant.

Examining the test print after processing

(1) If it is lacking in density (pale in colour)—repeat the procedure opening the lens one stop.

(2) If it is too dense (very dark in colour)—repeat the procedure closing the lens one or even two stops.

(3) If it is lacking in yellow—make two more tests with the same green and red exposure but with 20 seconds and 25 seconds through the blue filter.

Note. This testing procedure is not something you will have to follow every time you make a colour print. If you keep a record of the filter exposure times for different types of subject and lighting you will find that these records will be a reliable basis for future colour printing.

Selecting the correct exposure times

One of the two colour grids in your test print should be fairly near the correct colour balance. To help you identify the grids write the correct exposure information on the print. You'll find the easiest way of writing on the print is with a fountain pen or a Chinagraph pencil.

Bear in mind the colour changes that result from an increase in exposure through each of the three filters:

(1) Increasing the exposure through the blue filter produces an increase in yellow dye in the print.

(2) Increasing the exposure through the green filter produces an increase in magenta dye in the print.

(3) Increasing the exposure through the red filter produces an increase in cyan dye in the print.

When you have written on the grids you will be able to tell immediately the filter exposure times that produce the best colour balance.

When the correct balance appears to fall between two squares an intermediate exposure time should be given. For example, if on the test made with 15 seconds through the blue filter, the correct colour balance appeared to be half way between the squares made with 10 seconds green plus 10 seconds red and 20 seconds green plus 20 seconds red, the final correct exposure would be 15 seconds through each of the three filters.

If it appears that the overall density needs to be increased or decreased, all three exposures need to be altered proportionally. You may be able to check

the visual appearance of a 50 per cent increase or decrease in exposure by looking at one of the other squares.

For example, if 20 seconds blue plus 20 seconds green plus 20 seconds red appears too dense but correct in colour balance, you can see the effect of a 50 per cent decrease in exposure by looking at the density in the area made with 10 seconds blue plus 10 seconds green plus 10 seconds red. If this is too light then the exposure time should be 15 seconds through each of the filters which is a decrease of 25 per cent in the original exposure. Conversely, if the original square has received too little exposure you will need to increase the three exposures by 25 or 50 per cent.

Making the final print

Once you have decided the correct exposure times you are ready to make the final print. You will need to remove the card masks from the masking frame and set it for the full print area. Check that the picture is still sharp (resetting the lens if you have opened up for re-focusing). Expose and process the print.

This print should show a fairly satisfactory balance of colour. If you feel that the colour balance needs adjusting slightly then you can increase or decrease the exposure through one of the filters by about 20 per cent without any significant alteration to the density. The table below will help you to decide the necessary alteration.

Note: It is important that you make accurate exposures through each of the three filters. If you do not it will be very difficult to work out reliable exposure ratios.

Colour correction

Print shows excess of	*Cause*	*Alteration to exposure times*
Cyan (and is lacking in red)	Excess exposure in red layer Excess cyan dye	Reduce exposure through red filter
Magenta (and is lacking in green)	Excess exposure in green layer Excess magenta dye	Reduce exposure through green filter
Yellow (and is lacking in blue)	Excess exposure in blue layer Excess yellow dye	Reduce exposure through blue filter
Red (and is lacking in cyan)	Not enough exposure in red layer Excess magenta and yellow dye	Increase exposure through red filter
Green (and is lacking in magenta)	Not enough exposure in green layer Excess cyan and yellow dye	Increase exposure through green filter
Blue (and is lacking in yellow)	Not enough exposure in blue layer Excess cyan and magenta dye	Increase exposure through blue filter

Agfa—Subtractive Method

In their excellent book *Agfacolor User Processing—The negative–positive process*, Agfa outline the technique for subtractive printing as follows:

Exposing the first test strip

The negative from which a print is to be made should be placed in the enlarger and the required enlargement scale set. In order to determine the exposure needed, which will of course be governed by the enlarger itself and the scale of enlargement chosen, arrange a test strip of paper in the masking frame. If a set of Agfacolor gelatine filters is later used for filtering, the two cover glasses should be inserted in position in the filter drawer. The 10 per cent increase in the exposure necessary for each sheet of glass is then embodied in the basic exposure. The first test strips should then be exposed at different intervals of time. This is done by covering the test strip with black cardboard so that only a strip about $\frac{3}{4}$ in. wide remains, and then giving an exposure of, say, 2 seconds. Afterwards the cardboard should be moved another $\frac{3}{4}$ in. and a further exposure of 2 seconds given.

This is repeated until about six strips have been exposed, after which the correct exposure can usually be picked out.

Colour casts

In order to obtain the impression of correct colours in a print these must be reproduced in certain proportions, i.e. integration to grey must be achieved. Deviation from colour balance—referred to in photography as a colour cast—is noticeable over the entire surface of the print, that is to say one or two of the three emulsion layers have formed more dye than the others. From this it is possible to establish the following filtering rules which, once one is familiar with them, allow colour casts to be corrected without difficulty.

Filter Rule 1

A colour cast is removed by a filter of the same colour.

If a magenta cast is involved you will have to insert a magenta filter in the enlarger. In the event of a yellow cast a yellow filter would be used and a cyan filter for a cyan cast. The following system has been adopted for designating the various filter combinations: Under the subtractive filtering method the three filter colours are used in the strict sequence yellow, magenta and cyan. It is in this order too that the filter combination is noted, the filter colour not used being denoted in each case by a line. Accordingly, a filter combination of 20 yellow and 40 magenta density units would be described in the following way: 20 40 —. Similarly, a filter combination of 10 magenta and 20 cyan density units would be written as — 10 20.

From this the second filter rule can be derived.

Filter Rule 2

Colours not included in the filter pack are obtained by combining two filters of different colours.

All colours of the spectrum can be produced with two filter colours. Con-

versely, all colour casts can also be removed with one filter or combinations of two filters. According to the law on subtractive colour mixing only one third of the spectrum is absorbed by each of the yellow, magenta and cyan filters.

If all three filters are combined with each other the logical conclusion is that the entire spectrum must be absorbed. This means that a combination of all three filter colours would add up to a neutral density value which would simply cause an increase in the exposure. This brings us to another filtering rule.

Filter Rule 3

Every combination of three colour filters contains a neutral density value that does not exercise any filtering effect and must be subtracted from the total density of the filter combination.

This neutral density is always represented by the smallest density occurring in the combination of three filters—the density 20 in the example in question. The number 20 must therefore be subtracted from each of the density values for the yellow, magenta and cyan filters:

Combined filter densities:	30	60	20
Neutral density:	20	20	20
Final density combination:	10	40	—

Another example:

Combined filter densities:	15	50	30
Neutral density:	15	15	15
Final density combination:	—	35	15

The question is now which filter densities must be used to eliminate a colour cast? That will depend on the extent of the colour cast and, the stronger it is, the more density or colour the filter must have. This brings us to the next filter rule.

Filter Rule 4

The stronger the colour cast, the denser the filter.

In addition to determining the nature of a colour cast (red, magenta or blue cast) it is, of course, also necessary to ascertain its extent. With strong colour casts it is very difficult to make an on-the-spot assessment of the correct filter density. For this reason it is always advisable to carry out three filter tests. You should first estimate the correct filter combination and, proceeding on this basis, make two or three test exposures with 10 filter density units less or, with very marked colour casts, 20 filter density units less. Afterwards make another two or three test strips with higher filter densities. With these lower and higher values it is usually possible to narrow down the correct filter

combination so well that the colour cast can be removed completely when the next print is made. At all events it should be noted that a filter density which is too low will still reduce the same colour cast in the next strip, even if it is not as strong. If, on the other hand, the filter density chosen was too high, the original colour cast will not only be eliminated but also over-corrected and reproduced as a cast in the complementary colour. A print with a neutral balance can always be obtained by increasing or decreasing the filter density.

The action of a filter is such that, according to its density, it will always absorb part of the white printing light. Since filtering is not intended to alter the overall brightness of our print, the total exposure must be prolonged according to the filter density used or should be suitably shortened if the filter density is reduced. The final filtering rule is therefore as follows.

Filter Rule 5

Filters increase the exposure according to their colour density.

How, then, can this increase in exposure be determined? This is really quite a simple matter if use is made of the tables (in the Agfacolor book on pages 93–101). These tables include numbers for the various filter colours and filter densities which have to be multiplied by the best exposure obtained from your initial series of unfiltered test strips in order to compensate for the loss of light caused by the filters. The tables are arranged so that you can read off the correct exposure increase factor immediately for any filter combination occurring in practice. This applies both to individual colours such as magenta, and to combinations of two filter colours such as yellow and magenta.

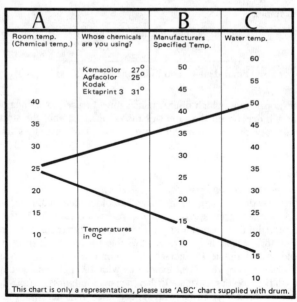

Fig. 10.5. Simmard A-B-C Temperature Guide.

The following table summarises the procedure again from the first test strips to the finished print.

	Filter correction	*Exposure*	*Result*
1st operation	Without filters (zero print)	Various exposures	Test strips of varying density; one strip with best exposure. Colour casts usually in all.
2nd operation (test strips)	Several filter corrections according to colour and intensity of colour cast in the test strips from the 1st operation	Exposure (based on test zero print exposure) corrected according to filters used	All test strips of correct density; colour cast reduced to varying extent. Colours of one strip very nearly or completely correct.
3rd operation (full size print, further test strips only if deviating greatly from neutral value)	Filter combination again corrected from colour cast of best test strip from 2nd operation	Exposure (based on best zero print exposure) corrected according to filters used	Final print of correct density balance; further operation only necessary in special cases.

Single Exposures

Both the methods described above use more than one exposure to create a test strip. The following method is different in a number of ways, not the least important of which is that it uses a single exposure only to make the test.

By the use of one of the proprietary devices currently available, it is possible to arrive at exposure times and filter factors from one test exposure only. One of the most convenient, effective and reliable methods is provided by the Simma-color calculator systems: FS1 for additive printing and FS2 for subtractive. Prints produced by these methods (and also many of those made by those just described) will usually be processed in the light-tight drums that accompany the devices. It seems sensible, therefore, to consider the techniques of exposure/filtration-calculating and drum-processing together. This is how the manufacturers describe the use of the Simma-color processing drum and the Simma-dot subtractive (FS2) filter/exposure calculator.

The Simma-color Process

Simmard Drum Processing, as opposed to tray or open surface methods, permits all development of colour prints in full room light once the print has been exposed and loaded into the drum. Chemicals and rinses are poured in and out of the light-tight spout. Temperatures and time periods are given by the manufacturer of the chemicals you have selected or you may follow the easier-to-use Simmard 'A–B–C' Temperature Guide (see Fig. 10.5). All popular makes of chemicals and papers may be used in Simmard Drum Processors. Paper sizes range from 16 × 20 in. (40 × 50 cm) down to 4 × 5 in. (9 × 12 cm).

Preparation

First, establish the correct developing temperature for your chemicals and water. We recommend the use of the Simmard 'A–B–C' Temperature Guide which permits heating water only while using chemicals at ambient temperature (check chemical temperature). Bring water to exact 'A–B–C' temperature in a plastic pail reservoir (use a good colour thermometer). Pour the required amounts of chemicals into clearly marked beakers. Make sure your working surface is level and, preferably non-slippery—a rubber pad is ideal. Be sure drum is clean and dry with appropriate paper holders in position desired.

Expose and Load

Once exposure has been made, roll the print, emulsion side inwards, and insert into open drum using guide rails for position. Place the end cap on the drum firmly. From this point on you may work with the room lights turned on.

Processing the Print

To pre-heat the drum and pre-wet the print inside, stand the drum on end in the sink and fill with water you have prepared in pail. Let stand for sixty seconds, then drain into sink. Now stand drum on its flat feet and pour the developer into the spout. The chemical will enter a trough at the bottom of the drum so that no processing begins until you turn it on its back.

Set your photo timer, then roll drum from side to side at about half second each way, letting the feet act as stoppers. Follow directions carefully allowing ten seconds to drain and reload at each step.

Processing temperature 27°C (81°F) for line B on Simma-color chart with Photax Kemacolor Processing Solutions:

1. Pre-soaking/warming	1	min*	Follow ABC chart
2. Developing	1½	min	Ambient temperature
3. Rinse	30	sec	
	or 2 × 15	sec	
4. Bleach/Fix	3	min	Ambient temperature
5. Final rinse	4 × 30	sec	Minimum four rinses with reserve water
6. Stabiliser	Minimum 30	sec	Do not rinse before drying or glazing

* These times allow the 10 seconds necessary to empty a Simma-color tank.

For purposes of comparison the following chart is given here for Agfacolor procedures:

Processing of Agfacolor Paper MCN/Type 7
(20°C and 25°C processes)

Agfacolor bath	Code	20°C process (min)	(°C)	25°C process (min)	(°C)
Paper developer 60	PaI/60	5	$20 \pm 0 \cdot 5$	3	$25 \pm 0 \cdot 3$
First wash*	—	$2\frac{1}{2}$	14–20	$1\frac{1}{4}$	14–20
Stop-fix bath K	PPaII/K	5	18–20	$1\frac{1}{4}$	18–25
Bleach-fix bath K	PPaIII/K	5	18–20	$3\frac{1}{2}$	23–25
Final wash	—	10	14–20	$5\frac{1}{4}$	14–20
Stabilising bath †	PaVIS	$2\frac{1}{2}$–5 †	18–20	$1\frac{3}{4}$	18–25
Total processing time		30		17	

* The first wash is a part of the processing proper and must therefore be kept as consistent as possible with regard to time and temperature. The temperature of the water can be chosen freely within the stated temperature range according to the results of sensitometric tests (a higher water temperature results in more intense subsequent development, and vice versa). Once the temperature of the water has been adjusted it must be maintained to an accuracy of \pm 1°C.

† An addition of 6 ml formalin (40 per cent) per litre stabilising bath is necessary to harden prints and stabilise the colours when glazing on rotary dryers (emulsion facing the drum). Prints should not be washed again after treatment in the stabilising bath.

Inspection: Type B Papers

You may safely remove the end cap after a short rinse at the end of the bleach step for inspection of the print. If you have made any mistakes or wish to alter your exposure or correct filtration, you need not finish processing the print. If satisfied, replace the print and end cap and continue to end of process. Clean the drum before developing next print to avoid any possible contamination.

Inspection: Type A Papers

You may clear the bluish cast from wet print by bathing it in Kodak Rapid Fixer concentrate (undiluted, without hardener solution). After the Hardener Fixing Bath squeegee off excess solution and agitate the print in Rapid Fixer for one minute at 73 to 77°F. Evaluate the colour balance, then complete the remaining processing steps as usual. If print is to be kept, double the wash time immediately following.

Simma-Dot Procedure to make Test Print

Set the enlarger to focus sharply at 8 × 10 in. size. Set apertures according to negative size (f 5·6 for 35 mm; f 8 for $2\frac{1}{4} \times 2\frac{1}{4}$ in.; f 11 for $2\frac{1}{4} \times 3\frac{1}{4}$ in.; and f 16 for 4 × 5 in.). Set timer according to negative density (20 seconds for a thin negative; 30 seconds for a normal well exposed negative; and 40 seconds if your negative is dense). Switch off the enlarger. Swing diffuser under the lens. Place 4 × 5 in. piece of colour paper in the centre of the

image area. Place Simma-Dot Calculator on top of it. Expose, then develop print in the usual manner in your Simma-Color Processing Drum. When fully developed carefully remove the print for evaluation.

Read the Simma-Dot test print

There are three columns of figures associated with the Simma-Dot test print, as follows:

Thin + 1f	Normal + 1f	Dense + 1f
16	24	32
13	20	26·5
11	16	21
8	12	16
6·5	10	13
5	8	10·5
4	6	8
− 1f	− 1f	− 1f

The centre column is the indicator column. You read the first number to become visible in the column having stepped densities. Then read immediately left if your negative is 'thin', or right if your negative is 'dense', or stay in the centre if negative is 'normal'. The numeral which you read in the appropriate column represents the corrected exposure time to be given your undiffused, unfiltered final print. If your print requires colour filtration, you simply multiply this basic exposure time by the filter factor of any filters added. *Example*: You have a thin negative. You expose it for 20 seconds through the diffuser and Simma-Dot Calculator. The developed test print shows the figure 12 as the first numeral to become visible in the centre, indicator column. You read the number to the left, which is 8. Your thin negative therefore requires an exposure of 8 seconds to give a well-exposed, undiffused colour print. Colour correction is the next step.

Next, look at the 88 coloured dots on the Test Print. Select the one grey dot. Check your selection with the supplied Grey Comparator Card. Now, find the identical spot on the Dot Chart (Fig. 10.6). Inside the circle will be the filters required to correctly balance your negative and equipment. Just outside of the circle you will see the correct filter-factor for these filters. Add the required filters to the UV filter already in your filter drawer, then calculate your exposure time by multiplying the filter factor by the original Test Time to find your final Print Time. Remove diffuser and expose final print.

Only Simma-Color CP filters are calibrated precisely to the chart. They are available in 3 ×3 in., 6 × 6 in., 7 × 7 cm and 12 × 12 cm sizes.

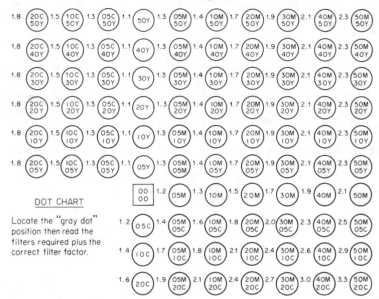

DOT CHART

Locate the "gray dot" position then read the filters required plus the correct filter factor.

Fig. 10.6. Simma-Dot Chart.

Possible exceptions and what to do

* *If the centre column of figures shows all of the figures?* You have mis-judged the density of your negative and have over-exposed. Re-expose in the adjacent column or close 1 *f* stop.

* *If the centre column has no figures visible?* You have under-exposed. Open 1 *f* stop and re-expose at the original exposure time or add ten seconds to the original exposure time.

* *If the numbers appear to be OK but there is no grey dot?* This means you have a predominance of one colour in your negative. Correct this as follows: Look at the one square dot and judge its colour by eye. If it appears moderately magenta, add a ·30 or ·40 Magenta filter to your filter drawer, multiply your original exposure time by the filter factors and re-expose. Since you are compensating for the change in density you should continue to read under the original columns, i.e. read in *thin* column if negative is thin, etc.

* *If the Test Print has a good grey dot but the final print is off colour?* This can be caused by 'subject failure' such as in a close-up shot of a red flower with no other balancing colour, or a shot of a small white dog on a large green lawn, etc. Decide which colour is in excess and add a filter of the same colour and approximate density, multiply the exposure time by the filter's factor and re-expose.

* *If your filter pack requires all three filter colours?* Eliminate the lowest common figure: e.g. a ·10M ·20C and ·30Y should be reduced to ·10C and ·20Y by removing ·10 from each. Always use the minimum number of filters.

* *If you require filter density beyond the ·50 limit shown on our Dot Chart?*

For a ·90 filtration, simply multiply the known factors of a ·40 and ·50 together.

Don't forget

* Every filter must be accounted for. If you add a filter, multiply its factor by the existing time. If you subtract a filter, divide by its factor.

* Aperture sizes given for the various sizes of negatives are essentially averages since there is an infinite variety of characteristics of lenses, lights, etc., adding their effect. Your first few Tests should tell you whether you are average or need to allow a little more or less exposure when using your equipment. Record the difference in exposure time for all future calculations.

* As the lens is moved closer to the paper (to make smaller prints, etc.) the light intensity will increase. To compensate, simply close the aperture as indicated on the chart (see Fig. 10.7). Each unit of distance requires a change of $\frac{1}{2} f$ stop.

$\frac{1}{2}$ f. increments

60.0"	1525 cm
52.5	1335
46.0	1170
40.0	1020
35.0	895
31.0	785
27.0	690
23.5	600
20.5	530
18.0	460
16.0	405
14.0	355
12.5	310
11.0	275
9.5	240
8.3	210
7.3	185
6.3	160
5.5	140

Fig. 10.7. $\frac{1}{2} f$ increment chart.

* To avoid a diffused 'hot spot' problem when calculating exposure, make Simma-Dot Tests at 8 × 10 in. focus. If final print is 5 × 7 in. close aperture one f stop. If final print is 4 × 5 in., close 2 f stops.

* The initial negative-density exposure times given (20, 30 and 40 seconds) are calculated for papers such as Agfa, Kodak, GAF and Fuji which are relatively fast. Other papers may require one f stop larger apertures at those times.

* To remove any excess colour from your print, change filters as follows:

If excess colour is	either add	or subtract
Yellow	Yellow	Cyan and magenta (blue)
Red	Yellow and Magenta	Cyan
Green	Yellow and cyan	Magenta
Blue	Cyan and magenta	Yellow
Cyan	Cyan	Yellow and magenta (red)
Magenta	Magenta	Yellow and cyan (green)

Whether you use the additive or subtractive method, and process your prints in a light-tight drum or open dishes, there are still so many variables in equipment, materials and aesthetics that the only way to achieve real progress is to *practise the necessary disciplines and exactitudes until you can regularly produce consistent results.* Then you will have a secure basis (that will save you endless frustrations and a lot of time) on which to create, express and communicate your unique vision of the world of colour that we all inhabit.

Summary

There are two basic methods of printing: by contact for same-size reproduction; and by projection for enlargement or, less often, reduction. The enlarger is the key instrument and consists of:

A head: with light source, diffuser and/or condenser, negative carrier, lens and focusing device;

A baseboard: to provide a secure base for the whole unit and also a printing platform;

A column: to support the head and provide vertical movement for it above the baseboard.

Enlargers are available for various negative sizes (the larger ones accepting adaptors or providing masks for smaller formats) and some have colour capability.

Printing papers are available in many sizes from $2\frac{1}{2} \times 3\frac{1}{2}$ in. upwards, usually rectangular, in single or double weight, and with emulsions to give neutral, blue or brown-black images. The usual paper-base colours are white, ivory and cream, but many other base colours and materials can be obtained. Textures vary from smooth to coarse and finishes from gloss to matt. Contrast grades are low, medium and high in up to six categories. The points to remember are: size, weight, emulsion, colour, texture and contrast.

The basic process of printing follows this pattern: expose, develop, stop, fix, wash/clean, dry.

The basic equipment needed is: paper, easel, chemical solutions, enlarger, timer, thermometer, safe-light, dishes, and washing facilities.

The basic steps are: preparation of materials, framing and focusing the image, gauging the exposure (f number setting and duration) by test-strip(s), exposing, processing.

Glazing and mounting are aids to the final presentation of the print. The former is least expensively carried out by a flat-bed glazing sheet/plate, and the latter by 'dry-mounting'. Finishing eliminates any small black and/or white spots caused by dust and must be undertaken with the greatest delicacy.

Shading, burning-in and masking allow local control over image rendition during the exposure of the paper.

Colour printing requires the addition of a voltage regulator. A set of colour filters, built in to the enlarger head or separate, is also needed, whether for additive (multi-exposure) or subtractive (single exposure or 'white-light') printing. Tests must be made not only (as in black and white) to gauge the exposure, but also to assess the colour filtration needed.

SOME SPECIAL EFFECTS

The main aim of this chapter is not to offer you a catalogue of detailed techniques that will instruct you in how to obtain certain effects, but broadly to outline some approaches that are not all entirely common and so tempt you to create your own goals and your own method of scoring.

Treat the following notes as starters only. *Select, reject, amend, pursue or ignore them as you wish.* They are no more and no less than square one on your own journeys of exploration, experiment and fulfilment.

Form and Content

There is always a two-way movement between form and content. Some pundits will claim that you must have something to say (photographically) before you can consider how you wish or ought to say it. The truth is, as usual, less simple:

Some subjects (or things to be said—content) can be presented in many forms, and there is never a definitive best but merely a best choice at a given time in a given set of cirumstances for a particular photographer.

By consistently exploring and immersing yourself in a given form (say, to over-simplify, shooting with multi-image filters or printing for tone separation) you may well find that certain subjects will not only suggest themselves as suitable vehicles, but may, as you apply yourself to the mastery of the given form, achieve a necessity in your mind.

Style

Style shows itself in the relationship between form and content, and this relationship can harmonise or conflict. In some proportions, harmony will be right and proper, completely sympathetic and supportive. When the harmonising relationship is taken near to its extremes, it becomes in danger of gliding into the superficial and cliché. Equally, conflict can be right and proper, exposing singularities and incongruities. When the conflicting relationship is taken near to its extremes, it becomes in danger of lurching into lunatic imbalance. The photographer's statement about the human condition should reveal whether he sees

people and their environment as a unity that exists only in his mind; externally existing—as at one and in a unity; diverse but in a unity; or totally external, alienated and disparate; or, indeed, any combination or permutation of them all at the same or at different times. *His choice of form and content and his manipulation of their relationship will sum up his statement and his vision.*

It is hoped the following starters will invite you to explore the many facets that *your statement of vision* contains.

Selective Enlargement

One of the most powerful and flexible of the 'special effects' available to the photographer—who is by this stage in the process more of a printer, directly concerned with making rather than taking a picture—is what is known as **cropping.** The word generally means reaping a full yield or cutting off, and it is the latter that is usually meant to apply in photography. The former is, in actual fact, more appropriate since the idea of cutting off or keeping out suggests an emphasis upon negative aspects or rejection, and it is the *constructive, positive aspects of selective enlargement* that enable the photographer to reap the optimum impact from his negative. The emphasis should be upon the positive inclusion of what you want and not the negative exclusion of what you do not—that should not have found its way on to the negative in the first place. *Selective enlargement is essentially creative and expressive,* not remedial or therapeutic.

By selective enlargement you can create one or many prints from one negative and an excellent way of training your eye (and coming to grips with the kind of photographs you want to make and therefore the kind of camera and lenses you need and want to settle with) is to concentrate on gaining the maximum variations from, say, a dozen negatives.

Shape and Contrast

When you combine the possibilities of the degree of selective enlargement with the arrangement of the image within the printing frame and the contrast grade of the paper, the possibilities from just a few negatives become almost endless. There is no reason why the final print should assume the same vertical/horizontal relationship to the format as it had in the original negative. Nor is there any reason why you should not run the full gamut of printing from low-contrast negatives on to low-contrast papers, to high-contrast negatives on to high-contrast papers, not necessarily excluding the compensatory techniques to achieve an average contrast on the final print.

Vignetting

Vignetting is a special application of the techniques of shading and

burning in. It is used to produce a print of a subject isolated against a light or dark background, the edges of which are diffuse. Vignetting may be used to obtain a print of only one subject from a group on the original negative or exclusively to capitalise its soft-edged effect.

It is easier to produce a vignette on a light rather a dark background because of the physical manipulation required for the latter, and it is more sensible to use low contrast, matt printing papers since their special qualities will work with you to achieve the desired effect. If you use high contrast gloss papers you will constantly have to compensate for their natural tendencies to produce sharp edges and gradations.

Multiple Printing

Masking, printing in and combination printing are techniques that can be used for landscapes, double-portraits and other effects that at one extreme doctor the print to improve on nature (by inserting cloud formations that were not present in the original subject, for example), or at the other quite dramatically reach into the realms of surrealism. Exactitude is needed in exposure timing and mask handling if the techniques are to succeed.

Treating the Negative

Some special effects are created basically before the negative is placed in the enlarger: multi-exposures, with or without flash; zooming on to the subject over a sufficiently long exposure (and even zooming on to a transparency in the slide-copier—a slightly unhappy last resort to create the blur some photographers believe to be the essence of movement); movement of the subject or the camera; using lens filters, screens and mirrors; exposing black and white infra-red film and bromide paper in the camera; and finally burning negatives with chemicals or direct heat.

Treating the Paper

Some special effects can be produced very easily without a negative at all. (The methods can also be combined with the use of suitable negatives for particular effects.) Photograms are made by placing objects on the printing paper and exposing it to the open light from the enlarger. If the object is opaque, it will provide a 'silhouette' image with well-defined outlines. Translucent objects will leave their images lighter or darker accordingly. Feathers, fabrics and plastics are especially susceptible.

Paints, dyes, oil, gum and wax can be applied to the paper (or film if you wish to be mildly extravagant) before it is exposed, and according to their filtration densities they will pattern the paper in varying tones. It is a matter of taste whether you use materials that can be completely or partly removed before or after processing—some can be used

to achieve a three-dimensional, genuine bas-relief result (genuine as opposed to the bas-relief photographic effect referred to below). Salt, sand, sugar and pepper (with or without liquids, solvent or otherwise) are all easy to use and effective. There are proprietary printing screens to create textured effects on the print. These screens are placed immediately next to the negative in the carrier. It is a simple matter to devise and create your own to place directly on to the paper surface.

Related to the technique of 'painting' the subjects with light from hand-held spots or lamps, is the 'painting' of the paper itself with the thin beam of light from a pencil torch or similar. The method can be used by itself or in conjunction with the actual paints and oils referred to above, to produce interesting abstract effects.

This physical handling of the paper and light can also be applied to the projected negative image. The printing easel or enlarger head can be tilted to 'correct' converging verticals or to increase the angle of convergence. The printing paper itself can be curved and held in a concave or convex position (or indeed both). The printing easel can be turned between separate exposures so that symmetrical patterns are created. It can be turned once, twice or three times through 180°, 90° or 270°.

From handling the printing paper in this way it is not a large step to collage, and later to montage, experiments in which the paper prints (as many as you need) are firstly cut into regular shapes or randomly torn and then re-assembled in a variety of ways. The segments of the final print can cover the whole image area or spaces of black or white background can be left to gain an exploding effect. Alternatively, pieces may be omitted to obtain a final effect of imploding.

Multi-stage Processes

Transparencies (negative or positive) which provide a full tonal range can be used to create prints or more positive and negative transparencies with the tones completely eliminated and only black and white remaining or a restricted number of tones clearly stepped in their gradation. By the use of contact or projection printing, with more than one negative or positive in the carrier—exactly in register or just out—you can achieve effects known variously as tone-elimination; tone-separation; posterisation; and bas-relief. The larger the format of your negative and enlarger, the easier the process will be, especially if you decide to use some of the specialist films normally supplied to graphics studios: lith and line ortho stock.

While it is true that certain effects can only be achieved by using special films and intricate steps (and total if not obsessive care and delicacy in a completely dust-free atmosphere), it is also true that by projecting a perfectly ordinary slide on to grade 3 (not even 4) paper, processing the print to a quick wash and placing it, still wet, emulsion-

to-emulsion on to another piece of grade 3 paper and exposing the damp pair (negative print uppermost) to the open light of the enlarger lamp, you can make a most pleasing final print, with the tone-gradations well dispersed. The whole process need take no more than a few minutes. The area for experiment and exploration is still wide open.

Treating the transparency or print to some other processes can create effects known variously as solarisation; pseudo-solarisation; Sabbatier effects; Mackie lines; and reticulation. All but the last produce a transparency or print (basic negative or positive) that combine the elements of a reversed image within themselves. Thus, a treated 'negative' contains some elements of the corresponding and actual 'positive' reversal. The key lies in the exposure to light of the transparency or print at some time during the actual stage of development. The film or paper is taken from the developing solution and exposed to the light of a small lamp (15–40 watts) at a distance of some inches or a few feet for a split (or few) second(s). The proportions of light-strength, exposure-time, distance, and the point at which the second exposure is given during development ($\frac{1}{2}$, $\frac{2}{3}$ or $\frac{3}{4}$ way through) all affect the result. Personal experiment is the only way to discover basic methodology that works for you.

Reticulation is a maltreatment of the emulsion that causes it to break from its regular formation and to re-group. The method is to place the fixed (but not hardened) film in very hot water for about five minutes and then immerse it in ice-cold water and dry normally.

None of these processes gives entirely predictable results and considerable time and patience are required for them all. The results, however, can be astounding and intriguing.

Bleaching and sepia toning are two processes that are simple and simply what they say they are. Prints (or indeed films if you wish) are bleached, washed and sepia toned (a dull reddish-brown) and washed— in that order. Proprietary brands are easily obtainable or you can make your own: Kodak give their easy-to-make-up formula in their booklet *Developing, Printing, Enlarging*.

Most of the techniques previously noted can be applied to colour work. Additionally, it is possible to create surprising results by printing black-and-white negatives on to colour paper, with and without colour filters; processing negative, reversal and infra-red colour films in the 'wrong' chemicals (i.e. chemicals intended for one particular process or one particular manufacturer's materials); exposing daylight and artificial-light films to the 'wrong' light or to mixed light sources (lamp-lit rooms with windows, lamp and shop-lit streets in the early evening); and making three exposures on one frame of a mainly static subject with some moving elements, through each of the primary colour filters, or using a completely static subject and moving the camera slightly for each

exposure (the results will be similar to prints of subjects lit to create colour shadows).

By the time you have reached line films, tone elimination, additional exposures and chemical distortion, you will have realised the inadequacy of instruction and the greater inadequacy of books when you are experimenting and exploring not only photographic materials and processes but also your own personality. The things that will most help you to progress are: care, pride in and love of your work and yourself in it; an enquiring and agile eye and mind; a healthy disrespect for all tips, rules, disciplines and materials; and a contempt of all forms of photographic orthodoxy and clichés.

Only you can accurately assess your actual achievement against your potential and your expectation. You are in a unique position to benefit from that assessment if you have the awareness, the confidence and the drive.

The illustrations that follow are not intended to tell you how to 'do' anything in particular. They are offered merely as examples and starting-points for your own experiments, explorations and interests.

Plates 11.1–11.4. Selective enlargements from one negative.

Plate 11.2

Plate 11.3

Plate 11.4

Plate 11.5. A plain print ...

Plate 11.6. ... used in multiple printing.

Plates 11.7–11.9. Night: variations plus x-ray.

Plate 11.8

Plate 11.9

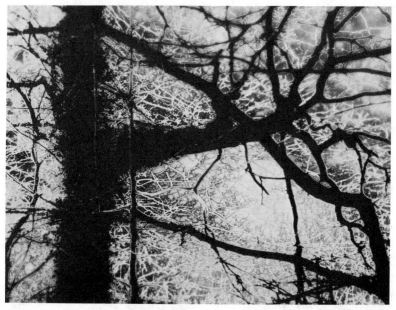

Plates 11.10–11.12. Multi-stage processes.

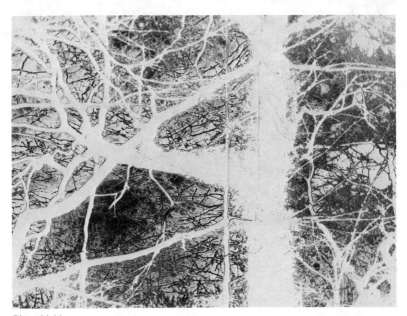

Plate 11.11

Plate 11.12

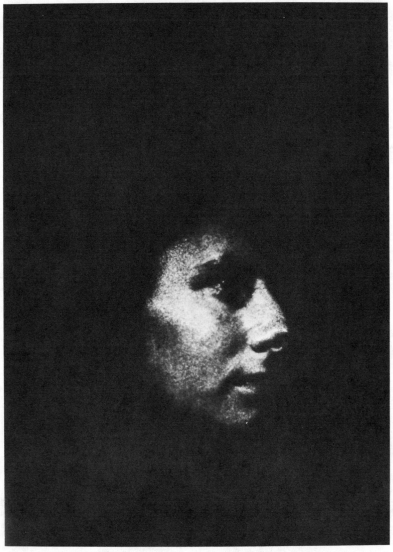

Plates 11.13 and 11.14. Vignetting with emulsion-to-emulsion printing.

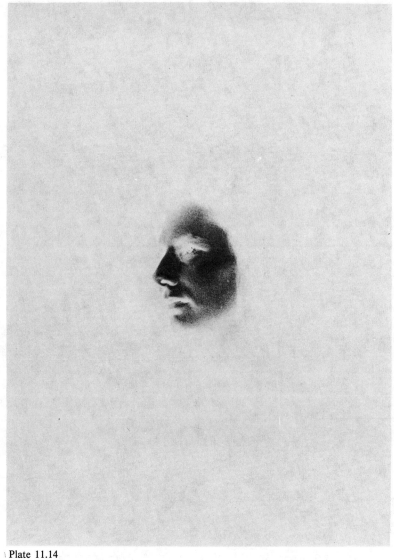

Plate 11.14

Plates 11.15–11.19. Multi-stage processes.

Plate 11.16

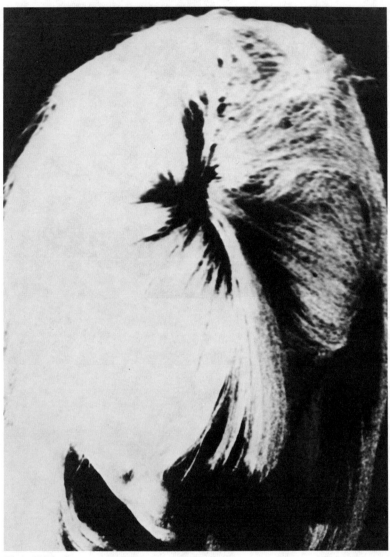

Plate 11.17

Plate 11.18

Plate 11.19

Plates 11.20 and 11.21. Vignetting.

Plate 11.21

Plate 11.22. Printing through a fine screen.

Plates 11.23 and 11.24. Hard and soft paper effects.

Plate 11.24

Plate 11.25. Paper treated with chemicals.

Plates 11.26 and 11.27. Printing on rolled/bent paper.

Plate 11.27

Plates 11.28 and 11.29. Multi-stage processes.

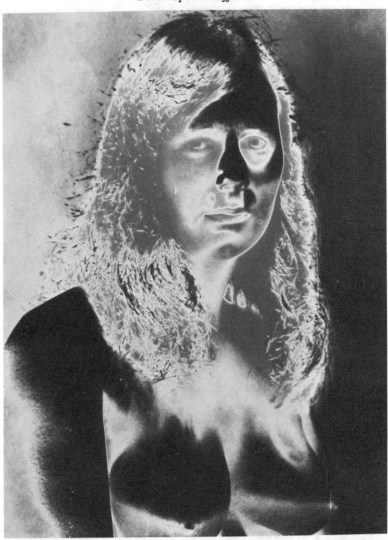

Plate 11.29

Plates 11.30 and 11.31. Positive–negative printing.

Plate 11.31

Plates 11.32–11.34. Paper treated with chemicals.

Plate 11.33

Plate 11.34

Plates 11.35–11.37. Burned transparencies, projection printed.

Plate 11.36

Plate 11.37

PRESENTING THE PICTURE

Prints

Just as when the photographer is taking and making the picture it can be said 'all is in the eye of the beholder', so can it be said when the audience (friend, client or public) is viewing the final print.

In the section dealing with composition it was noted that there are *four major elements that govern the way in which anyone will interpret your pictures:*

(a) Their personal psychological, emotional and physical condition at the time.
(b) Their previous visual experience.
(c) The essential nature of the message.
(d) The environment of the experience.

There is little that the individual photographer can do to affect the first two factors, but the last two are much more under his direct control. The third (the essential nature of the message) will already have been created by the form and content of the picture. All that remains now is the creation of the connection between viewer and picture—the arrangement of the instruments or vehicles that will provide the agency and the means by which the viewer gets the message. Whether you believe the medium to be or not to be the message, it is indisputable that the means you employ to present your pictures to public gaze will undoubtedly affect the kind and degree of final impression they achieve. It is now time to consider this means of presentation.

The two main methods of mounting (dry and gum) were noted in Chapter Ten. There are others: double-sided sticky tape; corners; split-paged albums; but the first two seem to give the best impression of a final print well presented, finished off and shown off by the same process.

Size and Viewing Distance

Next comes consideration of the size of the print in terms of making an impact on the viewer. Once again the subjective aspects of the apparently objective question of resolution arise. What may seem to be a

proper degree of graininess (and therefore good resolution) at a distance of a few feet, may seem to be considerably over-grainy at a matter of inches. You must try to *control the conditions of viewing as much as possible.*

If your prints are to be held in the hand or in a small album you will not have made them for a viewer to study through a magnifying glass. This is taken for granted. What is not taken for granted is that if your final print is to be presented on a wall (be it in your own home or on exhibition or display) there will be an optimum viewing distance and a viewer will not improve his appreciation and experience of your picture by moving closer than that. Little harm is done if he is too far away and generally this is a self-correcting fault in any case. If he is too close, the viewer is, in fact, re-framing your picture and, in a sense, making his own selective enlargement of your picture. This you want to prevent, and the first step in doing so is to recall that the angle of view of the human eye is approximately half a right-angle. This angle of view you must try to fill, not necessarily with just the print, but also with whatever background you feel is needed for it. This can be done most easily by ensuring there is sufficient clear space surrounding the print—and in its plane—and plenty of encouragement for the viewer to 'stand back' at the right distance. If you want your viewers six feet from your print it is wise to ensure the nearest obstacle is not less than nine feet away. If there are walls or pillars at six feet your viewers will almost certainly refuse to stand with their backs immediately next to them. Help them to get your pictures in perspective—literally and metaphorically—because that is what taking, making and looking at pictures is all about.

There is no rule of thumb that inexorably ties together the camera-to-subject and viewer-to-picture distances (though some purists maintain the only proper viewing distance is the focal length of the taking lens multiplied by the degree of enlargement). But in your manipulation of line and tone, perspective and contrast, these two factors must be considered, together with the focal length of the taking lens, the degree of enlargement, and the powers of resolution of the lenses, chemicals and materials all through the process. Plate 12.1 is an example of a print that loses its essential meaning—and therefore considerable impact —if it is viewed too closely.

While the ratio of size-of-print to distance-of-viewing is an important factor in creating the final experience in the eye of the beholder, it is not the only one. The following elements are all worthy of attention:

Shape

There is *no need*, though convenience will tempt, to stay with the printing paper in the shapes and sizes produced by the manufacturers.

Plate 12.1. Printing through a home-made screen.

Your print can be square and in or out of the vertical (perhaps making a diamond); rectangular-to-square or tall-and-thin or long-and-narrow; or circular; or, indeed, any shape that supports what you want to say. Nor need the final print reflect the contours or the content of the image. They too can harmonise or conflict as you wish. Some variations can be seen in Plates 12.2–12.6.

Background and Edges

Whether the main background is the page of an album or folio or the wall of a living-room or exhibition hall, the main colour should be taken into consideration (and it is to be hoped there is no startling pattern for you to contend with). The principles behind emotional response to colour were noted on page 106 and they obtain for backgrounds also. *The texture, colour and/or tonal intensity of the background will affect the effect of your print*, either by complement or contrast, and this effect will be further modified by whatever framing you choose. It may be that you want the image to cover the whole face of the paper so that the picture creates and becomes its own frame. Alternatively, you may decide to edge the image with a border of white or black, created photographically, and as wide, narrow or symmetrical as you prefer. You can make the delineation even more obvious by framing the frame in or on additional materials: fabrics, plastics, wood, metal and glass. Each

Plates 12.2–12.4. Montage mounting for impact.

Plate 12.3

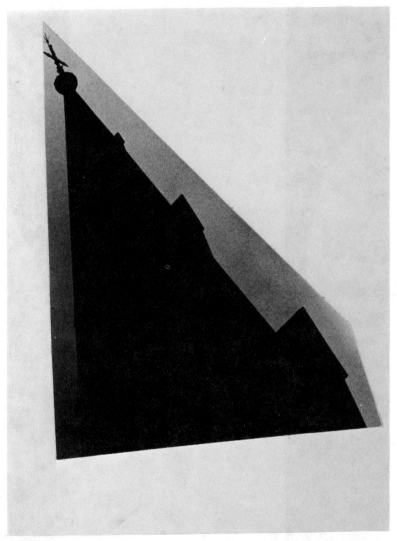

Plate 12.4

Plates 12.5 and 12.6. Tall and thin ... or long and narrow?

image can be framed exclusively individually, or a number of images (although providing their own frame by their very nature) can be framed together as a unit. For example, a sheet of hardboard 6 × 4 ft covered in black, white or bleached hessian, provides a flexible framing device for a large number of prints. Their inter-relationships within the larger frame then become a significant part of the overall effect. This leads naturally to a consideration of the effects of association.

Association

Proximity (nearness in space or time), *continuity* (uninterrupted in time or sequence) *and contiguity* (contact of impressions in place or time) will all vary the impact of any given print, whether it is placed in the viewer's hand or is shown in an album or folio or on a wall. The principle outlined at the beginning of the chapter—that a viewer's response will be conditioned by his previous visual experiences—relates to the immediate past as well as the more distant. Whether you want to make your statement by a subtle and gentle, but inexorable, guided movement through a series of closely related (by form and content) images or by dramatic and perhaps incongruous juxtapositions, *the order in which the viewer sees the individual images or groups of images will channel his opportunities to respond.* The six Plates 12.7–12.12 show three simple pairings: complementary; contrast; positive/negative.

However, no matter how much care you take in the lay-out and order of presentation of your prints, the final choice is one of 'viewing by arrangement' exclusively decided by the individual. This is not the case when it comes to presenting transparencies.

Transparencies

The success of any slide show depends upon the *selection* of the images and the *order and manner* in which they are presented. You can guide your audience into certain opportunities and prevent them from taking others (taking a quick flip-back to image number 3 after seeing number 15, for example) in a way that is not a practicable possibility with prints. In presenting a slide show *you are expected to be in charge.* You can never control the experiences your audiences will perceive and remember—they will still see only what they can and want to see—but you have a greater measure of control over the way the stimuli are administered. You can exercise that control in a number of ways:

(1) Initial selection.
(2) Size of image.
(3) Viewer-to-image distance.
(4) Organisation and method of image changing.
(5) Environment of the event.

Plate 12.7. Complementary prints: positive and reversal from one negative.

Plate 12.8

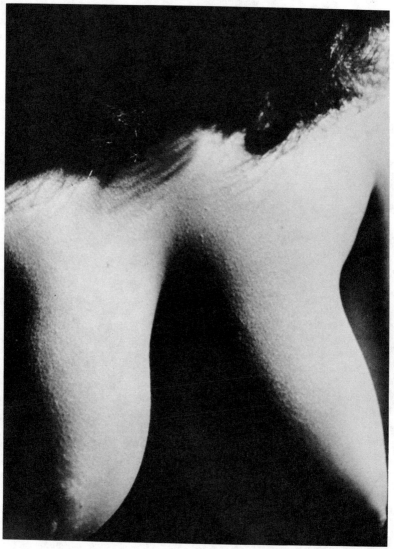

Plate 12.9. Simple contrast.

Plate 12.10

Plate 12.11

Plate 12.12. Contrasting prints: positive and reversal from one negative.

These are considered later. First come some of the practical necessities:

Slide Preparation and Mounting

If you send your film away to be processed it will usually be returned to you already mounted in cardboard or plastic. This method may be satisfactory to you and when processing your own transparencies you may decide to obtain similar mounts. They are easy to use and inexpensive to purchase.

You may prefer to give your transparencies the added protection (against dust, dirt, damp, fungus and scratches) of a glass sandwich mount, and you can do this whether you process your own films or send them away. (If you do the latter, it is sensible to instruct the laboratory to return them unmounted and so leave you a completely free hand.) The necessary factors for success in slide mounting, filing and projection are the standard ones of care, cleanliness and systematic method. This latter will be progressed swiftly if you always 'spot' (with or without reference numbers) your slides in the top right hand corner when projected. This is standard practice.

If you decide to mount your transparencies in glass sandwiches, do not miss the opportunity to experiment with water, oil, hydrogen peroxide and dyes placed in the otherwise empty frames, to provide intriguing and moving images. Small quantities only are needed in the sandwich and chemical reaction and physical convection provide intriguing visual movement. Many of the slides so produced provide exciting images when photographed in a slide copier.

The transparencies that were burned by chemicals or heat (see Plates 11.35–11.37) also offer an interesting facet: by using the focusing mechanism it is possible to 'travel through' the treated emulsion and so provide a constantly changing set of images—an excellent exercise also for training the eye.

An element of particular importance is the nature of the receiving surface for the image.

Screens and Surfaces

The projected image from a transparency is intangible and generally much bigger than a print. These two factors alone immediately change the nature of the impact of the image on an audience. The quality of this change will be affected by the surface on to which the image is projected.

Usually these surfaces are screens and equally usually any audience sits on the same side of the screen as the projector. (Back-projection screens are easy to obtain or to make for yourself. The major drawback is that they need either the same space behind as in front of the screen

to provide the average size image for an average size audience, or an expensive wide-angle lens.) Although in practice screens vary from walls of all kinds to bed-sheets and lengths of plastic, it is worth investigating the qualities of purpose-made screens if you require your images to be projected to the best advantage. There are three main kinds:

(i) *Beaded and Metallic:* These provide bright, clear images with the beaded type performing less well as the viewing angle to the screen decreases and the metallic type being prone to over-bright spots around some highlights.

(ii) *Matt:* The smooth surface provides a diffuse image which is less bright than that from beaded or metallic screens, but does not suffer from either of their drawbacks.

(iii) *Translucent:* The semi-transparent rear-projection screen provides a bright, clear, partly-directional image, and if it is to be used in other than intimate gatherings, suffers from the drawback mentioned above.

The size, shape, nature and edging (if any) of the screen affect the presentation of the projected image in the same way as they did for prints, and pose the same questions about framing.

Lenses

The quality and focal length of the lens of the projector will affect the quality and size of the projected image. If you settle for a single image size and a regular projection distance, you will need only one lens. If you want to vary either or both you will need more than one lens, or a zoom lens—just as with the camera. Manufacturers supply full details of the sizes of images projected by their lenses at different lengths of throw and by consulting them you can quickly determine the range you need.

The zoom lens has a straightforward functional advantage in enabling you to adapt to varying screen sizes and lengths of throw with a minimum of bother. It also has the added merit that when projecting a programme you are able to exercise that extra degree of control over the way in which you achieve your intentions. Provided the screen and projector are set up for maximum image size, you can vary the size of the image between and during actual projections of shots.

Projectors

There is a large variety of transparency projectors available. As might be expected, the choice is much larger for 35 mm and 126 cartridge types than it is for $2\frac{1}{4} \times 2\frac{1}{4}$ in. (6 × 6 cm). You can pay as little as £25 for a basic projector and up to twenty times that amount for

sophisticated models without approaching the limit. The more you pay, the more efficient and flexible are the main features likely to be.

(i) *Slide-Change Mechanism:* This will vary from a single push-pull frame that shows single slides to rectangular tray and circular magazine models carrying from 36 to 120 slides, some with facilities for projecting and changing any single slide individually; to push-button operated change-mechanisms that can be controlled locally or remotely to move the programme backwards or forwards, one, or more than one slide at a time.

(ii) *Optical/Illumination System:* This will vary from a basic mains lamp and condenser system; to low voltage halogen lamps and more (and more efficient) condensers; to models incorporating heat-resistant glass, a cooling fan and automatic focusing which can be pre-set and over-ridden by local or remote control; to built-in fading and dissolving devices.

(iii) *Tape-Synchronisation:* Some projectors can be controlled by a pulse signal recorded on to magnetic tape and played back through a tape-recorder. The systems vary from simple, individual slide changing with one projector only, to sophisticated programming that will provide changes of one or more images from one or more projectors by immediate cuts, and fading or dissolving.

If you propose to specialise in transparencies—monochrome or full colour—you need to pay as much attention to acquiring and using good projection equipment well, as you did to the shooting and processing of the film. Just as the photographer who turned his attention carefully to printing became essentially a printer rather than a photographer at the appropriate stage, so will you now need to become essentially a projectionist.

The effective presentation of a slide show is much more under the control of the editor/projectionist than are the results of the efforts of a print-photographer/exhibitor. As mentioned earlier, the audience will expect you to take the initiative and control of the programme, and to retain them throughout. This is only partly because an actual operator is required. It is also because audiences generally incline to laziness and are only too happy to sit back and let someone else do the 'hard work'. Since this 'hard work'—which is, of course, no such thing—permits you to lead your audience on a disciplined and guided tour, it is an opportunity to be seized. In slide presentation, the eye of the operator's projector is a supreme dictator of stimuli and manipulator of experiences.

The projectionist's control over the impact of any programme lies in the imagination and skill he can bring to the main elements, which can be summarised as follows:

1. *Initial Selection and Preparation*
 (a) Quantity and quality of slides.
 (b) Size of image and viewing distances.
 (c) Number of projectors and screens.
2. *Method of Presentation*
 (a) Speed from image to image.
 (b) Visual movement from image to image.
 (c) Operation.
3. *Environment*
 (a) Physical surroundings.
 (b) Lighting.
 (c) Concrete sound.
 (i) Commentary.
 (ii) Sound effects.
 (iii) Programme music.
 (d) Abstract sound.
 (i) Vocalisation—words.
 (ii) Sounds—music.
 (e) Montage and tape synchronisation.

Initial Selection and Preparation

The first principle is simple and straightforward: if you have any doubt at all, no matter how slight, about the quality of any slide, do reject it. Be ruthless, for there is no place for nostalgia, sentimentality, romantic or personal bonds, when selecting slides for viewing. A limited number of slides of excellence will be more memorable than a larger number of not-quite-so-good ones. Pare back and refine your selection until each image is necessary to your theme. If you know the specific purpose of each slide you will stand a good chance of making your programme telling. Individual slides may not achieve the purpose you had in mind (indeed, none of them may) but without that initial, clear intention on your part, the images are more likely to achieve nothing.

There can be no rule about how many slides you can or should show in any one session. This will depend upon the number of projectors and screens you want (or are able) to use; the detailed method of presentation; the time available; the environment; and the size of image and viewing distance. The more easily your audience is able to escape the total impact of the images by looking away the more slides they will need before they will feel they have had enough. If the conditions of viewing deny them anything else to look at (because the images are large and cover the angle of view, and the room is in total black-out) and the images are powerful, your audience will become satiated or exhausted in a relatively short period. Your theme and purpose will dictate the resolution of these considerations.

Method of Presentation

Pace: The pace (*quantitative movement*) with which you progress from image to image will be governed by your wish to create a fleeting impression or to encourage perceptive contemplation, and this will in turn be governed by the form and content of the images. Since each image will have a different optimum viewing time for each member of the audience, and it is impossible to please everyone all of the time, this is an area where you must rely exclusively on your sensitivity and sensibilities. There is risk in showing slides for too short or too long a time. The former creates frustrations and the latter brings boredom. Both are demonstrated by physical symptoms of unrest in the audience and it is always as important to keep your eyes on the viewers as it is on the screen, if not more so, certainly in your first few presentations.

Style: The style (*qualitative movement*) with which you progress from image to image will dramatically alter the overall effect of the presentation, as well as the individual impact of each image. The variations are almost endless in the four main styles:

Focus: By taking the image out of focus (and at the same time making it larger, if you have a zoom lens) you can smooth the edges of image-transference with one (or more) projector(s), and this is useful when simply changing images or, without complex manipulation, when approximating a dissolve without the proper means.

Cut: This is the normal method, and its main merit lies in the abruptness with which an image can be made to appear or disappear; it is particularly effective when an image cuts in on a slowly fading one.

Fade: Apart from the cut, this is the easiest style to achieve with a single projector without the purchase of expensive equipment or aids. By sliding pieces of card (or handkerchief, cloth or your fingers) across the lens, either straight or in scissors-style, you can achieve a smooth and efficient fading system which will enable you to cut out and fade in or fade out and cut in.

Dissolve: With two basic projectors you can use this method. As one image fades out a second is faded in. The system has two main merits: it makes the progress from image to image smooth and apparently effortless; and it bonds the images in the minds of the audience, at the same time creating areas of ambiguity and confusion which can provoke tension or relaxation and conflict or harmony dependent upon the form and content of the images.

The operation of these effects, whether simple or sophisticated, can be undertaken by hand at very little cost of time, effort or money. They can also be performed mechanically and electronically. The more your projector does for you, the more it will cost. But remember, in these

days of television, cinema, sound-and-light shows, and colour supplements, your audience will be made up of sophisticated experts and their standards will therefore be that much higher or their visual palates will be numbed. Either way, you will need to impress them.

Environment

The physical surroundings you arrange for your presentation will affect the psychological attitude of your audience. If it is intimate and informal they will tend to respond in that manner and if it is relaxing, plain, fussy or obviously well thought out and planned they will respond accordingly.

It is desirable to have some smooth control over the level of lighting whether you want a partial dim-out or total black-out. Miniature, domestic dimmers are inexpensive and easy to fit and they overcome the problem of the final 'plunge' into darkness if you have decided on a full black-out. (A word of warning here: the period of time that any group of people can tolerate *total black-out* is limited. Even in the friendliest, domestic circumstances the panic threshhold can quickly be reached—so do not cause unnecessary strain.)

Sound

The sounds that accompany the presentation are an important factor in the environment, and this embraces the sounds of the projectionist in action, including whispered instructions. These, however, are sounds to be avoided.

Those for positive selection fall into two main categories: concrete sound and abstract sound. The former bears a direct naturalistic connection with the images; can be easily accepted and perhaps expected; and creates no element of surprise. Its function is supportive and explanatory to the form and content of the image without adding a unique message. The latter has none of these elements and its function, generally, is to jolt the audience into a state of heightened awareness (perhaps because of the apparent incongruity of sound and image). Its function is therefore not supportive but stimulatory and exploratory.

Concrete Sounds (not to be confused with sound or musique concrète), generally reinforce the image and its surface meaning and they embrace the following:

Commentary, whether live (produced naturally or amplified through a microphone) or recorded (with or without the obtrusive 'bleeps' that indicate 'it is time to change a slide').

Sound Effects, reflecting naturally the content of the image.

Programme Music, reflecting sympathetically the form and content of the image (often mere 'Muzak').

Abstract Sounds generally challenge the image and its deeper meaning and they embrace the following.

Vocalisation: The use of mouth-music and disconnected consonant, vowel and word structures (thematically related poetry lies half-way between commentary and vocalisation).

Sounds and Music, by their very unexpectedness, can place the image in a new and significant context.

Montage and Tape Synchronisation. The aural part of the slide presentation experience is often referred to as 'atmosphere'. If it is relegated to this position it is more likely to achieve the effect of atmospherics.

Slide projection with tape synchronisation is surely an area of presentation that should be taken seriously by any photographer with an eye to the future. The sound that comes from the tape should be fully acknowledged for what it is: an integral part of the total experience, and if you place a low value on the ears of your audience they will be only too willing to place the same low value on your images, and their appreciation of them. *The nature of the aural stimulus will drastically change the viewer's perception of the visual image.*

Experiment for yourself by projecting a single transparency in a fully darkened room. Accompany it by different and contrasting music and sounds, and notice how your vision of the image changes before your very eyes. While you are doing this you might experiment also by projecting the image on to a moving cloth, transparent or opaque; on to the screen or wall at an extreme angle; and on to the three planes at the corner of walls and ceiling. Even the most ordinary transparency takes on extraordinary meaning from the unusual dimensions.

The synchronisation of the tape-recorded sound track can be undertaken manually, electrically or electronically, and can be simple or sophisticated (from a single projector and separate tape-recorder to four projectors, each with full cut, fade, and varying dissolve facilities, operated by an eight-track tape-recorder, also providing quad sound facilities).

The sound montage on the tape itself can also be simple or sophisticated with similar controls over the style of changing from one sound to another: cut, fade or dissolve.

The techniques of cutting, fading and dissolving from image to image all require the eye to be used sensitively and perhaps even trained.

Training the eye (no matter which meaning of the verb or noun: learning or aiming; camera, enlarger, projector, taker of image, maker of picture, viewer-at-large) brings us to the end of this book, since training the eye is what it is all about, and the photographer has a thousand eyes—and the ability to open millions.

Summary

The effective impact of your pictures will be affected by the attitudes and experiences that your viewers bring with them, and they are generally beyond your control. But you can arrange the physical conditions of presentation to work to your advantage.

The main points regarding prints are: size of the pictures and optimum viewing distance; picture shape (square, rectangular, circular, etc.); backgrounds and edging/framing; inter-relationships of placement and spacing of pictures (proximity, continuity and contiguity).

The main points regarding transparencies are: size of images and optimum viewing distance; the nature of the screen (beaded/metallic, matt, translucent); the use of a zoom lens to change image size (to meet physical projection conditions, or to heighten impact); the method of transparency-changing in the projector (manual/automatic/tape, local, remote); the method of image-changing on the screen (pace and style; focus, cut, fade, dissolve); the environment of the event (physical surroundings; house-light control; accompanying sound(s), concrete, abstract, montage).

GLOSSARY

aberration. A defect in the performance of a lens preventing the production of a true image, causing distorted or unsharp results. *Chromatic aberration* occurs when the lens focuses different colours in different planes.

additive. Colour manipulation by the use of the three *primary* colours: red, blue and green.

angle of view. The angle formed by the extremities of any distant-subject image that is fully accepted on the negative format, usually stated in terms of the diagonal. The angle of view is controlled by this diagonal and the focal length of the lens.

aperture. The opening in a lens through which light passes; usually controlled by an iris diaphragm.

ASA (American Standards Association). Film speed rating: under 100 ASA, slow; over 400 ASA, fast.

astigmatism. A lens aberration causing failure in the ability to focus at the same time on a horizontal line running through the centre of the lens and one vertical to it.

back lighting. The lighting of a subject from behind when viewed from the camera position; the extreme case is one of silhouette.

back projection. The projection of an image on to a translucent screen, from behind when viewed from the audience position.

base. The material on which light-sensitive emulsion is coated.

burning in. A process in enlarging of giving extra local exposure to part(s) of the image.

circle of confusion. Circles which are too large for the eye to accept as points.

colour cast. The presence of an undesirable overall hue.

colour negative. Film which contains hues *complementary* to those in the subject.

colour reversal. Film which contains hues *similar* to those in the subject.

colour temperature. The temperature at which a corresponding black body would emit a coloured light similar to the source in question.

contrast. In the image, the range and width of *tonal spacings*; in the subject, the range of *luminosity*.

depth of field. That zone in which subjects can move in depth to and from the camera and remain in focus.

depth of focus. The range of lens movement possible before the image on the film plane becomes unsharp.

development. The first stage in emulsion processing—to make the latent image visible.

diaphragm. Thin overlapping metal plates that open outwards to provide a circle of variable size to permit light to pass through the lens.

differential focus. The separation of part of the overall subject by the use of sharp focus and out-of-focus, for comparison and contrast.

dissolve. An optical effect in which one image fades out gradually, while another fades in.

dodging. A process in enlarging of giving less local exposure to part(s) of the image.

filter. A coloured element placed in front of light sources or lenses to control *hue* in colour work and *tone* in black and white by absorbing selected parts of the light spectrum.

fixing. The second stage in emulsion processing—to make the unexposed silver halides susceptible to washing or cleansing away.

f number. The focal length of a lens divided by its effective aperture, to give a measure (the f number) of its light-transmitting power.

focal length. The distance from the optical centre of the lens to the sharply focused image of a distant subject.

fog. Photographic density in the developed emulsion caused by abnormal exposure to light or unwanted chemical reaction.

gamma. A means of comparing subject input and image output tonal contrasts. When gamma is 1 the ratio is unaltered. When it is less than 1 the ratio has been decreased.

grain. Small silver halide particles conglomerating to form the photographic image.

halation. The reproduction of a discernible halo round a highlight. It is much avoided by the use of an anti-halation layer between film emulsion and base, preventing unnecessary reflection by the base.

image. Two-dimensional visual reproduction of the interaction between light rays and objects. When formed on a surface, it is called *real*; when it could be formed on a surface but is not, it is called *latent* or *aerial*; and when it cannot be formed on a surface but can be perceived, it is called *virtual*.

incident light. The light falling on a surface.

lens. A transparent medium with one or both sides curved, to converge or diverge light rays by refraction.

negative. A negative image is one in which *tones and/or hues are reversed* from those of the subject. The term is also applied to negative *film stock* whether exposed or unexposed, developed or undeveloped.

orthochromatic. The word means correct-colour rendition, but ortho-films are not sensitive to red light.

panchromatic. The word means all-colour rendition, and pan-films are sensitive to all the colours of the visible spectrum.

parallax. The apparent change in position of a subject due to altering the position of the viewer. It is a relevant factor in all cameras if there is a lens for viewing in addition to the one for shooting.

pentaprism. A special glass block incorporating reflecting surfaces to provide a vertically and horizontally correct image.

perspective. The phenomenon of visual perception by which objects that are actually constant in their inter-relationships of size and placement appear to change as the observer's position changes on any straight line to and from the objects.

range finder. A device for measuring distances without moving, often achieved by displacement of images by mirrors or micro-prisms until the controls have been adjusted to indicate the correct distance.

reflection. There are two kinds of reflection: *diffuse and specular.* The first occurs when light is reflected evenly in all directions as it is from a matt surface; the second occurs when each reflected light ray leaves the reflector at the same angle at which it fell on it, as occurs with a gloss surface.

refraction. The *bending of light rays* when they travel obliquely from one medium to another. The deflection occurs at each surface change.

resolution. The ability of lens and emulsion to reproduce faithful, fine detail.

reversal. A type of film which produces a *positive image* on the originally exposed material. It also refers to the *process* by which such images are created: the latent image is developed, at stage one; then destroyed at stage two; and the remaining sensitised potential realised at stage three (by light or chemicals); finally fixed and washed. The film can be black and white or colour.

sensitivity. The degree of response of emulsion to the colour and intensity of light.

shutter. The shutter in a camera allows light to pass through the lens and reach the film for an appropriate duration. There are two main kinds: *focal-plane and between-the-lens.* The former is a laterally movable blind with a variable gap; and the latter a fast-action-return iris diaphragm.

silver halides. The light-sensitive salts used in emulsions: silver bromide, chloride, and iodide.

spectrum. The electromagnetic spectrum (a band of wavelengths of defined frequencies) includes radio waves, cosmic rays, X-rays, ultra-violet rays and infra-red rays, and visible light rays. The latter occur between 4,000 and 7,200 Angstrom units and consist of violet, blue, green, yellow and red—the extremities of invisible rays being marked by ultra-violet and infra-red.

subtractive. Colour manipulation by the use of the three *complementary* colours directly related to the primaries: the secondaries: cyan, magenta and yellow.

sync. Events are said to be in sync when they occur with inexorable coincidence. The sync-pulse is used in projection to link images with a sound-track recorded on $\frac{1}{4}$ in. magnetic tape.

tonal range. The *differential in densities* (reflective or transmissive) that exists between the greatest and the least in any given matter—be it *subject or image*. The extremes are transparency and opacity, and luminosity and obscurity. When the differential is great, the contrast is said to be high; when it is little, it is said to be low. Low contrast in the light-grey range is said to be high-key; and in the dark-grey range to be low-key.

transmission. The passing of the light rays through a non-opaque medium. There are three kinds: *diffuse*, when the light rays are scattered in many directions; *direct* (or specular), when the light rays are not scattered and are passed on without interference of any kind when the angle of entry is perpendicular to the medium; and *selective*, when the medium absorbs some wavelengths and passes through only the remainder (this can be diffuse or direct).

zooming. The manipulative operation of a *variable focal-length lens*, either between shots or during shooting. In the first case the factor is one of convenience, and in the second one of aesthetics.

SUGGESTED FURTHER READING

Magazines and Brochures

There are many monthly magazines readily accessible on the shelves of most newsagents. Two of outstanding interest, merit and significance are perhaps less well known. They are well worth your investigation and are:

The British Journal of Photography, published weekly by:
Henry Greenwood and Co. Ltd,
24 Wellington Street, London, WC2E 7DH.
Price: 50p.

Creative Camera, published monthly by:
Coo Press Ltd,
19 Doughty Street, London, WC1N 2PT.
Price: 60p.

The quantity and quality of helpful information sheets, leaflets and brochures published by Kodak Ltd is impressively high. Many are available free of charge. The service and information is expectedly good and they invite you as follows:
'If you need help with a photographic problem, write to Kodak Ltd, Product Services, P.O. Box 66, Kodak House, Station Road, Hemel Hempstead, Herts.'

Guides

Focal Press, London, publish *Camera Way* books of specific information. The prices range between £2 and £4 and deal with the following models: Asahi Pentax, Canon, Contaflex, Contax, Hasselblad, Praktica, Leica & Leicaflex, Retina, Rollei.

Focal Press also publish *Focal Camera Guides* of specific information at prices under £1 for many more models.

Books

Barrett, Cyril, *An Introduction to Optical Art*, Studio Vista, London, 1970.

Bruce, David, *Sun Pictures*, Studio Vista, London, 1973.

Bryn-Daniel, J., *Grafilm: an approach to a new medium*, Studio Vista, London, 1970.

Capa, Cornell (Ed.), *The Concerned Photographer 2*, Thames & Hudson, London, 1973.

Cartier-Bresson, Henri, *Man and Machine*, Thames & Hudson, London, 1972.

Cartier-Bresson, Henri, *The Face of Asia*, Thames & Hudson, London, 1972.

Cartier-Bresson, Henri, *The World of Henri Cartier-Bresson*, Thames & Hudson, 1968.

Feininger, Andreas, *Basic Colour Photography*, Thames & Hudson, London, 1972.

Feininger, Andreas, *Dark Room Techniques* (Vol. I and Vol. II), Thames & Hudson, 1974.

Feininger, Andreas, *Manual of Advanced Photography*, Thames & Hudson, London, 1970.

Feininger, Andreas, *Principles of Composition in Photography*, Thames & Hudson, London, 1973.

Feininger, Andreas, and Emerson, W. K., *Shells*, Thames & Hudson, London, 1972.

Feininger, Andreas, *The Complete Colour Photographer*, Thames & Hudson, London, 1969.

Feininger, Andreas, *The Complete Photographer*, Thames & Hudson, London, 1966.

Fletcher, A., and Facetti, G., *Identity Kits: a pictorial survey of visual signals*, Studio Vista, London, 1971.

Garland, Ken, *Graphics Handbook*, Studio Vista, London, 1966.

Holter, Patra, *Photography Without a Camera*, Studio Vista, London, 1973.

Jenkins, Nicholas, *Photographics: photographic techniques for design*, Studio Vista, London, 1973.

Langford, M. J., *Advanced Photography*, Focal Press, London, 1972.

Langford, M. J., *Basic Photography*, Focal Press, London, 1973.

Langford, M. J., *Professional Photography*, Focal Press, London, 1974.

Roh and Tschichold, *Photo-Eye*, Thames & Hudson, London, 1974.

Sausmarez, M. de, *Basic Design: the dynamics of visual form*, Studio Vista, London, 1964.

Schwarz, Hans, *Colour for the Artist*, Studio Vista, London, 1973.

Strache, Wolf, *Forms and Patterns in Nature*, Studio Vista, London, 1973.

Thurston, T., and Carraher, G. H., *Optical Illusions*, Studio Vista, London, 1967.

INDEX